Gendered Transformations
Theory and Practices on Gender and Media

European Communication Research and Education Association (ECREA)

This series consists of books arising from the intellectual work of ECREA members. Books address themes relevant to the ECREA's interests; make a major contribution to the theory, research, practice and/or policy literature; are European in scope; and represent a diversity of perspectives. Book proposals are refereed.

Series Editors

Nico Carpentier
François Heinderyckx

Series Advisory Board

Denis McQuail
Robert Picard
Jan Servaes

The aims of the ECREA are

a) To provide a forum where researchers and others involved in communication and information research can meet and exchange information and documentation about their work. Its disciplinary focus will include media, (tele)communications and informatics research, including relevant approaches of human and social sciences;

b) To encourage the development of research and systematic study, especially on subjects and areas where such work is not well developed;

c) To stimulate academic and intellectual interest in media and communication research, and to promote communication and cooperation between members of the Association;

d) To co-ordinate the circulation of information on communications research in Europe, with a view to establishing a database of ongoing research;

e) To encourage, support, and where possible, publish, the work of young researchers in Europe;

f) To take into account the desirability of different languages and cultures in Europe;

g) To develop links with relevant national and international communication organisations and with professional communication researchers working for commercial organisations and regulatory institutions, both public and private;

h) To promote the interests of communication research within and among the Member States of the Council of Europe and the European Union;

i) To collect and disseminate information concerning the professional position of communication researchers in the European region; and

j) To develop, improve and promote communication and media education.

Gendered Transformations
Theory and Practices on Gender and Media

Edited by Tonny Krijnen, Claudia Alvares and Sofie Van Bauwel

intellect Bristol, UK / Chicago, USA

First published in the UK in 2011 by Intellect,
The Mill, Parnall Road, Fishponds, Bristol, BS16 3JG, UK

First published in the USA in 2011 by Intellect, The University of Chicago Press,
1427 E. 60th Street, Chicago, IL 60637, USA

A catalogue record for this book is available from the British Library.

Cover design: Holly Rose
Copy-editor: Rebecca Vaughan-Williams
Typesetting: John Teehan

ISBN 978-1-84150-366-0

Printed and bound by Gutenberg Press, Malta.

Contents

Liesbet van Zoonen

Nicole Kidman, the famous Australian actress, thinks that the standard Hollywood portrayal of women as weak sex objects probably contributes to violence against them. The actress is a good-will ambassador for the UN Development Fund for Women (UNIFEM) and testified in October 2009 for a United States House committee that investigates possible international legislation about violence against women. Kidman said furthermore that Hollywood has also produced less demeaning portrayals of women, and that she herself tries not to contribute to these images: 'I can't be responsible for all of Hollywood, but I can certainly be responsible for my own career.' News media immediately picked up the celebrity's critique and published it widely, yet often adding a comment about Kidman's own performance in feeble roles or as sexy celebrity. On the internet, reactions were more cynical, and 'hypocrite' was one of the friendlier terms used to discuss Kidman's statement.[1] When Kidman appeared in the same month on the cover of *Gentleman's Quarterly*, dressed in black lingerie only, that did little to enhance her credibility.

This little incident demonstrates the complexity of discussions about gender and media in the twenty-first century. To begin with Kidman's straightforward connection between media images and real-life violence against women used to be contested among academics and feminists as the 1980s controversy about the slogan 'Porn is the theory, rape is the practice' testifies. Yet, nowadays, serious news media support such a claim, as they did when the American Psychological Association published their report about the sexualization of girls in 2007. Then too, the press release saying that sexualized images harm girls and young women found an easy way into mainstream news media, and governmental task forces have been set up around the world to prevent possible further damage (Van Zoonen & Duits, under review). This consensual uptake of the harmful

1

media effects paradigm does not mean academic media research has finally managed to prove such negative influence, on the contrary. Traditional effects researchers are moving away from the effects paradigm towards a mediation model in which media exposure is only one factor among many (e.g. Slater, 2007), while cultural studies researchers have always focused on situated uses and interpretations of sexualized images (e.g. Attwood, 2005). A second complicating factor comes from Kidman's double articulation as a women's activist and a Hollywood celebrity. As the best paid actress of Hollywood she is deeply entrenched in the cultural codes of the industry and thus has a visual presence that is inevitably typified by style, glamour and sexiness. Moreover, a number of her film roles are not easily qualified as portraying strong anti-stereotypical women. The likely sincerity of her motives notwithstanding these factors in concert work against her authenticity as an activist and her claims about the harm Hollywood might cause (see also Street, 2002). Finally, the incident shows the essential intertextuality and multimediality of contemporary culture: in this case news, film, internet and glossy together comprise the arena in which Kidman's claims are made, interpreted and contested.

Feminist media scholars trying to make sense of the Kidman episode are confronted with a claim about their academic turf that is at the intersection of scholarly controversy, celebrity culture, gender conventions and political opportunism; a sheer insurmountable challenge. The pioneers in their field certainly had a much easier task. When Betty Friedan wrote *The Feminine Mystique* in 1967 she singled out women's magazines and their advertisements as the prime media responsible for perpetuating the myth of the happy housewife. *The Feminine Mystique* not only became one of the sparks that set off the second wave of the women's movement, the book also inspired more research about the media and their contribution to what was then usually called 'sex roles'. Content analysis was the method of choice at the time, and advertising images popular research targets. Invariably, these early projects found that the media portrayed women and men in stereotypical roles and did not offer the alternative images and examples that would stimulate and support women´s emancipation. Feminism in the academy and in the activist arena was firmly intertwined and many a research project was part of monitoring and lobbying the media industries.

When I entered the field in 1985 this relatively straightforward situation had already began to crumble: a clear split had emerged between the 'sex roles' approach that had found a home in social psychology, and the 'gender identity' approach that informed cultural studies. Both types of scholars, especially the younger ones like myself at the time, had no self-evident relation with activism outside the academy. The media landscape, however, had not changed much yet; in the Netherlands and most of continental Western Europe we only had public broadcasting, two channels with late afternoon and evening air time; the magazine market was diversified but limited; national and local newspapers still thrived. All in all the landscape was easily surveyed, and it seemed as if the situation was ideal for the field of gender and media studies to

develop into 'normal science' as Thomas Kuhn meant it some 50 years ago: a relatively stable object of study, clearly demarcated disciplinary boundaries and communities of dedicated scholars across the globe which would meet and exchange research in the gender sections of the international communication organizations, with the International Association for Media and Communication Research (IAMCR) covering a truly global community, the International Communication Association attracting mainly US scholars. The main research themes were clear and concerned production, texts and audiences. Thus, we knew that in general women were under-represented as professionals in all media industries both in quantitative and qualitative terms, but many specific sites of media production had not been analysed yet. We also knew that media texts, whether you would analyse them through content, semiotic, narrative or discourse analysis contained stereotypes, told male-dominated stories and used women as visual spectacle, but there were little historical or comparative analyses yet. And we began to find out, through ethnographically oriented audience studies that women and girls appropriated these texts in manifold and contradictory ways, although we tended to highlight their resistant readings rather than their confirmatory ones. This was more or less the situation when working on *Feminist Media Studies* in the early 1990s: it was entirely possible to summarize the field through 'canonical' research like Janice Radway's *Reading the Romance* (1984), or Ien Ang's *Watching Dallas* (1985) and new big research projects were building on that legacy, such as Ann Gray's study of women's use of video recorders (1992) or Joke Hermes' study of readers of women's magazines (1995). It was also entirely possible to identify which areas were ready for more research and the accumulation of feminist media knowledge. There was a real sense of excitement in the small community of feminist media scholars and our work was beginning to feed into other areas of gender studies on the one hand, and media studies on the other.

The mid-1990s, however, was also the period when public broadcasting monopolies in Western Europe were crushed by deregulation, commercial channels found their way to increasingly fragmented audiences and the internet became user-friendly and ubiquitously popular. For the development of feminist media studies into a solid and acknowledged research enterprise, these developments were devastating. Within two years, say 1994–1995, our field of research had multiplied, but most of our students thought the internet more interesting and commercial television more fun than the old world of newspapers (dull), public television (passé) and magazines (so 1980s). Moreover, didn't we know all there was to know about these old media already? What more could we find about the stereotypes of women in advertising? Who was still interested in yet another study of the marginal position of women in the media workforce? Hadn't we already proven that women were active audiences, appropriating degrading images and stories into their own relevant and less damaging meanings? Didn't this wonderful new digital medium deliver us the means to transform these active meanings into real material media products of our own, or at least to break away from the confines of dichotomous embodied gender

discourse. Only some of us (myself not always included, I admit) doggedly and slowly moved forward on the track of 'normal' science, specifying our general understanding of the manifold ways in which media limit and enable the progress of women, into ever more situated projects. While the steady flow of publications in the journal *Feminist Media Studies* shows much of that work, it seemed, nevertheless, as if the kind of big and exciting publications that defined the naissance of the field almost disappeared, unless they concerned the internet. This was as much a result of the compelling appeal of the new over the old, as it was of research councils and other funders massively moving their money to the challenges that digital technologies offered to society, culture, politics… the economy, health care, education…entertainment, work, business…and so on, and so forth.

I have often wondered why my 1994 book *Feminist Media Studies* (about the old media without a word about the internet) just keeps selling and selling and is still, sixteen years after publication, widely used as a textbook for gender and media courses. It makes me tremendously happy, of course, but it is strange that a book from 1994, covering work from way before that, keeps its relevance, especially when everyone agrees that the world has changed dramatically in the past decade, not only due to digitization and commercialization, but also due to the fall of the Berlin Wall, massive migration movements and, unmistakably, 9/11 and its aftermath. All that is solid melts, but the field for feminist media studies remains stable? Very unlikely. One issue which did come up with some prominence was that of postfeminism, identifying the perverse transformation of feminist ideals into neoliberal consumer models of femininity (e.g. McRobbie, 2008). Yet, with the benefit of hindsight, it may be that the changes in the 'old' media were so much less spectacular in comparison to those that the internet turned out on a day to day basis, that they were only visible to an ever-diminishing group of feminist media scholars.

It seems as if now, with the normalization of the internet and the convergence of offline and online culture and practice, our field is beginning to recover; we see some movement to take up the 'old' issues again. The report of the APA about the sexualization of girls (2007) has many flaws and doesn't carry my kind of feminism, but it did bring the objectification of the female body back on academic, policy and funders' agendas. The recently launched journal *Girlhood Studies* may suffer from a telling amnesia when it comes to acknowledging the field's history (Duits & Van Zoonen, 2009), but it does offer a new and appealing outlet for traditional feminist work. The volume at hand is a similar example of 'forward to the past'. It is the initiative of a group of young feminist media scholars who academically grew up with the internet and postfeminism, but who are also old enough to know the outcomes and challenges of earlier periods; a prerequisite for producing work that acknowledges both the new complexities of the field as that it builds on previous insights. The included chapters present a combination of classic topics appearing under new social and cultural conditions and approached

with innovative methodologies (e.g. equality in the media workforce); of topics that always received less attention than their societal relevance justifies (women, media, politics); of well theorized but less often actually researched topics (gender identities in the mediated settings of television and internet). Significantly, the volume does not structure the chapters on the basis of medium types, although this would have been easy, with the press, television and internet being the main carriers discussed. In the current cultural condition of multimediality and intertextuality it makes more sense, however, to be driven by particular issues like the ones in this book (politics, performativity, socialization), and see how particular media and media combinations are articulated with them in situated diachronic and synchronic contexts. The volume thus offers a much needed research-based accumulation through which we can begin to understand the new challenges, and support Nicole Kidman...or not.

– Loughborough, 2009

Endnotes

1. See http://www.huffingtonpost.com/2009/10/22/nicole-kidman-hollywood-c_n_329 709.html for a juxtaposition of the news with sexy images of Kidman, and http://deceiver.com/2009/10/22/nicole-kidman-thinks-hollywoods-degrading-of-women-is-bad/ for the hypocrite discussion. Both retrieved on 7 November 2009.

References

Ang, I., *Watching Dallas*, London, Methuen, 1985.

APA, Report of the task force on sexualization of girls, 2007, http://www.apa.org/pi/wpo/sexualizationrep.pdf. Retrieved 23 November 2009.

Attwood, F., 'What do people do with porn? Qualitative research into the consumption, use and experience of pornography and other explicit media', *Sexuality and Culture*, 9:2 (2005), pp. 1095–5143.

Duits, L. & Van Zoonen, L., 'Avoiding amnesia: 30+ years of girls' studies', *Feminist Media Studies*, 9:1 (2009), pp. 111–115.

Gray, A., *Video Playtime. The Gendering of a Leisure Technology*, London: Routledge, 1992.

Hermes, J., *Reading Women's Magazines*, Cambridge: Polity Press, 1995.

McRobbie, A., *The Aftermath of Feminism*, London: Sage, 2008.

Radway, J., *Reading the Romance*, Chapell Hill, NC: University of North Carolina Press, 1984.

Slater, M., 'Reinforcing spirals: The mutual influence of media selectivity and media effects and their impact on individual behaviour and social identity', *Communication Theory*, 17:3 (2007), pp. 281–303.

Street, J., 'Bob, Bony and Tony B: The popular artist as politician', *Media, Culture & Society*, 24 (2002), pp. 433–441.

Van Zoonen, L., *Feminist Media Studies*, London, Sage, 1994.

Van Zoonen, L. & Duits, L., 'Coming to terms with sexualization' (under review).

SECTION I
GENDERED POLITICS

CHAPTER ONE:
SILENT WITNESS: NEWS SOURCES, THE LOCAL PRESS AND THE DISAPPEARED WOMAN

Karen Ross

Introduction

In a media environment in which most broadcast news items are around eight seconds long, on the grounds that this is the typical attention span of the average adult, it is perhaps unsurprising that journalists have moved away from traditional forms of political reportage towards an interpretive rather than a 'straight' reporting style. News stories have become less about what was actually said in any given parliament by a particular politician, and more about what the journalist thinks such utterances mean. While selection processes have always played a part when decisions need to be made about what should go on the front page or be included in the evening news on TV, the contemporary news media landscape has seen a real shift in both what actually counts as news and whose voice should be heard. Our contemporary fascination with celebrity means that the views of a pop star on a political issue of the day are given equal weight to those of an elected parliamentarian, all of which are then refracted through a journalistic lens which extracts the most 'entertaining' elements and puts them out as the day's news. While this analysis can be regarded as a little cynical, there is nonetheless a real problem with political news discourse in the twenty-first century given that it persistently seeks out sleaze over substance but, at the same time, continues to prefer elite voices over those of the citizen.

At the time of writing (June 2009), Britain is in political meltdown as waves of MPs resign over the 'expenses' scandal, but the voices raised in alarm about the venality of our elected members are those of journalists, not the citizens whose taxes have actually been hijacked to benefit precisely those people who are supposed to be representing 'us'. It is with this issue of news sources that this paper is concerned. I argue that the

media operate a clever sleight of hand by using particular sources in particular ways to frame a story, but without appearing to have any influence whatsoever. This clever strategy is regularly employed so that across the mainstream news media at least, there appears to be a shared understanding of what the issues of the day are and how they should be understood and interpreted. The constant use of elite voices at the expense of the less media-savvy but equally valid commentators who constitute the 'public', means that hegemony is preserved, awkward questions go unasked and a particular view and perspective on the world is maintained.

A cursory glance at any newspaper demonstrates that a majority of mainstream news stories, other than editorials, round-ups and opinion pieces, routinely include either a quotation from a source or some paraphrasing of a source's words (Sundar, 2001). The use of sources is thus an extremely important part of the story's construction and orientation as well as, ultimately, the point of view being supported (see Tuchman, 1972). Crucially, in the wider context of news content and news production, questions of gender and 'class' bias have been consistently raised over recent decades, both in terms of the restricted range of story types in which women and citizens appear (Tuchman et al., 1978; European Commission, 1999; WACC, 2005), but also in relation to women's relatively subordinate positions within mainstream newsrooms (Gallagher, 1995; Meehan & Riordan, 2002; De Bruin & Ross, 2004; Mahtani, 2005). This chapter considers the ways in which gender plays out in, for example, the selection of news sources, and the use of female decision-makers, elite commentators or members of the public. The salience of gender, in terms of a journalist's propensity to use women or men as sources in their work, is also considered. I take a case-study approach by sampling three English regional newspapers whose content is interrogated using a gendered frame analysis as the primary explanatory framework. Issues of gender are often ignored in much of the research which analyses media texts, thereby eliding important differences in the ways in which gender is both performed but also marginalized. I begin by discussing the broader landscape of news discourse before moving on to consider the findings of the larger study upon which this paper draws. I then, finally, reach some tentative conclusions.

The national vs the local: The big guns and the small fry

Over recent decades, the news industry has come under considerable scrutiny and has mostly been found wanting in terms of its contribution to the public understanding of, say, politics, or even in terms of providing a balanced news diet to a hungry audience. There is a clear requirement to exercise judgement over content and voice, simply on the grounds of available space, let alone the commercial imperative to increase market share (of viewers, readers or listeners). It is precisely the mechanisms by which those decisions are made that have formed the basis of much media scholarship about the media's role in framing and

agenda-setting (Entman, 1989, 2008; Bennett, 1990; Dearing & Rogers, 1996; Iyengar, 2001; McCombs, 2004). The relatively uncontroversial theory which has emerged from studies of news over recent decades suggests that the 'frames' within which stories work contain particular ideological biases which are presented to the news consumer as simple 'truth' (Eldridge, 1995; Philo, 1999; Hardt, 2004). It is precisely this pretence at neutrality which so exercises media commentators, not least because the public tends to believe that the news really is what has happened on any given day, and does not regard it as a constructed package which is entirely partial. For feminist media scholars, the persistent and almost exclusive framing of women as victims (usually of male violence), eye candy or the mother/sister/wife of a newsworthy man constitutes yet another layer of the news media onion which incorporates patriarchy within the hegemonic practices of mainstream newsworkers (Myers, 1999; Carter et al., 1998; WACC, 2005; Byerly & Ross, 2005; Ross, 2007).

However, much of the work that is focused on news discourse, framing and source selection in Western contexts is based on analyses of mainstream and, predominantly, national media. Yet, there is good reason to believe that local and regional media have a different role to play with the public and could be expected to be less constrained by the demands of 'big' news culture. One of the obvious ways in which local media differ from the nationals is in their specific local appeal, and their ability to take advantage of their very localism to engage readers with news that they really want, which includes stories which feature their neighbours, their community, their local services and, at certain times, their elected representatives. As part of this agenda, the question arises as to the extent to which citizens' voices are heard, in particular, those of the 51 per cent of the population which isn't male.

Who is invited to speak as a commentator on and in the news says vitally important things about who 'counts' in society, and whose voices have legitimacy and status. The hierarchy of news values identified by Gans (1979) 30 years ago, which made clear that some sources were more equal than others, is alive and well in the twenty-first century journalist's toolbox: citizens are simply not as equal as government spokespeople, and women are almost never as equal as men. The infatuation which journalists have with the authoritative male source means there is little room for other kinds of voices, namely those of women, minorities, the general public or challengers to the status quo. This repetitive use of the same kinds of elite voices, the same kinds of gendered perspectives, inevitably leads to a commonsense understanding of 'how things are', thereby regularizing an opinion and making it seem like fact. Even when the discordant or anti-establishment voice is allowed a brief spell in the media sun, these voices are usually the 'acceptable' face of radicalism and are unlikely to stray too far off the path of tolerable dissent. And, if Joe Public struggles to register on the journalistic radar, Joanne Public is almost entirely invisible as a citizen, although she is occasionally asked to speak in her role as mother (Stephenson, 1998; Wykes, 1998; WACC, 2005).

Rationale and methods

The study upon which this chapter is based was principally concerned with two related questions: first, are women and men differently represented as (local) newspaper sources in gross volume and status terms and by story topic? And secondly, does the sex of a journalist influence his or her selection of women and men as sources in their copy? A third interest of this paper lies in identifying the balance of 'elite' sources and those from the general public, again differentiated by gender. In order to explore these questions, I sampled three local newspapers published in the Midlands region of England: the *Birmingham Post* (BP), the *Coventry Evening Telegraph* (CET) and the *Leicester Mercury* (LM). I chose to analyse local rather than national newspapers precisely because the local and regional press claim greater freedom to present local stories of local interest and could thus be expected to use a wider and more diverse range of sources. Given that mainstream journalists will often suggest that they don't source women because they rarely have status authority, we might expect to see more of them used as sources in the local and regional press precisely because they do occupy status roles at a local level, and because we might expect the local press to source more 'community' voices, including those of women.

Given that the literature relating to the national press suggests that public voices are more likely to be sought out during election campaigns, the monitoring period for the case study was chosen to include the build-up to the 2005 British general election, the election campaign period itself and the period immediately after the election in order to identify if this was also the case for the local press. I monitored the press over a ten-week period, choosing one day each week for analysis, using Monday 13 March in the first week, Tuesday 21 March in the second week and so on, continuing until Friday 16 May. This amounted to a total of ten weekdays over the ten-week period. The three newspapers were selected mainly as a convenience sample since I had ready access to all three, but also because they share a broad, regional geographical boundary, serve broadly similar communities and have similar circulations in relation to population size.

As this study is interested in the generality of news stories and their sources, rather than particular types of story or particular categories of source, the first twenty stories in each newspaper were coded in terms of story type, gender of source/s, status of source/s and other variables such as the sex of the reporter. Occasionally, fewer than twenty stories were coded for an individual newspaper because news items ran out early on and were replaced by features, lifestyle or sports sections. For the purposes of this study, I only coded those items which were 'straight' news stories, including 'soft' news, but excluded news summaries, editorials, opinion pieces and letters to the editor. I also filtered out all stories which did not include at least one quoted source, and ignored those which were 'national' rather than 'local' in flavour since the study was only concerned with the local news agenda rather than repeats of national news. A total of 30 newspapers were thus monitored (three newspapers each day over ten monitoring days), a total of 538 articles analysed and 925 individual sources coded.

At this point it is perhaps worth saying a few words about the vital statistics of each of the selected newspapers. The *Birmingham Post* was first launched (as the *Birmingham Daily Post*) in 1857 and is now part of the Trinity Mirror group and has a circulation of around 13,000. It is a daily paper published Monday–Saturday and, at the time of writing (autumn 2005), has a female editor, Fiona Alexander. It styles itself as a 'thoughtful' paper—it is the only regional broadsheet in Birmingham—and claims to be more 'cerebral' than its sister paper, the *Birmingham Mail:* its own publicity says that it has the 'business readership' at its heart.[1] The *Coventry Evening Telegraph* was founded in 1891 as Coventry's first daily newspaper and is also now a member of the Trinity Mirror Group. It has a circulation of around 58,000 and is an evening paper, published Monday–Saturday. It has an all-male editorial team (editor: Alan Kirby) and a readership profile which is split one-third, two-thirds, ABC1 and C2DE. The *Leicester Mercury* was first published in 1874 and is now a member of the Northcliffe group. It has a circulation of around 84,400 and is an evening paper, published Monday–Saturday. Its senior editorial team of eleven staff (editor: Nick Carter) includes two women (deputy editor and features) and its readership profile is very similar to that of the *Coventry Evening Telegraph*.

Findings and analysis

To start with, then, what kinds of stories make it into the local press? As we might imagine, the news agenda is very different to that of the nationals, with 'human interest' stories being far and away the most frequent story category. There was a clear clustering of story types between the three newspapers, suggesting that there is a broadly accepted 'sense' among local journalists of what a local newspaper should contain. Given that the monitoring occurred before, during and after the 2005 British general election, what is perhaps surprising about the breakdown of story categories is the relatively low number of stories that are either about politics in general (nine stories) or the general election in particular (five stories). While we would not expect the local press to be covering national political or election stories to any great extent, it would be reasonable to expect to see something about local campaigns and candidates. Yet, only the *Birmingham Post* had a sufficient volume of stories about the general election to make this category one of its top five most popular. The *Birmingham Post* certainly has the feel and style of a broadsheet newspaper, unlike the CET and the LM which are very clearly marked out as local red tops by their use of relatively short articles, the high number of unattributed items and a large number of photographs and advertisements. The *Birmingham Post*, on the other hand, tends to include longer articles and often covers 'national' stories, which might be one of the reasons for its more 'serious' engagement with politics. If we begin to break down the data a little more, we find that there are clear gender skews both in the status of female and male sources, but also in terms of the kinds of stories in which women and men appear.

What we see from Table 1 is that women are three times more likely to be asked to speak as members of the public than men, and they have a significant presence as education workers and spokespeople for the charitable and voluntary sectors, areas of

Table 1: Status and sex of sources

Status of source	Sex of source	
	Female (%)	**Male (%)**
Business person	8	16
Joanne Public	36	-
Professional	7	12
Joe Public	-	14
Local councillor	3	10
Police officer	3	8
Education (teacher/lecturer)	9	4
Local government employee	5	6
Charity/voluntary sector Campaign/consumer group	11	3
MP/PPC	3	4
Criminal justice	2	5
Mother	5	-
Trades union	1	2
Professional association	<1	3
Tie-in to story	2	1
Events organizer	2	2
Emergency services	<1	2
Religious group/organization	<1	2
Miscellaneous*	1	<3
Total	**302 (33%)**	**623 (67%)**

*the miscellaneous category included: civil servant: father; alleged criminal; celebrity; political party worker; victim; government minister; and victim: each of these categories comprised less than 1 per cent of all responses.

work which are typically undertaken by women. By contrast, men are twice as likely as women to be asked to speak as representatives of business, three times more likely to speak as local councillors and nearly three times as likely to speak as police officers. But these gender-biased proclivities on the part of journalists are not a consequence of women's absence from these occupations. For example, of 68 local councillors used as sources, 60 were men (89 per cent), despite the fact that in 2004, 29 per cent of all councillors were women,[2] an average which is more or less constant across the three regions in which the sample newspapers are published. Similarly, of 58 police officers used as sources, nine (15 per cent) were women, even though in the West Midlands Constabulary, an area which covers two of the three sample newspapers, 24 per cent of police officers are female.[3] So, additional factors must be determining the selection of particular sources by journalists, such as a persistent choice of the usual (male) suspects, or a simple denial of women's authority to speak.

The absolute number of sources is still heavily biased towards men, so that even in the category of 'human interest', which appears to favour women, the actual numbers of women and men quoted in these 122 stories are 75 and 138 respectively. In only two categories (local celebrity and sex-discrimination) do absolute numbers of female sources (four, three) exceed those of men (three, one). In only one category (pets/animals) do women and men achieve parity (four sources each), but everywhere else, women are outnumbered by a ratio of at least 1:2, and this figure is often even higher. It is only as 'members of the public' where the absolute numbers of women and men sourced across all story types were almost identical (112 and 111 respectively). It is extremely disappointing to find, on average, the same gender skew in local press reporting as has been discovered in studies of national newspapers. This is particularly the case since it might have been expected that, relieved of the need to slavishly report the major national stories, journalists would look a little more imaginatively at their local community for source inspiration.

As well as gender skews in terms of source selection, more generally, although these are less marked than gender differences in status, there are also some (albeit small) differences in the kinds of stories in which women and men feature, as Table 2 below shows. This is quite a positive finding as it suggests that journalists are moving away from the habit of only asking women to talk about health and only asking men to talk about the economy.

Importantly, a preponderance of male journalists in regional newsrooms cannot be 'blamed' for this persistent disavowal of women's views, as Table 3 below shows. Of the total sample of 538 articles analysed for this study, 332 (62 per cent) had clearly identified writers, and Table 3 shows the distribution of writers and the number of articles across the three newspapers, disaggregated by gender.

It is clear that the *Coventry Evening Telegraph* and *Leicester Mercury* have more or less equal numbers of male and female journalists (albeit based on attributed author articles only), with the *Birmingham Post* appearing to conform to the gender skew evident in

Table 2: Sex of source by story category

Story category	Sex of source	
	Female (%)	Male (%)
Human interest	74 (25)	143 (23)
Employment/economy	32 (11)	68 (11)
General crime	20 (7)	56 (9)
Environment	24 (8)	50 (8)
Health/well-being	17 (6)	37 (6)
Arts/culture	15(5)	24 (4)
Music event	12 (4)	23 (4)
Education/training	20 (7)	24 (4)
Transport	12 (4)	25 (4)
Sports-related	12 (4)	19 (3)
Burglary/theft	6 (2)	18 (3)
Charity event	12 (4)	18 (3)
Enterprise	6 (2)	19 (3)
Various other	40 (13)	59 (8)
Total	**302 (100%)**	**623 (100%)**

the national press. Perhaps its more 'serious' style requires it to have more serious (i.e. male!) journalists, just like its national colleagues. While some research suggests that female journalists are more likely to use female sources in their stories than their male colleagues do (Zoch and VanSlyke Turk, 1998), the findings of this study challenge that finding, as Table 4 shows.

In terms of the proportion of female and male sources used, there is a remarkable consistency across all of the articles analysed, both those with named writers and those without bylines (unattributed). This accords with other research which suggests that men are more than twice as likely as women to be used as sources in news (WACC, 2005). However, as is also clear, there does not appear to be any significant relationship between the sex of a source and the sex of the journalist using that source. Zoch and VanSlyke Turk's (1998) work also suggested that where women were in a minority in their newsroom, this could militate against them using more women as sources. However, this

Table 3: Newspaper title and sex of journalist (attributed articles only)

Sex of journalist	Newspaper title			
	Birmingham Post	*Coventry Evening Telegraph*	*Leicester Mercury*	**Total**
Female	24 (28%)	71 (50%)	53 (52%)	148 (44%)
Male	64 (72%)	72 (50%)	48 (48%)	184 (56%)
All	88 (26%)	143 (43%)	101 (30%)	332*

*two articles had a female–male joint authorship

Table 4: Sex of journalist and use of women and men as sources

Sex of source	Sex of journalist				
	Female (%)	Male (%)	Both (%)	Unattributed (%)	Total (%)
Female	98 (34%)	107 (33%)	4 (36%)	93 (32%)	302 (33%)
Male	187 (66%)	235 (67%)	7 (66%)	194 (68%)	623 (67%)
Total	285 (100%)	342 (100%)	11 (11%)	287 (100%)	925 (100%)

current study also contests that finding, since of the 330 articles analysed which had attributed authors, 43 per cent were written by women, 54 per cent were written by men and three per cent were the work of a female–male team

Discussion

The constructed nature of news is not only a matter of journalists choosing to include one story over another, but the individuals invited to speak in the story provide a perspective legitimacy, a corroborating voice which marks out the authority of the story to the audience. While there is considerable guidance contained within the various codes of conduct relating to news media which explicitly require balance and fairness in reporting, the empirical evidence against which these rhetorical demands might be measured rarely

finds in their favour, and the results of this study are no different. Through the exercise of its alleged commitment to providing news of interest to its local community, the local press has an ideal opportunity to subvert both the national agenda, and thus national proclivities towards the use of elite male sources, and the bias which privileges the maintenance of the status quo. Yet what the findings of this, admittedly modest, study show is that who speaks in the news and who writes the news is alarmingly similar in the local and the national press. This is not just in terms of the dominance of elite voices over 'the public', or of men's voices over those of women or of white voices over black, but is also in terms of who writes the news, the beats which are awarded to journalists (i.e. women do culture and home, men do politics and the economy, again) and the types of story which make it into print. While this study does show that more women are becoming journalists in the local press sector at least, the ratio of women to men in the newsroom certainly does not reflect the ratio of women and men in the journalism classrooms, and women are still more likely to be given traditionally 'female' beats, although not exclusively so.

Any number of feminist media studies suggest that the composition of newsroom staff in terms of the balance of women and men influences the content produced by that newsroom. If there is not always a different focus, then there is certainly a different tone and style, because women have different experiences in the world and thus bring a different perspective (Steiner, 1998; De Bruin, 2000; Melin-Higgins, 2004). In Rodgers and Thorson's study (2003), they found that female and male journalists practised a differentiated journalism in terms of style, tone and sources used, but that these differences were most marked in smaller newsrooms and where there was a more even balance between male and female newsworkers. This suggests that larger newsrooms, with a predominance of male staff, strongly encourage a conformist outlook which produces a hegemonic journalistic output in terms of 'routinizing' a male-ordered frame, a finding echoed by other studies of gendered journalism (see also Van Zoonen, 1998; Robinson, 2004).

If content in some form or another is influenced by the sex of the journalist writing it, and if sources are a crucial aspect of story orientation, then there could be a relationship between the sex of the journalist and her or his choice of source. Encouraging a diversity of views among news writers makes good business sense, since there is some evidence to suggest that female news consumers are more engaged by the more personalized, intimate and less adversarial approach that female journalists are considered to promote (Van Zoonen, 1998; Peiser, 2000; Ross, 2005). One of the ways in which women 'do' journalism that is identifiably different to their male colleagues is in their use of sources. In most studies, men dominate as sources, and in their own work, Shoemaker and Reese (1996) found that men were twice as likely as women to be featured as subjects or sources in newspaper articles (see also Delano Brown et al., 1987; Liebler & Smith, 1997). Similarly, Zoch and VanSlyke Turk (1998) looked at the topic focus of stories in relation to source selection in three US newspapers over a ten-year period (1986–1996) and suggested that women rarely feature in news of national or international importance. Armstrong's

analysis of gender as an influencing factor in the use of female and male sources found that the latter were much more prevalent than the former. Interestingly and optimistically, both Zoch and Van Slyke Turk (1998) and Armstrong (2004) found that female journalists were far more likely to use women as sources in their pieces than their male colleagues.

The 'so what' question implicit in this study is answered, then, by arguing that who is asked to speak in the news, as well as what that news is, says crucially important things about whose voices count and who has status in society. While Nylund (2003) perhaps overstates the case a little by suggesting that news is constructed almost entirely from the use of quotes and journalistic interpretations of various source statements, it is clear that the persistent use of certain categories of commentator influences story orientation and, potentially, our understanding of the world. Does the news-consuming public only want to hear men speaking in the register of privilege and defence of the status quo, or would they/ we like some diversity? Men *still* dominate the news, even when that news is even more at the discretion of the journalist than for the nationals. Where is the ventilation of all those other voices, other stories, other lives? Men and women are differentially understood as *doing* (male-active) or being done *to* (female-passive). If what we see and read and hear are men's voices, men's perspectives, men's news, then women continue to be framed as passive observers rather than active citizens, despite the factual evidence to the contrary which shows, for example, the high incidence of female-owned start-up businesses or the number of women councillors. To be clear, women's occupation of decision-making positions is considerably less than that enjoyed by men, but their marginalization in the local press as business people, professionals, politicians and even members of the public, is hard to understand without using a gender-based analysis which suggests that women's invisibility in the press is a consequence of a deliberate strategy which denies their authority to speak. In Zoch and VanSlyke Turk's study of regional newspapers in the United States, they found that women rarely featured in news stories of national or international significance (1998), and this current study also demonstrates that Tuchman et al.'s prescient description of women's 'symbolic annihilation' from the news agenda in 1978 holds just as true now, more than 30 years later, as it did then. If the local press is to continue to call itself 'local' in any meaningful way, it needs to work a lot harder to more genuinely reflect the views and interests of local communities back to themselves, in all their glorious shapes and colours.

Endnotes

1. www.trinitymirror.com

2. The National Census of Local Authority Councillors in England 2004, London: Employers' Organizations for Local Government.

3. West Midlands Police website: www.west-midlands.police.uk/our-people/women.asp.

References

Armstrong, C.L., 'The influence of reporter gender on source selection in newspaper stories', *Journalism and Mass Communication Quarterly*, 81 (2004), pp. 139–154.

Bennett, W.L., 'Toward a theory of press-State relations in the United States', *Journal of Communication*, 40 (1990), pp. 103–125.

Byerly, C. & Ross, K., *Women and Media: A Critical Introduction*, Oxford, Blackwell, 2005.

Carter, C., Branston, G. & Allan, S. (eds), *News, Gender and Power*, London and New York, Routledge, 1998.

De Bruin, M., 'Gender, organizational and professional identities in journalism', *Journalism*, 1 (2000), pp. 239–260.

De Bruin, M. & Ross, K. (eds), *Gender and Newsroom Cultures: Identities at Work*, Cresskill, NJ, Hampton Press, 2004.

Dearing, J.W. & Rogers, E.M., *Agenda-Setting*, Thousand Oaks, CA, Sage Publications, 1996.

Delano Brown, J., Bybee, C.R., Wearden, S.T. & Straughan, D.M., 'Invisible power: Newspaper news: Sources and the limits of diversity', *Journalism Quarterly*, 64 (1987), p. 50.

Eldridge, J. (ed.), *Glasgow Media Group Reader, Vol. 1: News Content, Language and Visuals*, London and New York, Routledge, 1995.

Entman, R.M., 'How the media affect what people think: An information processing approach', *Journal of Politics*, 51:2 (1989), pp. 347–370.

Entman, R.M., 'Theorizing mediated public diplomacy: The U.S. case', *International Journal of Press/Politics*, 13:2 (2008), 87-102.

European Commission, *Images of Women in the Media*, Brussels, EC, 1999.

Gallagher, M., *An Unfinished Story: Gender Patterns in Media Employment* (Reports and Papers on Mass Communication 110), Paris, UNESCO, 1995.

Gans, H.J., *Deciding What's News*, New York, Pantheon Books, 1979.

Hardt, H., *Myths for the Masses*, Malden, MA, Blackwell, 2004.

Iyengar, S., 'The method is the message: The current state of political communication research', *Political Communication*, 18:2 (2001), pp. 225–230.

Liebler, C.M. & Smith, S.J., 'Tracking gender differences: A comparative analysis of network correspondents and their sources', *Journal of Broadcasting and Electronic Media*, 41 (1997), pp. 58–68.

Mahtani, M., 'Gendered news practices: Examining experiences of women journalists in different national contexts', in S. Allan (ed.) *Journalism: Critical Issues*, Maidenhead, Open University Press, 2005, pp. 299–311.

McCombs, M., *Setting the Agenda: The Mass Media and Public Opinion*, Cambridge, Polity Press, 2004.

Meehan, E. & Riordan, E. (eds), *Sex and Money: Feminism and Political Economy in the Media*, Minneapolis, MN, University of Minnesota Press, 2002.

Melin-Higgins, M., 'Coping with journalism: Gendered newsroom culture', in M. de Bruin & K. Ross (eds) *Gender and Newsroom Cultures: Identities at Work*, Cresskill, NJ, Hampton Press, 2004, pp. 197–222.

Myers, M. (ed.), *Mediated Women: Representations in Popular Culture*, Cresskill, NJ, Hampton Press, 1999.

Nylund, M., 'Quoting in front-page journalism: Illustrating, evaluating and confirming the news', *Media, Culture & Society*, 25:6 (2003), pp. 844–852.

Peiser, W., 'Setting the journalist agenda: Influences from journalists' individual characteristics and from media factors', *Journalism & Mass Communication Quarterly*, 77 (2000), pp. 243–257.

Philo, G. (ed.), *Message Received: Glasgow Media Group Research 1993–1998*, Harlow, Longman, 1999.

Robinson, G., 'Gender in the newsroom: Canadian experiences', in M. de Bruin & K. Ross (eds) *Gender and Newsroom Cultures: Identities at Work*, Cresskill, NJ, Hampton Press, 2004, pp. 181–196.

Rodgers, S. & Thorson, E., 'A socialization perspective on male and female reporting', *Journal of Communication*, 53:4 (2003), pp. 658–675.

Ross, K., *Women and the News Agenda: Media-ted Reality and Jane Public*, discussion paper # MC95/1, Leicester, Centre for Mass Communication Research, University of Leicester, 1995.

Ross, K., 'Women in the boyzone: Gender, news and herstory', in S. Allan (ed.) *Journalism: Critical Issues*, Maidenhead, Open University Press/McGraw-Hill Education, 2005, pp. 287–298.

Ross, K., 'The journalist, the housewife, the citizen and the press', *Journalism*, 8:4 (2007), pp. 449–473.

Shoemaker, P.J. & Reese, S.D., *Mediating the Message: Theories of Influence on Mass Media Content*, 2nd edn, White Plains, NY, Longman, 1996.

Steiner, L., 'Newsroom accounts of power at work', in C. Carter, G. Branston and S. Allan (eds) *News, Gender and Power*, London and New York, Routledge, 1998, pp. 145–159.

Stephenson, M-A., *The Glass Trapdoor: Women, Politics and the Media During the 1997 General Election*, London, Fawcett, 1998.

Sundar, S.S. & Nass, C., 'Conceptualizing sources in online news', *Journal of Communication*, 51:1 (2001), pp. 52–72.

Tuchman, G., 'Objectivity as strategic ritual: An examination of newsmen's notions of objectivity', *American Journal of Sociology*, 77 (1972), pp. 660–679.

Tuchman, G., Daniels, A.K. & Benet, J. (eds), *Hearth and Home: Images of Women in the Mass Media*, New York, Oxford University Press, 1978.

Van Zoonen, L., 'One of the girls? The changing gender of journalism', in C. Carter, G. Branston & S. Allan (eds) *News, Gender and Power*, London and New York, Routledge, 1998, pp. 33–46.

WACC, *Who Makes the News?* London, World Association for Christian Communication, 2005.

Wykes, M., 'A family affair: The British press, sex and the Wests', in C. Carter, G. Branston & S. Allan (eds) *News, Gender and Power*, London and New York, Routledge, 1998, pp. 233–247.

Zelizer, B. & Allan, S. (eds), *Journalism after September 11*, London and New York, Routledge, 2002.

Zoch, L.M. & Vanslyke Turk, J., 'Women making news: Gender as a variable in source selection and use', *Journalism and Mass Communication Quarterly*, 75:4 (1998), pp. 762–775.

CHAPTER TWO
TRACING GENDERED (IN)VISIBILITIES IN THE PORTUGUESE QUALITY PRESS

Claudia Alvares

Introduction

This chapter aims to present a critical analysis of the results obtained in a European Union funded research project on the discursive representation of women in two Portuguese 'quality' newspapers, the *Diário de Notícias* and *Público*, between February and April 2006. My objective is to draw attention to how Portuguese media discourse conceptualizes the 'feminine' as the subject and object of texts. I will concentrate on the framing of issues pertinent to feminism within a news agenda-setting context that draws attention to topical issues usually ostracized from the front pages of the press. In this manner, I propose to establish a link between the discourse of feminist theory and the representation of women in the Portuguese mainstream press, inquiring into the degree to which these media texts have been influenced by either liberal or radical feminisms.

The debate over the public and the private has been greatly expounded on by both liberal and radical feminists. Although the dichotomy between them has opened up to include discussions with socialist as well as postmodern feminists, I am here essentially concerned with the influence of liberal and radical feminism on the way in which the popular imagination has come to understand the concepts of public and private spheres. Liberal feminism has traditionally placed the emphasis on ideals such as emancipation and individual autonomy as aiding in the promotion of the socio-economic rights of women. Radical feminism, on the other hand, posits a singular feminist essence against a patriarchal universality. The term 'radical' in radical feminism connotes 'going to the root' of feminism. This root is associated with patriarchal gender relations, as opposed to legal systems (as in the case of liberal feminism). Radical feminism bases itself on a

dichotomical logic of domination/oppression, exploring issues related to both the 'place' occupied by women in a production system ruled by patriarchal relationships and the reproduction of these in the ideological domain of daily life (Strinati, 1995: 197–198). The existing inequality in social relationships of production and reproduction is revealed, according to Susanne Mackenzie (1989: 56), in the dichotomy that equates production with masculinity and reproduction with femininity. By celebrating a feminine universal essence, radical feminism has chosen the concept of reproduction as a symbol of women's universalism, investing it with a positive connotation.

Thus, while liberal feminism has privileged a discourse on 'rights and rules' that regulates interaction through criteria of justice within the public sphere, radical feminism has attempted to politicize personal issues, drawing attention to the public relevance of issues allegedly pertaining to the private sphere. By questioning the privacy of personal issues, radical feminism interrogates the boundaries of strictly delimited public and private domains. Because the media's agenda-setting function contributes to what is publicly thought of as being relevant in any society, this research project seeks to investigate how feminine identity is constructed by the press as a matter of public relevance. The conceptual frameworks of liberal and radical feminisms will help us to delineate a typology which indicates how public and private have come to be understood within academia. This will then allow us to verify whether or not the press texts analysed reflect in any way the perceptions of public and private articulated by these two currents of feminist theory.

Contextualizing the public and the private

Various feminist theorists (Fraser, 1990; Felski, 1989; Benhabib, 1992) take issue with the universality posited by the Habermasian conception of the public sphere, defined as a 'realm of social life' open to all in which individuals come together to discuss political issues relevant to the 'common good' (1989). They focus on the social exclusions which, allegedly, influence the deliberative processes within the official public sphere. The object of analysis thus becomes the activity of participants in counter-public spheres rather than that of participants in an official public sphere. Because the feminist counter-public sphere is founded on the specificity of a female identity, it distances itself from Habermas's project in that the will towards emancipation is orientated towards the assertion of particularity in relation to issues of 'gender, race, ethnicity, age and sexual preference' (Felski, 1989). Moreover, it critiques a strict dichotomy between public and private realms, drawing attention to the fact that the public and private are intertwined (MacDonald, 1995).

However, the feminist counter-public sphere can also be read as being premised on the idea of universality as a result of presupposing the universal character of gender oppression. In privileging the latter, the feminist counter-public sphere is often accused of marginalizing struggles based on other exclusions, namely those of race and class.

Bell hooks, for example, states that from its onset, working-class women associated the feminist movement with a comfortable, 'upper middle-class' liberal feminist hegemony, centred on romantic issues of freedom and equality (1989: 23–24).

McLaughlin (1993: 614), however, claims that feminist media studies should recuperate the concept of the traditional public sphere, going beyond 'the tendency to focus on internal, oppositional identity at the expense of a consideration of the media's role in hindering the establishment of representative space necessary for democracy in late capitalism'. Seyla Benhabib (1992: 52) has also defended the Habermasian ideal of communicative rationality, holding up dialogical consensus as a form of overcoming disagreements between factions through the 'capacity for reversing perspectives'.

The capacity of the media to effectively provide a truly representative space for the exercise of participatory citizenship is linked to the degree to which it promotes dialogue and debate concerning issues deemed as publically relevant. The theory of agenda-setting, which can be traced back to McCombs and Shaw (1972), draws attention to the fact that the news media exert influence on issue salience: in other words, the more any particular issue is covered by the media, the greater importance attributed to it by media consumers. This interconnection between media and public agendas continues to resonate today, particularly among those who believe that the media constitute a sphere of public debate through which citizens gain political visibility and recognition.

Content analyses which focus on the representation of women in the media have traditionally operated within the liberal feminist perspective, concentrating on the 'symbolic annihilation' of women (Tuchman, 1995 [1978]: 406–407). A logic of sameness between male and female rationality provided the basis for women's claim to equality: 'since women are as rational as men, society carries a duty to give its female citizens equal opportunity to take part in social organisation' (Gambaudo, 2007: 94). However, women's greater visibility in the public arena leads to a distancing from the liberal focus on 'sameness' and equality. Instead of placing emphasis on women's capacity to assimilate characteristics associated with masculinity, such as rationality, proactivity and responsibility (Gambaudo, 2007; 94–95)— traits that allegedly caused women to judge themselves from a male perspective—radical feminism foregrounded women's right to difference. Radical feminism thus drew attention to the fact that liberal feminism imposed a masculine model on women's recognition in the public sphere, outside of which they remained invisible.

Methodology

Despite often being criticized for overly foregrounding the denotative aspects of texts, feminist content analyses are valuable since they draw attention to gendered constructions through the study of media or literary texts. Central to any content

analysis is the elaboration of a typology of categories which conceptually define the object of study: one or more categories are attributed to each text unit so that the researcher may quantify the frequency of those classifications (Wodak, 2000: 58, 229, 231).

By creating polar oppositions within each category of a typology which defines liberal and radical feminisms, we attempted to cover the largest number of alternatives possible for each category. Methodologically, this procedure drew inspiration from the Saussurean presupposition (Wodak, 2000: 115) that concepts may only be defined negatively against each other: a concept may be more accurately defined by drawing attention to what it is not, rather than by specifying what it actually *is*. This typology, which contemplates categories that define liberal[1] and radical[2] feminisms, served as the basis for the coding of text units drawn from two newspapers, the *Diário de Notícias* and *Público* respectively, so as to assess the representativity of those very categories.[3] The *Diário de Notícias* and *Público* were selected as quality papers due to habitually being used as benchmarks when assessing the eminence of other Portuguese newspapers. For the sake of optimization of resources, analysis was restricted to the first week of February, the second week of March and the third week of April 2006.

Subsequent to the conclusion of this content analysis, I proceeded to complement it with a critical discourse analysis (CDA) of the coded text units. My objective was to focus on the contradictions between explicit and implicit messages, adopting CDA to point to the ambivalence of meanings that contribute to discursively perpetuating an ideologically conditioned view of the world. If at a manifest level there may be adherence to feminist ideals in the press, this apparent celebration is often contradicted by other elements at a more latent level.

Fairclough claims that 'meaning-making depends upon not only what is explicit in a text but also what is implicit—what is assumed' (2003: 11). This assertion brings to mind Althusser's concept of symptomatic reading (1970), which can be defined as a 'double reading': first, one reads the manifest text; afterwards, one focuses on the distortions, silences, absences and interruptions of the manifest text so as to produce the latent text. From Fairclough's socio-cultural perspective, latent meanings reflect unconscious, commonsense assumptions that are intertextual to the extent that they build a bridge between social context and text (2003: 17).

For Van Dijk, the 'aim of CDA is to critically analyse the details of discursive domination…by specific elite authors, and in specific contexts' (2008: 821). In effect, news reporting which purposefully ignores the negative actions of influential social agents is ethically reprehensible, because it serves the purpose of 'implementing locally the overall ideological discourse strategy of positive self-presentation of in-groups' defined against a negative presentation of the out-group (Van Dijk, 2006).

Content analysis results

A comparison of the *overall* frequencies of the categories inherent in the typology defining liberal and radical feminisms for the *Diário de Notícias* and *Público* newspapers during the three months studied yielded the results visible in Table 1.

The categories which achieve a particularly high rating in any *one* of the three months analysed, in comparison with the frequencies obtained for the same category during the other two months of the time-frame of our project, are: homosexuality, transsexuality and maternity. Charts 1, 2 and 3 demonstrate the frequency rates for these categories. In February, homosexuality in both newspapers scored a higher frequency rate than normal due to the possibility of lesbian marriage being on the agenda. Despite ranking low in absolute terms, transsexuality was given more coverage by both papers in March. This came about because of the abuse and death of a Brazilian transvestite, Gisberta, at the hands of a group of adolescent boys. Maternity was pervasive in the news during April due to the Portuguese Socialist Government's decision to close a number of maternity wards throughout the country, with the aim of concentrating services in larger hospitals so as to maximize efficiency.

Critical discourse analysis of topical issues

Homosexuality in Diário de Notícias

When two lesbians attempted to marry on 1 February 2006 at Lisbon's Seventh Registry Office, they received a great deal of media attention, most notably from the *Diário de Notícias*. The issue I would like to explore here, on the basis of Van Dijk's critical discourse analysis (2005), is that of the type of 'in-group' that the *Diário de Notícias* wished to appeal to in its coverage of this event. If, on the one hand, the news features of this paper appear to empathize with the lesbians' cause, on the other hand, a subtle mechanism of censorship manifests itself.

Teresa Pires and Helena Paixão are first depicted as the active agents of an attempt to legitimate their 'love' before the whole of society. Emphasis is placed on their fairy-tale like 'dream' of marriage, an aspiration to 'recognition and dignification' that would place these two lesbians on a par with the majority of the population. Such predicates underscore their difference from the 'in-group' for whom marriage is an unfashionable institution.

The women are represented as having a mind of their own and as openly defying society's conventional social codes. However, they are simultaneously regarded as enjoying 'this moment of self-exhibition, fame and glory in a life that has until now been marked by rejection and persecution' (Câncio, 2006a). We are told that a gardener turned his hose on the two women because they dared to walk down a street hand-in-

Table 1: Global averages for the most frequent categories

Categories	*Público*	*Diário de Notícias*
Liberal feminism	41.3%	51.6%
Radical feminism	12.5%	14.8%
Liberal feminism equality	36.6%	45.6%
Liberal feminism autonomy	22.0%	27.6%
Liberal feminism – influence	15.2%	17.0%
Radical feminism – female body	9.7%	12.8%
Liberal feminism – cause promotion (social influence)	10.0%	9.1%
Liberal feminism – high hierarchy	9.2%	8.4%
Liberal/radical feminism – relationships	6.0%	9.7%
Liberal/radical feminisms – maternity	5.2%	9.8%
Liberal feminism – political visibility	7.1%	8.2%
Liberal feminism – judicial complaints	4.6%	5.3%
Liberal feminism – celebrity (social influence)	4.1%	5.8%

*Shaded areas represent the highest percentages within each category.

Chart 1: Homosexuality

Chart 2: Transexuality

Chart 3: Maternity

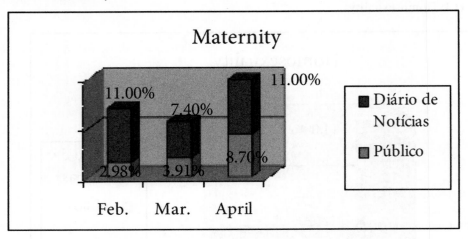

hand. This example connotes lesbianism as offensive to the masculine psyche, which cannot accept the idea of the 'uselessness' and 'powerlessness' of a hose, a hose that then must be turned on the two women in a vengeful act of masculine affirmation.

Both have collected, throughout their lives, 'insults, humiliations, betrayals and abandonments', leading them to leave Lisbon and seek refuge in a more tranquil town. The predicates used to depict their lives until this moment of media frenzy point to victimhood: whereas they were once visible 'victims', a target to be pointed at by the 'in-group', they are now visible 'agents', attaining the dignity they crave through a short-lived media infatuation with two women desperate for fame.

Homosexuality in Público

While the 1 February edition of the *Diário de Notícias* dedicated its first two pages to news features on Teresa and Helena's attempt to marry, *Público*'s first two pages for that same day were dedicated to the foreseeable success of Ang Lee's *Brokeback Mountain* at the forthcoming Oscars' ceremony. The film, which narrates the romantic entanglement of two gay cowboys in the United States of the 1960s and 1970s, is hailed as breaking the

film industry's conventional codes, and broaching a 'difficult and controversial' theme (Siza, 2006a). Because the topic of lesbian marriage can be assessed along similar lines, it is better introduced, according to *Público*'s logic, by an international film agenda that is the target of a certain elite cultural dialogue. *Público*'s discourse on culture posits a 'self' moulded in the best tradition of Western liberal values, namely freedom and tolerance.

Teresa and Lena are scantily referred to in the main news feature dating from 1 February (Branco, 2006b). In fact, they only briefly appear as subjects in the first paragraph of the article, when we are told that they will try to marry in Lisbon's Seventh Registry Office. Their agency is soon colonized by that of a petition in favour of gay marriage that 'counts MPs amongst its subscribers'. From then on, the discourse is completely centred on the positions that political parties have on the issue, namely whether or not they intend to defend an alteration of the Civil Code in Parliament.

Transsexuality in Diário de Notícias

Transsexuality, a theme that is usually absent from the *Diário de Notícias*'s pages, became conspicuous for a brief moment when a Brazilian transvestite, Gisberta, was tortured and killed by a group of boys aged between eleven and sixteen who were living in a Catholic correctional home. The focus on the incident was very much juridical, centering on the condemnation of the youngsters.

The first article on Gisberta's death alludes extensively to 'habeas corpus', without once defining what this legal term means to the ordinary citizen. The descriptions of the punitory measures inflicted on the minors are intricate, ranging from internment in correctional centres to preventive imprisonment in the case of the sixteen year old. Gisberta, who is notoriously absent from the text after making a brief appearance in the lead, resurfaces in the last phrase as a passive subject who will be remembered at a vigil held that very evening. Emphasis on the condemnatory measures to which the minors will be subjected foregrounds the difference between the 'civilized' conduct of the readers' 'in-group' and the brutal intolerance of difference on the part of the young ruffians. A moral consensus is articulated around the fact that deviant behaviour must be properly punished.

Transsexuality in Público

Despite also concentrating on the punitive measures inflicted upon the minors, *Público* appears to be particularly interested in whether or not Gisberta died by drowning. The title 'Exams confirm that gisberta died by drowning' (Laranjo, 2006d) verifies that Gisberta was indeed a victim of homicide, having been thrown into a well while still alive, and was not 'simply' a victim of a corporeal offence. The insinuation, camouflaged by juridical terminology, is that the difference between the two alternatives is significant, as if a 'corporeal offence' were indeed something transvestites might be moderately used to.

The issue of whether or not the youngsters involved in the crime were conscious of Gisberta being alive before throwing her into the well is allegedly fundamental to

the State Prosecution Service. *Público* places itself in the latter's role, only to shroud its concern over the 'morality' of the youngsters beneath a denotative interest in the juridical mechanisms of the process. 'Morality' is something that *Público* wishes to refrain from exercising on any explicit level, for it goes against the leftist 'urban chique' of the 'in-group' it wishes to appeal to.

Maternity in Diário de Notícias

Unlike *Público*, which gives extensive coverage on 16 April to the closure of a series of maternity wards by the Portuguese government, the *Diário de Notícias* remains curiously silent on the issue. However, despite not pronouncing a word on the topic during that entire week—ranging from 15–21 April—which may be indicative of an internal agenda that remains indifferent to external politics, the focus on maternity appears to have been 'transferred' to other health issues linked thereto, namely those of infertility and congenital foetal abnormalities.

The *Diário de Notícias* ran two news features on these topics under the titles 'Social Pressure Affects Infertile Couples in the Cradle of the Nation' (Silva, 2006b), alluding to the city of Guimarães as the residence of the first king of Portugal, and 'Foetal Anomalies in Amarante County' (Silva, 2006c). The first feature, which bases itself on the results of a study carried out by two researchers, points to social pressure on infertile couples as being particularly intense in Guimarães, due to both traditional family structures and a setting that is not quite urban.

The second feature focuses on the proportionately higher rate of congenital foetal anomalies in Amarante county when compared to the rest of the country. While half of the six cases of serious malformations were detected in a private medical clinic there, the other half were diagnosed by the Amarante public hospital. Despite refraining from alluding to the government's decision to close various public maternity wards throughout Portugal, the newspaper is stating the importance of maintaining the public health system operational. Proof of the latter's significance resides in a public health unit having detected half of the cases of congenital foetal anomalies in that particular region of Portugal.

Maternity in Público

The category 'maternity' received particular attention from *Público* on 16 February 2006 due to the Health Ministry's decision to close down nine of the 50 maternity wards in the country. One news feature opens by focusing on a human interest story, that of hairdresser Margarida, who can no longer give birth to her second child at the Barcelos Hospital due to ward closure. This human interest story rapidly turns into a public interest feature because Margarida becomes a symbol for the general population who disagrees with the government's measure. However, the news story soon adopts a medical perspective on the ward referred to, whereby the reader is informed about the few stays for delivery, the decrease in the number of births, the limited number of

doctors, the existence of overworked health professionals and the precarious conditions for babies with serious pathologies who have to be transported to Oporto for treatment. By supporting the government's discourse on ward closure, after giving us some elements with which to assess the disadvantage of that measure, *Público* seems to be adhering to a semantic strategy of 'apparent empathy' (Van Dijk, 2005: 202), only to then stress that women will, ultimately, benefit from safer conditions in larger hospitals.

Comparing trends in the *Diário de Notícias* and *Público* newspapers

In general, it can be said that *Diário de Notícias* is more attentive to issues of the private sphere than *Público*. However, the former's perspective on themes which usually remain ostracized from newspapers, such as homosexuality and transsexuality, reveals that such topics are either broached from a normative standpoint or almost totally ignored. While coverage of the possibility of marriage between two lesbians emphasizes their monogamous and stable commitment, a type of relationship that many women in heterosexual partnerships aspire to reach, coverage of Gisberta's death was scant and very much geared towards the legal details of the process. The issue of maternity, on the other hand, was less politically orientated in *Diário de Notícias* than in *Público*, since instead of centering on the government's decision to close down a number of maternity wards, the paper chose to dislocate the topic to other issues tangentially linked to that of maternity, namely those of 'infertility' and 'congenital anomalies'. This may be interpreted as an attempt to sidestep the political agenda regarding the closure of maternity wards; as if to say, 'we will not focus on the subject when the government deems it correct to do so, but rather when we feel the time is right…'. Nonetheless, implicit in the coverage of the topics of infertility and congenital foetal abnormalities, is the idea that experience has shown the importance of the public service sector in the detection of health problems that are not usually openly discussed, particularly in non-urban settings.

Público focuses far less than *Diário de Notícias* on matters of the private sphere. However, it has a preoccupation with keeping a 'modern' semblance, seeking to situate issues that may be on the agenda within a wider 'European' context, the values of which are those of the Enlightenment. The issue of gay marriage, for example, was framed by the success of the film *Brokeback Mountain* at the 2006 Oscars ceremony. As such, the topic definitely had its importance as a 'spectacle', but no more than that. In fact, *Público* implies that it did not warrant serious parliamentary debate, in line with the opinions on the subject of the two major Portuguese political parties.

This newspaper's coverage of the death of the Brazilian transsexual emphasizes that responsibility for this outcome lies, above all, with the State and Catholic Church for failing to provide a proper education to the young in care institutions. A democratic argument is cast in accordance with Enlightenment ideals, and foregrounds the fact

that anyone could have acted in the same manner as the youths had he or she had the misfortune of being a 'victim' of a care institution. We are, therefore, all born equal. 'The State' is that which introduces inequalities among us.

The State, however, is not the government. *Público* is, in fact, sympathetic towards the government's decision to close nine of 50 maternity wards throughout the country so as to maximize safety and efficiency. Sticking to this line of discourse, *Público* empathizes with the plight of local populations but, nevertheless, paints a picture of the happiness in store for them in the near future if the government plan is adhered to.

The whole issue of maternity is framed within a discourse of liberal feminist values. Indeed, the 16 April 2006 issue of *Público* not only focused on ward closure, but also carried various features which linked the public sphere with maternity. First-lady Laura Bush, French socialist MP Ségolène Royal, and French feminist author Simone de Beauvoir are all referred to in the context of, at times, contradictory subject positionings between motherhood and the fulfilment of 'professional duties'. It is as if *Público*'s focus on a private sphere issue such as maternity was, in part, redeemed by the focus on women who have high visibility in the public sphere and yet are mothers. Curiously, it is precisely when *Público* feels threatened by the private sphere that it manages to reflect a non-compartmentalized view of private and public spheres. Usually, however, it much prefers to let the private be private and the public public, in line with a logic of non-promiscuity between the two domains.

Despite giving more attention on a daily basis to the fusion of public and private spheres, *Diário de Notícias* does not differ substantially from *Público* in the overall frequency of the most common categories. Indeed, both papers defend liberal feminist values, with a stronger focus on equality than on autonomy. The frequency rates for the categories 'influence', 'cause promotion', 'political visibility' and 'celebrity' do not differ greatly between the two newspapers, indicating the existence of a certain consensus regarding the representation of women in the public sphere.

The greatest discrepancies in frequency rates between both newspapers pertain to issues of the private sphere. In effect, the categories of conjugal relationships, maternity and the female body appear considerably more often in *Diário de Notícias* than in *Público*. These results indicate that *Público* is not particularly comfortable in dealing with matters of the private realm on a daily basis. However, the fact that *Diário de Notícias* reveals a greater permeability to the private sphere does not mean that it is significantly more in tune with radical feminist issues. In fact, it appears that the latter are broached by both papers due to the topicality of themes that are usually ostracized from the media agenda. It is precisely in this context that the issues of homosexuality, transsexuality and reproduction—under the guise of infertility and congenital anomalies—make their appearance.

Radical feminism emphasizes the affirmation of a specifically feminine universal essence that opposes the normative logic of patriarchal values. As such, the possibility of defining a specific form of female sexuality under the generic label of 'homosexuality',

as well as specific characteristics of the female body—which exceed the idea of gender as performativity (Butler, 1990 33)—under the generic label 'reproduction', are themes that are on the radical feminist agenda. Because radical feminism, in its search for the affirmation of an essence, at times questions a certain heterosexual normativity (Thompson, 2001: 14), mainstream newspapers such as *Diário de Notícias* and *Público* prefer to stick to the more conventional liberal feminist discursive framework that centres on 'rights' as an affirmation of female autonomy and equality.

Conclusion

At a time when the 'stigmata of affectivity' (Thornton, quoted in Murphy, 1999: 413) is said to have been transposed to the public sphere, leading to a blurring of the frontier that separates public from private, the research project undertaken witnesses that the traditional divide remains in place. Indeed, despite the 'nomadism' of contemporary theory, much of which celebrates concepts such as 'hybridity, fluidity and transgression' (Murphy, 1999: 412), the Habermasian public sphere, allegedly open to all, continues to ostracize certain voices (Gould, quoted in Pajnic, 2006: 392). However, while Myra Macdonald argues that '…private space is at once valued as a peaceful sanctuary, and yet devalued as that non-public space which we worry about only when its aberrations filter through into the public arena' (1995: 48), I would suggest that both *Público* and *Diário de Notícias* devalue to a greater extent issues related to radical feminism than they do those of the traditional private sphere.

Radical feminist themes, namely those related to sexuality, reproduction and the gendered body, are nevertheless closely imbricated with those of the private sphere. The radicality of this feminist current intends precisely to draw attention to the way women's understanding of themselves has been constructed within a patriarchal frame of reference (Thompson, 2001: 12). From this perspective, women are the only ones capable of defining the specificity that characterizes their 'lived experience' of womanhood. Bringing out certain issues linked to oppression in the private sphere, namely those of sexual orientation, gender identity and reproduction, would presumably draw attention to the patriarchal logic of the public sphere. Both *Público* and *Diário de Notícias*'s coverage of such issues sheds light on them as isolated 'rarities', the topicality of which may, at times, drive them to the front pages of 'respectable' newspapers.

In effect, both *Público* and *Diário de Notícias*'s editorial statutes contemplate the rejection of interference in citizens' private sphere. The general public interest is not regarded as overlapping with private matters, as if citizens' public personae constitute manifestations of ideal standards suitable to particular situations (Goffman, 1962: 35, 44)—namely that of newspaper reading—which do not come under the aegis of the private sphere. By fulfilling the expectations of the readers as idealized public personae, both *Público* and *Diário de Notícias* convey a masculinized idea of 'imagined community'

(Anderson, 1983) that trivializes the private.

We can point to the frequency rates of women's representation in the public sphere—24.3 per cent in *Público* and 27.3 per cent in *Diário de Notícias*—as being indicative of either their low visibility in the public sphere, or their growing visibility in the public sphere, depending on the perspective. More interesting than affirming whether or not women are actually visible in the public sphere is, to my mind, the fact that matters of the public sphere continue to be more prevalent than those of the private. As such, the bourgeois ideal of a private sphere as a space reserved for the activities of reproduction may be seen as remaining staunchly in place (Rose, 1993: 126–127).

> Women, the guardians of 'personal life', become a kind of dumping ground for all the values society want off its back but must be perceived to cherish: a function rather like a zoo, or nature reserve, whereby a culture can proudly proclaim its inclusion of precisely what it has excluded. (Williamson, 1986: 106)

I would take issue with this affirmation, claiming instead that a process of 'inverse colonialism' may be currently in place, with a significant proportion of space being allocated to women in the public sphere. The problem, however, is that the same proportion of space is not allocated to 'private' issues, as if woman must travesty herself to a patriarchal conception of power and visibility so as to be heard.

In other words, woman's movement from 'object to subject', through the expression of a 'liberated voice' (hooks, 1989: 9), takes place along masculine lines. While traditional liberal feminist conceptions would centre on the analysis of women's visibility or lack of visibility in the public sphere, drawing conclusions on the success of the battle for rights from the degree of that very visibility, I would argue that the move 'from silence into speech' is not affected by 'iron ladies', 'women warriors' or successful career women who manage to catch the media's eye. Rather, this move is the result of a turning of media attention to the private sphere in a non-sensationalist manner.

The problem, however, is that the very structure of the newspapers analysed reinforces a masculine conception of what is deemed to be important for readers, with clearly delineated 'political', 'economic', 'society' and 'sports' sections, as if the world we live in corresponds to tidy, compartmentalized camps. Indeed, the internalization by newspapers of the feminist dictum 'the personal is political' would be equivalent to a Freudian 'return of the repressed' (1993: 141), whereby texts would perhaps cease to be symptomatic of a need to express the forbidden idea that both men *and* women share a private sphere, the relevance of which has been systematically downplayed due to its habitual connotation with the feminine.

Endnotes

1. Basing ourselves on the theoretical discussions of liberal feminism, we divided this mega-category into two large categories, namely autonomy and equality. Within autonomy, we placed the following sub-categories: employment/unemployment; financial availability/financial unavailability; compulsory schooling/non-compulsory schooling; mobility/immobility; sexual activity/abstinence; abortion/non-abortion; conjugal relationship/non-conjugal relationship. Within equality, we placed the following sub-categories: remunerative equality/remunerative inequality; judicial power: plaintiff/defendant; power in the public sphere: influence, authority, participation; power in the private sphere: caretaking, home management, maternity.

2. In our typology, radical feminism is expressed by the category of feminine essence, within which we placed the following sub-categories: homosexuality/heterosexuality; assisted reproduction/unassisted reproduction; feminine body/masculine body; feminine mind/masculine mind (rationality, irrationality).

3. The NVivo 6 qualitative research software program was used to obtain frequency rates of categories that define liberal and radical feminisms in the newspaper texts analysed.

References

Althusser, L. & Balibar, E. *Reading Capital*, trans. Ben Brewster, London, New Left Books, 1970.

Anderson, B., *Imagined Communities: Reflections on the Origin and Spread of Nationalism*, London, Verso, 1983.

Benhabib, S., 'In the Shadow of Artistotle and Hegel', in *Situating the Self: Gender, Community and Postmodernism in Contemporary Ethics*, Cambridge, Polity Press, 1992, pp. 23–67.

Butler, J., *Gender Trouble: Feminism and the Subversion of Identity*, London, Routledge, 1990.

Diário de Notícias, 'Estatuto Editorial do *Diário de Notícias*', 22 June 2007.

Diário de Notícias, 'As noivas que querem mudar o Código Civil', 1 February 2006a, pp. 2–3.

Diário de Notícias, 'Pressão social afecta casais inférteis na cidade berço da Nação', 15 April 2006b, p. 20.

Diário de Notícias, 'Anomalias em fetos numa freguesia em Amarante', 17 April 2006c, pp. 18–19.

Fairclough, N., *Analysing Discourse: Textual Analysis for Social Research*, London, Routledge, 2003.

Felski, R., *Beyond Feminist Aesthetics: Feminist Literature and Social Change*, Cambridge, MA, Harvard University Press, 1989.

Fraser, N., 'Rethinking the Public Sphere: A Contribution to the Critique of Actually Existing Democracy', *Social Text*, 25/26 (1990), pp. 56–80.

Freud, S., 'The Disposition to Obsessional Neurosis: A Contribution to the Problem of Choice of Neurosis', trans. J. Strachey, in J. Strachey (ed.) *On Psychopathology*, London, Penguin, 1993, pp. 134–144.

Friedan, B., *The Feminine Mystique*, New York, Dell, 1963.

Gambaudo, S., 'French Feminism vs Anglo-American Feminism: A Reconstruction', *European Journal of Women's Studies*, 14:2 (2007), pp. 93–108.

Goffman, E., *The Presentation of Self in Everyday Life*, New York, Doubleday Anchor Books, 1962.

Habermas, J., *The Structural Transformation of the Public Sphere: An Inquiry into a Category of Bourgeois Society*, trans. Thomas Burger, Cambridge, MA, MIT Press, 1989.

hooks, b., *Talking Back: Thinking Feminist, Thinking Black*, Boston, MA, South End Press, 1989.

Macdonald, M., *Representing Women: Myths of Femininity in the Popular Media*, London, Edward Arnold, 1995.

Mackenzie, S., 'Women in the City', in R. Peet et al. (eds) *New Models in Geography. Volume II: The Political Economy Perspective*, London, Unwin Hyman, 1989, pp. 109–126.

McCombs, M.E. & Shaw, D.L., 'The Agenda-Setting Function of Mass Media', in O. Boyd-Barrett & C. Newbold (eds) *Approaches to Media: A Reader*, London, Arnold, 1972, pp. 153–163.

McLaughlin, L., 'Feminism, the Public Sphere, Media and Democracy', *Media Culture & Society*, 15:4 (1993), pp. 599–620.

Meyers, M., 'News of Battering', *Journal of Communication*, 44:2 (1994), pp. 47–63.

Murphy, Th., 'Book Reviews', *Social & Legal Studies*, 8:3 (1999), pp. 411–413.

Pajnik, M., 'Feminist Reflections on Habermas's Communicative Action: The Need for an Inclusive Political Theory', *European Journal of Social Theory*, 9:3 (2006), pp. 385–404.

Público, 'Estatuto Editorial do *Público*', 2007, available at http://static.publico.clix.pt/homepage/site/nos/Estatutoedpublico.asp, accessed 28 December 2007.

Público, 'O Segredo de *Brokeback Mountain* lidera corrida aos Óscares', 1 February 2006a, pp. 2–3.

Público, 'PS e PSD desvalorizam debate político sobre casamento entre pessoas do mesmo sexo', 1 February 2006b, p. 12.

Público, 'Conservador decide hoje se autoriza casamento de Teresa e Lena', 2 February 2006c, p. 14.

Público, 'Exames confirmam morte de Gisberta por afogamento', 10 March 2006d, p. 24.

Rose, G. 'Spatial Divisions and Other Spaces', in *Feminism and Geography: The Limits of Geographical Knowledge*, Cambridge, Polity Press, 1993, pp. 113–136.

Saussure, F. de, *Course in General Linguistics*, trans. Roy Harris, Illinois, Open Court, 1916.

Strinati, D., 'Feminisms', in *An Introduction to Theories of Popular Culture*, London, Routledge, 1995, pp. 177–219.

Thompson, D., *Radical Feminism Today*, London, Sage, 2001.

Thornton, M. (ed.), *Public and Private: Feminist Legal* Debates, Melbourne, Oxford University Press, 1995.

Tuchman, G., 'The Symbolic Annihilation of Women by the Mass Media', in O. Boyd-Barrett et al. (eds) *Approaches to Media*, London, Arnold, 1995, pp. 406–410.

Van Dijk, T., 'Critical Discourse Analysis and Nominalization: Problem or Pseudo-Problem?', *Discourse & Society*, 19:6 (2008), pp. 821–828.

Van Dijk, T., *Discurso, Notícia e Ideologia: Estudos na Análise Crítica do Discurso*, trans. Z. Pinto-Coelho, Oporto, Campo das Letras, 2005.

Van Dijk, T., 'Ideology and Discourse Analysis', *Journal of Political Ideologies*, 11:2 (2006), pp. 115–140.

Williamson, J., 'Woman is an Island: Femininity and Colonisation', in T. Modleski (ed.) *Studies in Entertainment: Critical Approaches to Mass Culture*, Bloomington, Indiana University Press, 1986, pp. 99–118.

Wodak, R. et al., 'Comparison of Methods of Text Analysis', in *Methods of Text and Discourse Analysis*, London, Sage, 2000, pp. 226–236.

Wodak, R. et al., 'Content Analysis', in *Methods of Text and Discourse Analysis*, London, Sage, 2000, pp. 55–73.

CHAPTER THREE:
WOMEN'S TIME HAS COME: AN ARCHAEOLOGY OF FRENCH FEMALE PRESIDENTIAL CANDIDATES – FROM ARLETTE LAGUILLER (1974) TO SÉGOLÈNE ROYAL (2007)

Marlène Coulomb-Gully

*'Well, yes, I'm a woman and I'm venturing
to stand for president of this Republic of men...'*
– Arlette Laguiller,
presidential candidate, 20 April 1974

'Women's time has come'
– Ségolène Royal,
presidential candidate, 16 April 2007

'Women's time has come.' This is how Ségolène Royal, on several occasions during the presidential campaign of 2007, was presented and even justified her candidature, putting the gender argument at the heart of her personal rhetoric.

As a candidate of the socialist party, one of the two main parties in France, Royal belongs to a line of female politicians, a line of potential female presidents even, of which she can be regarded as the front runner. It is this lineage of female candidates that we propose to study. In doing so, our viewpoint will be a genealogical one, the intention being to attempt a sort of *archaeology* (to use an expression dear to Michel Foucault) of the prospective female president.

Saying: 'I'm [a woman] standing for president' constitutes a strong performative act, both individually and collectively, which is an effective opposition to a tradition of male hegemony and strong social norms regarding gender; a tradition which remains one of

the last bastions in the world of politics. While there have always been women in power, from Cleopatra to Catherine II of Russia or Elizabeth I of England and many others, female heads of state who are democratically elected remain the exception. Indeed, in France there have been none.

Nine women have been presidential candidates in France since 1965, when the country's president was first elected through universal suffrage. The gesture made by these pioneers is, above all, symbolic. Indeed, none of them, except for Ségolène Royal in 2007, could have hoped to make it through to the second round.

The objective of this analysis is threefold. First of all, we will stress the methodological perspective, and will then analyse a specific case, namely that of Arlette Laguiller in 1974. She was first woman to stand for the role of president of the Republic and is a kind of template upon which we can consider all of the other female presidential candidates who have followed in her footsteps. Finally, we will end with a comparison of Ségolène Royal's campaign in 2007 to those that have gone before, and will attempt to see how much things have changed for women in politics since 1974.

However, although it would be extremely interesting to understand and research what may be common currency and what may be attributable to national specificities (in terms of the rise in the power of female politicians, the identities deployed by them and the reactions they cause), this is 'another story', albeit one which we hope will be written soon.

Problems—method—corpus

Our approach is neither sociological nor based on political science, which in France are the areas which seem to attract the most research on the issue of women in politics. Instead, our outlook is communicational. It questions *the construction of the image of self* and the notion of *ethos* serving as a point of anchorage. The Aristotelian concept was rediscovered in the 1980s through discourse analysis and is defined as 'the image of self that the orator produces in his speech—and not that of his real person' (Charaudeau and Maingueneau, 2002: 238). This is interesting because it bypasses the question of the *real* individual, instead considering the speech produced as an object of interrogation in itself.

The ethos is rooted in 'stereotypes, an arsenal of collective representations which determine, in part, the representation of self and its effectiveness in a given culture' (Charaudeau and Maingueneau, 2002: 239). Contextualization by rooting in *a given culture* is a determining factor, as is the reference to the notion of *collective representations*. Indeed, the *stereotype* conditions the supposed effectiveness of the argumentative strategy. This second point is all the more important because here we are analysing women's candidatures where the mobilization of stereotypes in collective representations has always been particularly strong (and, without a doubt, conditioned) in the strategies deployed by female politicians.

As Maingueneau points out: 'all speech comes from an enunciator incarnate', and this incarnation covers 'not only the specifically vocal dimension but also all the physical and psychological determinations attached by collective representations to the enunciator's person' (Maingueneau, 1998: 79–80). The *saying* and the said, the verbal and the non-verbal, the articulation of an active imagination in the midst of a given collectivity, these are all the elements which should be analysed so as to define the models that these female politicians put forward for collective deliberation.

We will, of course, question the place of the gender dimension constitution of this ethos. How can the gender argument be mobilized? Is it explicit or implicit? Is it articulated by the candidates themselves or by their entourages (journalists, rivals, etc.)? Is it used positively or negatively (Bonnafous & Vassy, 2001; Bonnafous, 2003; Vassy, 2005)? Is it mobilized differently according to the period (a diachronic component)? And, above all, is it mobilized differently by the right-wing (in this case, a minority: three of nine) and the left-wing candidates?[1] In other words, how may gender and class ethos be articulated in the construction of these model female politicians?

The corpus of the analysis is twofold, and includes consideration of both television programmes and newspapers. So far as the former are concerned, we will study the eight o'clock news bulletins, which have the largest viewing figures, as well as a selection of political and entertainment programmes broadcast during the election campaigns in which the candidates appear.

The written press to be examined is as follows: *Le Figaro*, a daily paper on the right, characterized by a conservative position in relation to women; *Le Monde*, a paper on the centre-left, the 'yardstick'; and *Libération,* founded in the aftermath of May 1968 and sensitive to women's fight for emancipation.

Arlette Laguiller, the perpetual and symbolic candidate

In this archaeology of the female politician, the study of Arlette Laguiller is vital. First, in 1974, she was the first French woman to campaign for president and, secondly, she has participated in every presidential election since then, the campaign of 2007 being the most recent. To French citizens and, according to public opinion, she is the so-called candidate, with the woman and the role eventually merging into one. In this paper, however, we will limit ourselves to a presentation of her first campaign in 1974.

Some reminders of the context of this election are worthwhile. It should have taken place in 1975, but was brought forward a year following the untimely death of the serving president at that time, Georges Pompidou. As a consequence, the campaign was very short, lasting barely a few weeks, and was centred on the month of April. This presidential election, like that of 1969, followed the huge anti-establishment movement of May 1968,

which sent shockwaves through the upper echelons of French society. Arlette Laguiller was representative of this movement because she was both a woman and a candidate from the Lutte Ouvrière ('Worker's Struggle'), a small party on the extreme left.

The gender argument: A symbolic revendication of social opposition by Lutte Ouvrière

'Words, words, words...'

'Eh bien oui, je suis une femme, et j'ose me présenter comme candidate à la Présidence de cette République d'hommes...' ('Well, yes, I'm a woman and I'm venturing to stand for president of this Republic of men'). These were the first words uttered by Arlette Laguiller during her first speech in the official televised campaign on 20 April 1974. This introductory text is, therefore, highly illustrative.

The beginning has a certain strength, which is emphasized by the use of the three monosyllables in the formula 'Eh bien oui', and many are the linguists who have considered the functioning of the astonishing connective 'eh bien' (see especially Sirdar-Iskandar, 1981). First, though, we must stress that the candidate was simulating a scenario of imaginary dialogue, the objective being to inject some life into the monologic and, at best, rather dry official campaign by interacting directly with the citizen-television viewer.[2] Moreover, the statement which follows the interjection ('I'm a woman/I am going to stand for president...') appears as an unexpected sequel in the sense that it wasn't an eventuality which could be regarded as *normal* according to the beliefs attributed to either the addressee or a bystander. A woman standing for the highest office was, in the context of the 1970s, highly unusual. In making her statement, the candidate momentarily adopted the mental attitude of her interlocutor, but instead of drawing the conclusion that the latter was expecting ('Being a woman implies that I can't stand for president of the Republic'), she reaches the opposite one. Finally, we should note the strength of the adverbial phrase 'oui', which highlights the usage of the connective 'eh bien' ('Eh bien *oui*'), and the paradoxical use, in this context, of the conjunction 'and' ('I'm a woman *and* I'm venturing to run for president...'). Laguiller doesn't use the word 'but', which would effectively emphasize the contradiction in being a woman and standing for president, and instead chooses to categorically deny this contradiction by using the coordinating conjunction 'and'.

The formulation adopted by the candidate here resulted in a reassertion of her female status: 'I am a woman.' If Descartes, in the famous *Discourse on Method*, asserted himself as a thinker ('Cogito, ergo sum'[3]), and if Rimbaud, by stating that 'I is an other'[4], stressed the impossible self-control of his own identity, then Arlette Laguiller, by saying 'I am a woman', was asserting herself as a sexual being first and foremost, setting down gender as her prime component and allowing it to sum up her identity. The gender argument was thus explicitly revendicated.

But unlike decades which followed this first campaign, where the revendication of the political status of women went hand in hand with the strategic mobilization of a set of supposedly status-enhancing stereotypical qualities (such as a sense of responsibility, being hard working, being down to earth and accurate, able to spot nuance, lacking personal ambition, and having the ability to both see beyond the academic and take into account human qualities) (Vassy, 2005; Bonnafous, 2003), the gender argument *was not specified* by Arlette Laguiller. The simple openness of the statement somehow sufficed in itself and was free from any characterization. Indeed, the very starkness of the statement—its brutality?—is revealing of the radicality of the break with tradition occasioned by the candidate's gesture. Is it really possible to imagine a male candidate standing up in front of the electors and saying 'Well, yes, I am a man, and I'm venturing to stand for president…'?[5] The irreversibilty of the formula is revealing of the fundamental dissymmetry of the political space.

'…and I'm venturing to stand for president of this Republic of men', she continued. The formula highlights the symbolic show of strength that a female candidate represented in the deeply chauvinistic context of the 1970s. Let us remind ourselves that she was the only woman to stand in 1974 (which would again be the case in 1988) against eleven men.[6] The gender argument doesn't suffer from a lack of characterization because it is a challenge in itself. As a matter of fact, at the start of the official campaign, the président du conseil constitutionnel, Roger Frey, declared that: 'The definitive list of candidates standing for election as president of the Republic in alphabetical order has been established as follows: *Messrs.* Jacques Chaban-Delmas, René Dumont, Valéry Giscard d'Estaing, Guy Héraut, Alain Krivine, Arlette Laguiller, Jean-Marie Le Pen…'.

In analysing Laguiller's other speeches, it is notable that the revendication of gender went hand in hand with the denunciation of the situation experienced by other members of the population: workers, young people and immigrants. These terms (women/workers/ young people/immigrants) were almost always associated with each other and are potentially interchangeable. Together these groups formed a real paradigm, a cohort of people without rights and without voices, for whom Arlette Laguiller wanted to be the spokeswoman.[7]

Women thus fit into the notion of the dominated, their struggle being in common with all of those who, according to the ideology of the far left, suffered under middle-class, capitalist oppression.

An incarnation moves away from the stereotypes of bourgeois femininity

According to Maingueneau's definition of ethos, we have seen that all speech originates from an enunciator incarnate, with this incarnation covering 'not only the specifically vocal dimension but also all the physical and psychological determinations attached by collective representations to the enunciator's person' (Maingueneau, 1998: 79–80).

Arlette Laguiller was the very incarnation of the protest against the dominant social order, and the model of femininity that she represented was very much at odds with that proposed by middle-class society in the 1970s.

The media of that time, both print and audiovisual, presented two types of women during this very short campaign: the candidate, Arlette Laguiller, and the spouses of the main male candidates. Thus, Mesdames Giscard d'Estaing, Mitterrand, Chaban Delmas, Le Pen and Royer were all the subject of portraits. As a consequence, the specificity of the stance of the revolutionary candidate appears all the more clearly when seen in the light of these other women.

'For the general public, the first impression that Arlette Laguiller, 34 years old, makes is of being a slender young woman with black hair cut very short.' This is how the candidate was described in one of the first articles that the newspaper *Le Monde* devoted to her on 5 April 1974. Young, slight, her hair much shorter than many of her contemporaries at that time (Alain Krivine, her opponent from the Ligue Communiste Révolutionnaire and also running for president, had his hair much longer), almost always dressed in trousers, a T-shirt, a pullover or a blouse, wearing a duffle coat, and without make-up or jewellery, Laguiller offered an different incarnation, away from the models of femininity valued in middle-class society and of which the spouses mentioned above are prime examples. Other much valued attributes were long hair, if possible blond, which is a traditional object of male fantasy, a dress which uncovers the legs, another privileged area of male desire, make-up which adds its finishing touches to the body and jewellery designed to show it off.

This neutralization of the outward signs of femininity, as they are defined by the dominant code, gives the figure of Arlette Laguiller a kind of androgyny which is accentuated by the recurrence of her declarations concerning her refusal to marry and have children. Acknowledged in her biography (Laguiller, 1974), these statements were taken up by all of the media. For example, in *Le Figaro* on 23 April, Sylvain Zegel wrote:

> When she presents herself as a worker who has the time to be militant because she doesn't have a husband or dependent child, she doesn't just content herself with stating an opinion, she is thus expressing a choice and we have to understand that it's because she has neither husband nor child that she has the time to represent the workers.

Similar reflections were made in *Le Monde* and during a broadcast of a press conference given by Laguiller.[8] The near unanimity of these opinions bears witness to the unconventional character of the candidate in the eyes of the journalists; a woman *naturally*—in order to achieve the destiny allotted to her sex—has a husband and children (the portraits of the *wives of the male candidates* are exemplary in this respect). Arlette Laguiller, thus, departs from these gender roles.

Le Monde and *Le Figaro* both published portraits about Laguiller which were again very telling of the character of the candidate, who was perceived as unconventional. 'Comrade Arlette' (*La camarade Arlette*) was the title of the article in *Le Monde* on 5 April, while 'A female Saint-Just' headed the piece in *Le Figaro* on the 23rd of that same month. It is interesting to note that in French the term 'camarade' has the same form for both the masculine and feminine genders, while *Le Figaro* compared her to Saint-Just, a man, and the very epitome of the revolutionary hard-liner. The female political activist, Olympe de Gouges, or the well-known revolutionary, Rosa Luxemburg, could have been evoked in a similar vein, but it is a man who was chosen to serve as the model here.

The operation is all the more significant since another portrait, devoted to the male candidate from the Revolutionary Communist League, Alain Krivine, went by the title of 'the vestal Krivine' ('La vestale Krivine'). So, on the one hand, there is a feminization of the intellectual from the far left (Jewish, too, and the historical identification of Jews with women in stereotypical, disparaging forms is well known) and, on the other, the masculinization of the female revolutionary socialist. This two-way mix-up is revealing of the more or less conscious associations created by both the candidates' incarnations and the denial of femininity which characterized the first woman to stand for the role of president of France. The ethos of class further complicates matters, however, as we will see now.

Gender ethos and presidential ethos: The question of representivity

To conclude with this first campaign, let us focus on the second and final article that *Le Figaro* devoted to Laguiller. It is by Jean Fayard, dates from 22 April, and refers to the televised official campaign programme on the 20th of that month:

> I don't have anything against Miss Laguiller. She's actually rather pretty, reasonably well dressed in green and black and I think she fulfils her post as typist at the Crédit Lyonnais quite honourably. But when she seeks to become President of the French Republic, when, mumbling her way through a primary school text that she deciphers with great difficulty, she claims to represent women, I can't prevent myself from thinking that at least a million other women would be more capable, more gifted, more astute and better made to set out ideas.

The violence of the charge is extreme, and it's no coincidence that these lines were found in the columns of *Le Figaro*, a right-wing, conservative, daily newspaper. Arlette Laguiller, *a rank and file worker*, as she liked to define herself, a representative of a party on the far left and a woman to boot, was obviously the embodiment of the absolute counter-model in the opinion of the journalist. Even if these words were just those of the author, it can be

argued that there were many people who regarded Laguiller's candidature as scandalous. Her ethos, which inextricably combined gender and class, did not coincide with that of a potential president, at least in the imaginations of 1970s' citizens.

So, how can this ethos of a potential president be characterized? Simply, by a requirement for collective representation which refers to the imaginary citizen. In a presidential election in the system of representation which supposes to be a reflective connection between the governed and the governing, the president of the Republic is the *operator* who allows the passage from plural to singular and from diversity to unicity by the production of a collective identity (Gaxie, 1993; Rosanvallon, 1998). This identification is based on the objective relationship between opposing political powers, and any candidate not nominated by a majority party has no chance of winning the election. But such identification cannot be limited to this dimension alone, and the incarnations of the candidates in their personal dimensions also influence the work of the imagination. The candidate, Arlette Laguiller, departed in two ways from the standards of this incarnation as progressively defined by a succession of presidential elections: by her class ethos and by her gender ethos, the latter being the model of femininity put forward by the candidate which is at odds with the dominant models in the institutional sphere. Taking into account the status of women in 1970s' French society, this first female candidature could only be doubly marginal.

Ségolène Royal and *La France Présidente*

'Today, I'm offering a bold alternative'

More than 30 years have passed since 1974, and the status of women and the balance of political power have profoundly altered. Indeed, finally, in 2007, a woman was nominated as its candidate by a majority party, which had never happened before.[9]

Although the candidatures of Arlette Laguiller and Ségolène Royal were very different, they did share some common ground. Royal wholeheartedly revendicated the gender argument, just as Laguiller did before her, and she similarly underlined the break with tradition instituted by the choice of a female candidate. When Ségolène Royal announced: 'Women's time has come. France has nothing to lose, indeed, quite the opposite. Today I'm offering you a bold alternative' (official campaign programme, 22 April 2007), how can one not hear in these words a distant echo of those uttered by Arlette Laguiller analysed above? The revendication of the gender argument and the daring that this involves are the same, three decades later. It is also possible to question the status of the assertion made by Royal as the candidate of the Socialist Party at the beginning of her speech ('Women's time has come'). Should it be read as the serene affirmation of a reality that is, from now on, incontestable, or as her wanting to put the performative dimension of language to the test, a linguistic version of auto-suggestion?

Endnotes

1. This last question, though important when studying all of the French female candidates, doesn't make sense in this specific study. Ségolène Royal and Arlette Laguiller were both left-wing candidates (though the latter belonged to an extreme left party, whereas the former represents the governmental socialist party).

2. For the campaign in 1974, each candidate had an allotted two hours of radio and two hours of television broadcasts. On TV, these two hours were divided into slots of nine and eighteen minutes which were broadcast on the first and second channels, the latter being in colour. The candidate could appear alone, be interviewed by people of his/her choice or could even be represented by someone else. Arlette Laguiller chose to appear alone in all of the official campaign programmes.

3. *The Discours de la méthode* was first published in 1637.

4. Lettre à Paul Demeny, 15 May 1871.

5. It is interesting to note that, in the same period, the singer Michel Polnareff, in order to refute accusations of homosexuality, declared 'I'm a man, in short, what could be more natural?' ('Je suis un homme, je suis un homme, quoi de plus naturel en somme?'), while he posed in drag with his buttocks exposed.

6. Other female candidates should have been present at these elections in 1974, as the journalist Claude Servan-Schreiber pointed out: 'Elections remain a man's business...Admittedly, for the first time in an electoral campaign we have a female candidate, a marginal nevertheless, Arlette Laguiller, just one against eleven. But there could have been two female candidates. Five days before the closing date for registration of candidatures, the League of Women's Rights had put forward one of its militants. But failure to collect the necessary signatures through insufficient time meant that Huguette Leforestier had to abandon the idea of standing. ' (In *Le Monde* on 25 April 1974).

7. In *Moi, une Militante*, an autobiography which came out in April 1974, the candidate said that women are 'conditioned from their youngest age to play their role as women destined for domestic chores and to be at the beck and call of husband and children, in short, to play a role as slaves and the exploited' (Laguiller, 1974: 77).

8. 'For the general public, the first impression that Arlette Laguiller, who is 34 years old, makes, is of being a slender young woman with black hair cut very short who defined herself, in January 1973, as a militant without a husband or dependent chil-

dren, and who can represent and fight besides those who seek to build a real socialist society, a society in which police and struggle for profit will cease to exist.' (*Le Monde* on 5 April 1974) One of the journalists present at the press conference asked her: 'Why aren't you married?' To which the candidate humorously replied: 'Perhaps it's because nobody's thought about asking me. ' (The eight o'clock news bulletin *(20h)*, Channel 2, 19 April 1974)

9. Even if Ségolène Royal was nominated by bypassing the party executive; see, among others, Bacqué & Chemin, 2007.

10. 'All of us are going to build this "France President", an adult France, a sovereign France, a France where everything is possible.'

11. Two events sent out shock waves to female politicians: first, the shameful dismissal of the first—and to date only—female French prime minister, Edith Cresson, primarily on the grounds that she was a woman; secondly, in 1995, the no less shameful purging of the female members of Alain Juppé's first government, who had been nicknamed 'les jupettes' in a supremely chauvinistic pun on the French word for skirt ('juppe'). Women have since learnt their lesson and are now wary of being seen as making an issue of their gender.

12. She was, variously, a member of the president's advisory body, focusing on youth and sport (1982–1984) and social affairs (1984–1988), deputy minister for schools (1997–2002), and deputy minister for the family, childhood and the handicapped (2000–2002).

13. For a detailed analysis of gender and politics during the 2007 French presidential campaign, see Coulomb-Gully, 2009.

References

Bacqué, R. & Chemin, A., *La femme fatale,* Paris, Albin Michel, 2007.

Bonnafous, S., & Vassy, S., 'Réflexion sur une étude de la communication gouvernementale', in *Actes du 12ème Congrès de la SFSIC*, Paris, SFSIC, 2001, pp. 205–211.

Bonnafous, S., 'Femmes politiques: Une question de genre?', in *Réseaux n°120*, Paris, hermès-Sciences, 2003, pp. 121–145.

Charaudeau, P. & Maingueneau, D., *Dictionnaire d'analyse du discours*, Paris, Seuil, 2002.

Coulomb-Gully, M., 'Beauty and the Beast', *European Journal of Communication*, 24:2 (2009), pp. 203–218.

Fraisse, G., *Muse de la raison, Démocratie et exclusion des femmes en France*, Paris, Gallimard, 1995.

Gaxie, D., *La démocratie représentative*, Paris, Montchrestien, 1993.

Laguiller, A., *Moi, Une militante*, Paris, Seuil, 1974.

Maingueneau, D., *Analyser les textes de communication*, Paris, Dunod, 1998.

Rosanvallon, P., *Le Peuple introuvable: Histoire de la représentation démocratique en France*, Paris, Folio Histoire, 1998.

Sineau, M., *Profession femme politique: Sexe et pouvoir sous la Vème République*, Paris, Presses de Sciences Po, 2001.

Sineau, M., *La force du nombre, Femmes et démocratie présidentielle*, Paris, Editions de l'Aube, 2008.

Sirdar-Iskandar Ch., 'Eh bien! Le russe lui a donné cent francs', in O. Ducrot (ed.) *Les mots du discours*, Paris, Editions de Minuit, 1981, pp. 161–191.

Vassy, S., 'Ethos de femmes Ministres—Recherche d'indices quantifiables', *Mots-Les langages du politique*, 78 (2005), pp. 105–114.

Chapter Four:
Gender Analysis of Mediated Politics In Germany

Margreth Luenenborg, Jutta Roeser,
Tanja Maier and Kathrin Friederike Mueller

Introduction: Re-evaluating the representation of top-level female politicians in the German media

During the last few years, the political landscape has changed. The number of women who have reached high-ranking positions as heads of government or have run for such offices has increased. Indeed, in Germany, Angela Merkel became federal chancellor in 2005, and in Finland, Tarja Halonen is actually the state president, as is Christina Fernández de Kirchner in Argentina and Michelle Bachelet in Chile. Although Ségolène Royal did not succeed during the French presidential election in 2007 (see the chapter by Coulomb-Gully), her candidacy also highlights the advancement of female politicians when it comes to senior roles. These developments suggest that the media representation of high-ranking female politicians may now differ from in the past, when Margaret Thatcher was the only woman in Europe to hold an important public office. Several studies over the last twenty years have proved the marginalization and trivialization of top-level female politicians in both the German media (Schmerl, 1989; 2002; Sterr, 1997; Pfannes, 2004; Gnaendiger, 2007) and internationally (Norris, 1997; Sreberny & Van Zoonen, 2000; Pantti, 2007). It may, however, be the case that these findings are no longer current, and further research is certainly needed to take into account the changes that have taken place in society. This ongoing project examines whether media representations have altered in quantitative and qualitative terms as a result of the chancellorship of Angela Merkel, who is the first female chancellor of the

Federal Republic of Germany. We will analyse the intensity of her media presence as well as the coverage of her performance in foreign politics, a scene which has formerly been dominated by male protagonists. In another research question, we ask if her visibility, which is thought to be distinctive because of her status, also has a positive effect on the portrayal of other senior female politicians in Germany. For these reasons, the quantitative representation of these women is explored. Studies which concentrate on the election campaign in 2005, when Angela Merkel competed against Gerhard Schroeder, illustrate that the current chancellor faced no quantitative marginalization despite her femininity (Holtz-Bacha & Koenig-Reiling, 2007; Holtz-Bacha, 2008). Yet, up to now, we do not know how she has continued to be represented in either quantitative or qualitative terms. Accordingly, it is for this reason that a qualitative analysis, focusing on the modes of portraying Merkel, is also being undertaken. We seek out the consequences which result from the plurality of themes and broadcasting contexts where she appears. So far as other high-ranking female politicians are concerned, and because we can only refer to a small number of qualitative findings, we will also examine these women and their attributes in media texts. Consequently, we know little about past modes of representation. This desideratum results from the fact that earlier research analysed the subject in a quite constricted manner, with all of it focusing on quantitative data from news broadcasts or newspapers. Ang and Hermes (1994) highlighted the importance of the examination of *'gender representations'* (Ang & Hermes, 1994) as an aid to understanding how politicians who are women are portrayed. For example, the coverage of female senators in the Berlin senate was reduced to private contexts and was often scandalized, and these women were primarily reflected in a negative manner (Schaeffer-Hegel, 1995). It is presumed that the media coverage of female politicians in top-level positions is strongly shaped by inconsistencies, since two different social roles need to be merged in the mediated representation: on the one hand, these women are portrayed as the keepers of power and influence in professional contexts, while on the other their social role is coded in terms of traditional femininity. As femininity and power are socially constructed as opponents, a tension between these spheres might occur when female politicians become media subjects. Accordingly, wider research, which also emphasizes a qualitative *approach*, is necessary.

The first part of the chapter introduces the empirical concept of our research project. We then focus on the quantitative representation of men and women in high-ranking positions. Thereafter, as an example of our qualitative content and iconographic analysis, in the third part of the chapter we will present some qualitative findings relating to a particular media event: the opening of the Norwegian National Opera in Oslo in April 2008, which Angela Merkel attended wearing a robe which accentuated her décolleté.

The project 'Women at the Top Represented by the Media'

Before we present the first set of our quantitative and qualitative results, we would like to provide a brief insight into the basis data and methodological design of our work. The ongoing project 'Women at the Top Represented by the Media'[1] aims to contribute to fulfilling research desiderata. It combines quantitative and qualitative content analyses, as well as an iconographic analysis which investigates the textual and visual representation of women and men in leading positions.[2] Unique is the examination of the portrayal of managers and scholars alongside that of female politicians. The study is important because the relative representations of female managers and scholars in media content have never been investigated before.

The sample examined comprises broadsheet newspapers and the tabloid press, political, business and glossy magazines, weekly newspapers, and public and private broadcasts and magazine television programmes. This material was examined over a period of six months (from 1 April to 30 September) in 2008. The quantitative study contains a complete analysis of all of the media content published in this period by 23 daily newspapers, magazines and television broadcasts.[3] Thereafter, both a qualitative and an iconographic analysis will cover a selection of media output chosen from the overall sample. The quantitative data was evaluated by descriptive statistics. The aim of the study is to compare the presence of the three types of protagonists mentioned above, and to ask how men and women are represented by the mass media. Furthermore, our aim was to examine the influence that the representation of Angela Merkel, as the first female chancellor in Germany, has had on the media's depiction of women in top-level positions.

In a next step, we will conduct interviews with journalists in order to understand the modes of production of gendered texts. We are interested in professional routines and behavioural patterns in which gendered manners of representation are created. In addition, and in an attempt to gain insight into people's production of meaning, the reception of young women and men will also be explored by using focus group interviews. Studying the readers' perspectives is essential for acquiring an understanding of the social processes (Klaus et al., 2006) which may contribute to the audiences' role models. We argue that media professionals' perspectives and audiences' viewpoints are significant when it comes to understanding the reasons for the emergence of gendered media representations.[4]

Results of the quantitative analysis: Representations of women in top-level positions in the German media

Findings from the quantitative content analysis will now be presented and discussed in an initial consideration of the representation of women in top-level positions. The analysis was guided by the following research questions:

Representation in general: how many male and female high-ranking politicians, managers and scholars do the German media cover?

Different media: in which way does the representation of women in leading positions vary in different media genres?

Different professions: how is the relationship between male and female senior politicians, managers and scholars characterized?

Politicians: has the representation of top-level female politicians changed over the years since Germany has been governed by a female chancellor? Has the election of Angela Merkel had any (positive) effects on the representation of high-ranking female politicians?

In the quantitative analysis of six months of media content from newspapers, only the business and political sections were coded, while the entire content was examined in the case of the magazines and television broadcasts. All female and male politicians, managers and scholars with five or more lines devoted to them in texts were counted and differentiated by sex and professional status. In the television broadcasts and television magazine programmes, the politicians, managers and researchers who appeared for more than five seconds were selected (Table 1).

The number of coded individuals who fit into the coding categories is quite large, and there is immediately a disparity between male and female protagonists. Altogether, 57,548 people were noted: 47,694 men and 9,854 women. The following table (2) sets out the proportion of males and females and their numbers in absolute figures:

The first basic results reveal that women are still in a minority in terms of their portrayal in the German media, with only 17 per cent of all representations. With 21 per cent of the coverage, the percentage of women in top-level positions referred to is slightly higher. Nevertheless, in comparison to their male colleagues, female leaders are under-represented. Women comprised about one-fifth of all of the individuals featured, on both an average and a hierarchical level. This insight leads us to our first conclusion, namely that women are still marginalized in terms of media representation.

When comparing the findings from different forms of media, a certain homogeneity is noticeable; most of the representations of females are in the range of 17 to 20 per cent, irrespective of the source of the data. As seen in Table 3, the media which focus on providing information, like newspapers, political magazines and television news broadcasts, all include women at this sort of level.[4]

However, there are also positive and negative exceptions to the homogeneous results. The proportion of women featured in the business magazine, *manager magazin,* is, at 4 per cent, the lowest finding, followed by *Capital* and the television economics programme,

Table 1: Methodological proceedings: Overview

Media Sample	Three Types of Media
	- daily newspapers - magazines/weekly newspapers - television broadcasts
Coded Material	- the business and political sections of the newspapers - the entire content of the magazines, television news broadcasts, television magazine programmes
Coding Unit	- politician, manager, scholar mentioned for five lines or more in written articles and accordingly more than five seconds in television broadcasts

Table 2: Proportion of men and women in German media (percentage and absolute figures)

	Sex		Total
	Male	Female	
All coded Persons (in %)	82	17	100
All coded Persons (in absolute figures)	47694	9854	57548
All Persons in top-level Positions (in %)	86	14	100
All Persons in top-level Positions (in absolute figures)	38616	7830	46446

WISO (Table 3). The conclusion is clear: the economic sector is still a male-dominated sphere, and this clearly socially constructed connotation leads to an exclusion of women from the related media coverage.

In people and women's magazines, the visibility of female politicians, managers and scientists is more distinctive. With 59 per cent of its coverage devoted to them, the women's magazine *Brigitte* is at the top of all genres in terms of its portrayal of women. In addition, the general publications, *Bunte* and *SuperIllu*, and the television news broadcasts distributed by commercial stations, also feature an above average percentage of female protagonists (Table 3).[5] These results suggest that the media which focus on providing information still tend to marginalize women, while that which concentrates on entertainment, which usually relates more to topics of human interest, has more space for their representation. This is another

Table 3: Percentage and absolute figures of men and women in individual media

Medium		Percentage			Absolute Figures		
		Sex		Total	Sex		Total
		Male	Female		Male	Female	
Tabloid:	Bild	82	18	100	2635	580	3215
Broadsheet Newspapers:	Frankfurter Allgemeine Zeitung	84	16	100	10567	1984	12551
	Sueddeutsche Zeitung	85	15	100	9356	1630	10986
	Tageszeitung	81	19	100	5608	1298	6906
Political Magazines/Weekly Newspaper::	Focus	82	18	100	1813	399	2212
	Spiegel	83	17	100	2694	564	3258
	Die Zeit	81	19	100	1213	288	1501
Glossies:	Brigitte	41	59	100	30	43	73
	Bunte	76	24	100	449	142	591
	Stern	78	22	100	438	120	558
	Super Illu	78	22	100	490	136	626
Business Magazines:	Capital	88	12	100	373	51	424
	ManagerMagazin	94	6	100	495	29	524
Television News Broadcasts:	Heute (public)	83	17	100	2149	452	2601
	heute journal (public)	83	17	100	2494	526	3020
	Tagesschau (public)	81	19	100	2296	522	2818
	Tagesthemen (public)	84	16	100	2341	461	2802
	RTL Aktuell (commercial)	79	21	100	1328	351	1679
	SAT.1 NEWS (commercial)	73	27	100	541	204	745
Television Magazine Programmes:	Monitor (public)	75	25	100	68	23	91
	Panorama (public)	94	6	100	50	3	53
	Plusminus (public)	82	18	100	121	27	148
	WISO (public)	87	13	100	145	21	166
Total		83	17	100	47694	9854	57548

reason why the proportion of female protagonists represented in magazines is greater than in newspapers or on television news broadcasts. Since private broadcasters also use these journalistic strategies in their television news programmes, the percentage of women covered by them is above average when compared to German public broadcasting.

A closer look at the 21 per cent of women in top-level positions referred to in the sample reveals inequalities: the comparison between the three status groups leads to the conclusion that the media representation of women in senior positions differs according

to their professional background (Table 4). In politics, women are represented noticeably more often than they are in the fields of academia or economics.

The data shows that in comparison to men, the professions in which women receive the most coverage are the fields of top-level politics (30 per cent), followed by that of senior research (11 per cent). Only 4 per cent of managers in high-ranking positions referred to were female.[6] This under-representation of women in the media is often justified by their factual under-representation in society. Yet, examination of the data relating to the three professions under consideration herein, reveals that, once more, the media do not simply reflect the status quo, but also construct a traditional world in which hierarchical gender relationships are implied, particularly in certain professional contexts. Indeed, in the media coverage of economics, women seem to be almost irrelevant. Reports about the economy and major companies still ignore female managers and emphasize the male position. Between 9 and 13 per cent of the top-level managers in German businesses are female, but this is not reflected in the media (Bischoff, 2005: 35). In contrast, the field of politics is characterized differently: according to the media coverage of this field, there is a certain visibility of female politicians in this context. Although these women are slightly under-represented in the media, as they are in the German government, with 38 per cent of all cabinet members being female (BMBFSFJ, 2009), they are featured more according to their social relevance than the women in the two other professional fields under examination. Like in the economic sector, the situation concerning the representation of women in academia in the media reveals that they are again marginalized. In universities and applied research institutes, 17 and 8 per cent, respectively, of all leading positions are held by women (GWK, 2009: 10). So, to summarize the findings made about the link between the numbers of women in top-level positions referred to in the media and their professions, it becomes clear that their marginalization in society, which certainly persists, is intensified in the media. Nevertheless, there are enormous differences between these three fields, meaning that the visibility of female leaders depends on the sector with which they are involved. Economics in particular is still a man's world. Even though women with a high professional status are media subjects more often than others of their sex because of their function, they are referred to less than men in the same positions. Therefore, we have to conclude that their points of view and social relevance are valued as being less significant, since we still find modes and acts of disempowerment of females in the German media.

Changes in the representation of female top-level politicians in German media—what effect has a female chancellor had on the visibility of women as politicians?

A major aim of our examination is to analyse the impact that a female chancellor has had on the media representation of senior politicians. To do this, it is necessary to compare the proportion of top-level female politicians featured in the German media

Table 4: Proportion of women and men in top-level positions according to their profession

before Angela Merkel was elected chancellor to the situation more recently. A study by Jutta Roeser (2006), undertaken in 2005 just before Merkel was elected, is an ideal starting point. In that research, the proportion of female politicians referred to in the main news section in eleven German daily newspapers over a three-month-period was analysed, and at that time only 18 per cent of all of the politicians represented were female.

A comparison of the proportion of female politicians mentioned in the German media in the years 2005 and 2008 reveals that the number of women represented in newspapers has increased, but only by a small amount. Today, 20 per cent of all politicians featured in German newspapers are female, while in 2005 this figure was 18 per cent, as referred to above. But things have changed when it comes to women holding a high political office: at 30 per cent, the proportion of top-level female politicians featured in the media coverage is twelve points higher than when Gerhard Schroeder was the chancellor.

However, a look at the group of senior politicians featured in our sample who are women reveals that in relation to her female political colleagues in other leading positions, Angela Merkel dominates completely. In the four daily newspapers analysed, 55 per cent of the coverage of all female high-ranking politicians is devoted to her (Table 5).

The contrast between the number of times that Merkel is mentioned in the four newspapers studied compared to the overall group of top-level female politicians emphasizes these findings. In the *tageszeitung*, the *Frankfurter Allgemeine Zeitung* and the *Sueddeutsche Zeitung*, she is referred to in half or more of all representations about female political leaders (approximately 49 to 58 per cent). In the tabloid *Bild*, this figure reaches 70 per cent because the journalistic 'strategy of personalization' is used more often in this newspaper. The utilization of this approach seems to reflect a

concentration on featuring the woman holding the most important political office in Germany. Meanwhile, female ministers only benefit a little from this personalized kind of media coverage. These findings are supported by those of Christina Bauer (2008), who found that during the election campaign in 2005, Merkel was practically the only woman referred to in the television news; 95 per cent of the speeches by women that were covered were by Merkel, while this figure was only 38 per cent for her opponent, former chancellor Gerhard Schroeder. The journalistic 'strategy of gearing to the elite', therefore, seems to be more prevalent in reporting about women than about men. While national female ministers are outshined by chancellor Merkel, their male counterparts gain much more attention than their female colleagues.

Even though Merkel as an individual is well represented in the newspapers, this does not lead to there being a greater proportion of female politicians in leading positions in general being featured (Table 6). There are also no remarkable differences between the four newspapers, since the average proportion of top-level female politicians represented in all of them is about one-third of all of the coded politicians.

Given that they follow journalistic strategies which lead to a focus on topics characterized as 'human interest', the women's and people's magazines were expected to feature a higher percentage of female politicians. The results, indeed, reveal that the women's magazine *Brigitte*, with 58 per cent of representations, refers to female political leaders most often. In *Bunte*, 41 per cent of all top-level politicians referred to are female, while in *Superlllu*, a press magazine mainly distributed in Eastern Germany, this figure

Table 5: Proportion of coverage of women devoted to Angela Merkel in daily newspapers compared to other top-level female politicians (percentage)

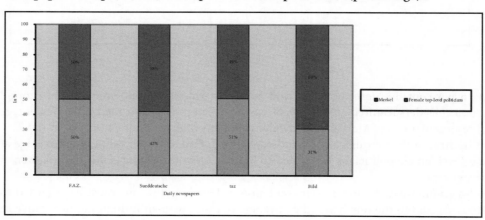

Table 6: Female and male top-level politicians in daily newspapers (percentage)

Daily Newspapers	Percentage			Absolute Figures		
	Sex		Total	Sex		Total
	Male	Female		Male	Female	
Bild	79	21	100	1762	471	2233
F.A.Z.	79	21	100	5246	1375	6621
tageszeitung	80	20	100	3609	893	4502
Sueddeutsche Zeitung	82	18	100	5565	1239	6804

Table 7: Proportion of coverage of women devoted to Angela Merkel in magazines compared to other female top-level politicians (percentage)

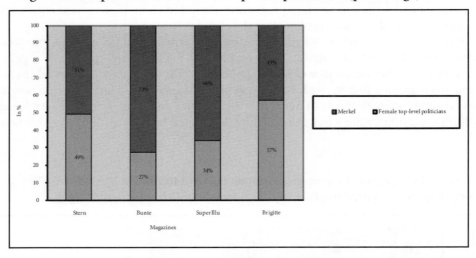

is 36 per cent. In *Stern*, however, and as in the overall sample, only one-third of all political leaders featured are female. Nevertheless, in the popular media, the percentage of representations of Merkel in particular is notably higher (Table 7).

In three of the four magazines studied, between 50 and 73 per cent of the coverage of top-level female politicians is devoted to Merkel. Only in *Brigitte* is this figure lower, at 43 per cent.[7]

To summarize, the media representation of female politicians must be regarded as Janus-faced. On the one hand, the coverage of those women in high political office in the media has obviously intensified recently when compared to 2005, when Germany

was governed by a male chancellor. On the other hand, however, it is clear that the fields of both economics and politics remain a man's world. We can, therefore, conclude that Merkel's chancellorship does have positive effects on the representation of high-ranking female politicians, since their coverage has almost doubled. Nevertheless, Merkel's chancellorship has not lead to greater coverage of top-level female politicians in general, and nor has it brought about a more distinctive plurality; the greater coverage of women overall is merely down to her presence. German female ministers, who undoubtedly hold influential positions, are not represented appropriately. In the case of female politicians who do not hold a senior office, nothing has changed at all.

Overall, the quantitative results of six months of media coverage lead us to conclude that—except for Chancellor Merkel—other female political leaders and ordinary female politicians are still neglected and marginalized, because their proportion of media coverage has remained almost the same as it was before Merkel was elected.[8]

Case study: Merkel's décolleté in the media

To illustrate our qualitative media analysis, we have chosen a specific case study from our research period. We employ a method which combines qualitative content analysis with iconographic methods. In April 2008, the German chancellor, who usually wears quite conservative clothes, provoked public attention by appearing in a décolleté dress. Numerous European media outlets reported on this unusual outfit, which Merkel wore at the opening of the National Opera in Oslo. We believe that the media discourse on 'Merkel's décolleté' highlights the contradictory elements of power and gender in a specific way.

We have analysed the media coverage in selected newspapers and magazines—quality press as well as tabloids and popular magazines[9]—between 13 and 21 April 2008. In all of the media reports we found the same three photographic images: the arrival of Merkel on the red carpet outside the opera; her shaking hands inside the opera house; and her conversing with guests (cf. Luenenborg et al., 2009: 77–84).

Almost every report in the German press featured one of these motifs. In what follows, we will explain how the voyeuristic gaze at the female body is visually constructed in this highly sexualized, staged presentation. The images that served as a trigger for the extensive coverage follow the common iconography of power concerning male and female political representatives. The following discursive patterns become especially visible.

Pattern 1: Is the outfit appropriate?
In the tabloid press (occasionally in the quality press as well) Merkel's turn to femininity is very positively appraised. Her outfit, so it is commented, appears to be a commitment to being more womanly in comparison to the trouser suits she normally wears. In this context, the décolleté has become a self-evident sign of authentic femininity. Thus, the

magazine *SuperIllu* (17 April 2008: 86) saw 'Merkel on top of fashion'. The headline in *Bunte* (17 April 2008: 30) read: 'What an appearance!' and talked about a 'statement of fashionable self-confidence'. According to *Bild* (14 April 2008: 2), German citizens favour a femininely dressed chancellor and not one who always wears trouser suits. The weekly news magazine *Focus* (17 April 2008: 190) gave Merkel first prize for her decision to wear this outfit, which is regarded as a nice variation on her usual business suit silhouette. Even the trouser suit, a female adaption of the business suit, seemed to be a deviation from the norm of femininity and confuses the heterosexual matrix. In this line of argument, the outfit Merkel was wearing in Oslo is perceived and assessed as being a calming stabilization of ideas of femininity and masculinity.

The media coverage evaluated Angela Merkel's outfit as something positive, and didn't only refer to aesthetic considerations or body constructions. Here, we also find a gendered debate on the professional status of the German chancellor. According to another *Bunte* headline, Merkel reigns 'with a woman's weapons'.[10] The magazine *Focus* (17 April 2008: 190) turns her into the 'Queen Mum. An alma mater who not only tames brawly politicians and saves Tibet, but who also wants to embosom the whole nation'.[11] *Stern* (17 April 2008: 20) nominated the chancellor as 'Queen of Might' in another headline, and in a double-side spread, the magazine presents an image of Merkel 'shaking hands' with Sweden's Crown Princess Victoria in the lobby of the opera house. It was also commented, in an annotation to the photograph, that Crown Prince Haakon, who is also seen in this image, had his eyes fixed on the handshaking and must, therefore, be considered a perfect gentleman. Thus, the coverage reproduces a heteronormative gaze and interprets women's breasts as the primary attribute of womanliness and attractiveness. It assumes that female breasts involuntarily cause heteronormative desire in the viewing subject (intended as a male viewer). The missing glance of the Crown Prince as shown on the photograph reintroduced the heteronormative gaze as a signifying practice on a linguistic level.

In this case, the vivid example of 'Merkel's décolleté' shows clearly how this quality of '*to-be-looked-at-ness*' (Mulvey, 1975: 11) and the voyeuristic gaze at the female body is being created by and in the media, not only on a linguistic but on a visual level as well. Another picture published in different newspapers and magazines shows the German chancellor and her Norwegian colleague, Stoltenberg, talking (Figure 1). A large part of the print media coverage, however, included a photo with only Angela Merkel in it (Figure 2). Sometimes Merkel is even cropped in the layout (Figure 3). The situation of political conversation becomes invisible on both of the final photographs shown here. Merkel is quoted out of context, the picture is decontextualized and the low-cut neckline stands in focus. In explicitly depicting femininity on the linguistic as well as on the visual level, the coverage in the media referred to constructs a *modern* type of female politician who does not question the heterosexual matrix.

Not in every instance do we find performative acts of gendering and sexualization when Merkel's outfit is discussed in the media. The newspaper, *Frankfurter Allgemeine Sonntagszeitung* (20 April 2008: 68), for example, critically comments on the double-bind situation for women in leading positions.[12] This is one of the very few articles which did not feature any of the photographs mentioned above. According to the piece, women in top-level political positions are perceived as unfeminine and assertive or, on the contrary, as feminine and politically incompetent.

Being the representative of the political elite of a Western democracy calls for a certain style, which should veil femininity rather than putting it on display. Images of femininity and political decency seem incompatible. This leads to the second pattern of media coverage we have found.

Pattern 2: Why did Merkel wear the décolleté?

The discussions in the newspapers focus on the question of why Angela Merkel was wearing a dress with a low neckline, and whether there was a strategy and tactics behind her performance. Predominantly, the quality press discourse shifted towards political issues. Referring to femininity at this point implies doubting the political legitimacy of the chancellor. For example, it was a conscious performance of femininity claimed the *tageszeitung* (15 April 2008: 1), under the satirical heading 'verboten': 'With her breasts chancellor Angela Merkel distracts from the significant problems of a politically, economically and socially deeply divided Germany. With this, she has played her last ace in the hole'.[13] A headline in *Die Zeit* (17 April 2008: 12) called Merkel's appearance 'Breasts Race'. In some parts of the coverage the issue is negotiated, with ironic undertones, as a conscious gender performance. Merkel is portrayed as someone who is capable of political acts and uses femininity to achieve her political goals.

The tabloid press maintains that Merkel's outfit was not a purposeful staging. Deputy government spokesman Thomas Steg was quoted several times in order to verify this

Figures 1, 2 and 3: *BamS* 13 April 2008, *Superillu* 17April 2008, *Bild* 18 April 2008

statement, i. e. in *Bunte* (17 April 2008: 30): 'The fact that her dress caused a furore was not intended by the chancellor'.[14] Furthermore, the media reporting called Merkel's advisors to account for the clothing choice. According to means of negotiating power and gender, the coverage stated that the German chancellor revealed a lack of expertise and independence. Implicitly, the media coverage criticized any assumption of a compatibility of femininity and political competence.

These two discourses on the intended or unintended quality of Merkel's performance clearly illustrate the gendering of politics. It becomes obvious that the political sphere is not a gender-neutral entity. Merkel's appearance is not being evaluated as politically intentional, but as some kind of seemingly 'natural act' by a woman who dresses fashionably. If a conscious staging on Merkel's part was insinuated, she appears to be less powerfully taking her political agency into account. If the media coverage assumed an intended performance, the female attributions would also expose political actors to the suspicion of obscuring technical subjects. On a symbolic level, the political sphere is being reconfirmed as male-dominated according to this media representation. Therefore, the exclusion of women and femininities appears to be natural.

Conclusion

The findings from the quantitative analysis show that Merkel has a unique position among the group of top-level female politicians. Because of her extraordinary status, she is represented in the media far more often than other female political leaders or run of the mill female politicians. In fact, the representation of these two groups has not increased fundamentally since Merkel became federal chancellor. We can clearly assert then that in the field of media coverage, chancellor Merkel outshines all other female politicians.

Because of Merkel's strong presence, it is even more interesting to analyse how senior female politicians—and especially Merkel—are being depicted. The constellation of tension between power and gender that exists for women as well as men becomes the focal point of a qualitative content analysis. It combines an examination of linguistic and visual representations.

Furthermore, the case study reveals that even a high level of media coverage cannot automatically be valued as a sign of proper representation, because the attribution of female protagonists also plays an important role. The thin line of seeming gender equality, which preserved Merkel from being trivialized in the news coverage during the election campaign (Boomgaarden & Semetko 2007; Holtz-Bacha & Koch, 2008), quickly turns into sexualization as soon as she leaves her usual gender-neutral appearance behind. We argue that the pictures have to be regarded as performative acts of gendering and sexualization. By choosing the moment the photographs were taken, their perspectives and details, the photographers and picture editors at the various media outlets have represented Merkel in this highly sexualized way. The widespread coverage provoked by her appearance is based on the difference between

the displayed femininity and the familiar. Two areas of conflict became clear in our analysis: on the one hand, the outfit in Oslo stands in clear opposition to Merkel's hitherto staged appearance, which was defined as being anti-fashionable and anti-feminine by the media; on the other, she has diverged from the existing dress code for women in top-ranking political positions. This code allows there to be a subtle emphasis on the female body, but it is not expected to be explicit. This difference used to be the main reason for broad media resonance and is being reconstructed consecutively in covering the issue. One can conclude that the coexistence of power and femininity is still not accepted and causes irritation to the media.[15]

Endnotes

1. This is a joint project carried out by Margreth Luenenborg (Free University of Berlin) and Jutta Roeser (Leuphana University Lueneburg). Our work is funded by the German Ministry of Science and Research (BMBF) and by the European Social Fund (ESF).

2. Since top-level politicians, managers and scholars take centre stage in this study, the meaning of the term 'leading position' in all of the three professional fields had to be defined. Top-level politicians are heads of government, federal ministers and chairs of a parliamentary party or group. Top-level managers are understood to be chief executive officers, chairs of the board of management, members of the board of associations, managing directors, managers and owners and managing directors of small- and medium-sized businesses and family-owned businesses. And finally, the group of highly qualified researchers includes professors and researchers with a leadership function at universities and independent research institutions as well as other internationally renowned researchers and scholars.

3. Regarding the selection of the material to be analysed, newspapers with sympathy towards different political parties were chosen. In case of the magazines, the market leaders of the different segments were chosen to be part of the sample.

4. In order to gain detailed knowledge of the representations of women and men in top-level positions, it is necessary to analyse the processes of representation, production and consumption. Although one crucial aspect of the project is to focus on the production and reception of media texts, this article first and foremost asks how men and women are represented differently by the mass media.

4. Even in the tabloid *Bild*, which tends to personalize and relate to human interest topics only, 18 per cent of women are represented. Two reasons related to the methodical setting lead to this lower proportion: on the one hand, only politicians, managers and

scholars were counted, but not all of the men and women appearing on the first two pages. So, actors, singers or other celebrities are not included, and neither are the wives of politicians or managers. On the other hand, only the political and business sections were examined. Politicians, managers or scientists named in other sections are not counted either.

5. In the print and television magazines, only a small number of cases were mentioned. Therefore, the absolute figures are low.

6. Altogether, following the absolute figures, the politicians also form the largest group, the managers are in the middle and the scholars are the smallest group: in the sample, 44,859 people are male or female politicians. The number of all male and female managers and scholars counted is remarkably lower. Only 10,572 men and women are managers, and 2,117 are scholars.

7. When comparing newspapers to magazines, it is important to point out that the absolute figures of all of those counted differ greatly: in the newspapers, 20,160 people were coded as top-level politicians, while in the magazines, only 1,169 female and male top-level politicians were found.

8. Nevertheless, in such a complex field as media broadcasting, the representation of social groups is not influenced by just one phenomenon. The interaction between social processes and media broadcasting is always multi-dimensional. So, we have to ask which influences prevent an appropriate representation of female top-level politicians and which characteristics connected to her office distinguish chancellor Merkel from other female high-ranking colleagues. Those questions cannot be answered by the quantitative, but by the qualitative content analysis.

9. The monthly magazines had not reported on the subject at that time. So, we extended our original sample by including the Sunday newspapers, *Frankfurter Allgemeine Sonntagszeitung* and *Bild am Sonntag*, and the daily newspaper, *Frankfurter Rundschau*, which addressed the topic early on.

10. '[M]it den Waffen einer Frau' (*Bunte*, 17 April 2008: 7).

11. 'Koeniginmutter…Eine Alma Mater, die nicht nur zankende Politiker zaehmt und Tibet rettet, sondern auch die ganze Nation an ihre Brust druecken will'.

12. The communications scientist Kathleen Hall Jamieson (1995) argues that double binds make it difficult for women to achieve positions of power in our culture. Ja-

mieson identifies five double binds for women: Womb/Brain, Silence/Shame, Sameness/Difference, Femininity/Competence and Aging/Invisibility.

13. '[M]it ihren Bruesten lenkt Bundeskanzlerin Angela Merkel von den wesentlichen Problemen eines politisch, wirtschaftlich wie sozial tief gespaltenen Deutschlands ab. Sie hat damit ihren letzten Trumpf ausgespielt'.

14. 'Dass dieses Abendkleid fuer solche Furore gesorgt hat, lag nicht in der Absicht der Bundeskanzlerin'.

15. The medial constellation of tensions between the attribution of femininity on the one hand and power through function on the other, described above, is also relevant for young women's acquirement of these stories and images. The initial explorative interviews that were conducted have shown this (cf. Luenenborg et al., 2008: 76–77 and 90–97). More insight into this field will be gained by using the data collection method of focus groups which is part of the ongoing project.

References

Ang, I. & Hermes, J., ,Gender and/in Media Consumption', in M.-L. Angerer & J. Dorer (eds) *Gender und Medien: Theoretische Ansaetze, empirische Befunde und Praxis der Massenkommunikation. Ein Textbuch zur Einfuehrung*, Wien, Braumueller, 1994, pp. 114–133.

Bauer, C., ,Merkel, Roth…und sonst keine Politikerinnen im Fernsehen', in C. Holtz-Bacha (ed.) *Frauen, Politik und Medien*, Wiesbaden, Verlag fuer Sozialwissenschaften, 2008, pp. 25–48.

Bild, 'Merkel zeigt Dekolleté', 14 April 2008, p. 2.

Bischoff, S., *Wer fuehrt in (die) Zukunft?: Maenner und Frauen in Fuehrungspositionen der Wirtschaft in Deutschland—die 4. Studie von der Deutschen Gesellschaft fuer Personalfuehrung e.v.*, Bielefeld, Bertelsmann, 2005.

BMFSFJ, http://www.bmfsfj.de/bmfsfj/generator/BMFSFJ/Presse/pressemitteilungen, did=106396.html. Retrieved 9 March 2009.

Boomgaarden, H.G. & Semetko, H.A., 'Duell Mann gegen Frau?! Geschlechterrollen und Kanzlerkandidaten in der Wahlkampfberichterstattung', in F. Brettschneider,

O. Niedermayer & B. Wessels (eds) *Die Bundestagswahl 2005. Analysen des Wahlkampfes und der Wahlergebnisse*, Wiesbaden, Verlag fuer Sozialwissenschaften, 2007, pp. 171–196.

Bunte, 'Was fuer ein Auftritt', 17 April 2008, pp. 30–32.

Bunte, 'Mit den Waffen einer Frau', 17 April 2008, p. 7.

Focus, '1. Preis fuer ‚das Dekolleté' von Angela Merkel', 17 April 2008, p. 190.

Frankfurter Allgemeine Sonntagszeitung, 'Dresscode', 20 April 2008, p. 68.

Gnaendiger, C., *Politikerinnen in deutschen Printmedien. Vorurteile und Klischees in der Berichterstattung*, Saarbruecken, VDM Verlag, 2007.

GWK, http://www.gwk-bonn.de/fileadmin/Papers/GWK-Heft-03-Chancengleichheit. pdf. Retreived 9 March 2009.

Holtz-Bacha, C. (ed.), *Frauen, Politik und Medien*, Wiesbaden, Verlag fuer Sozialwissenschaften, 2008.

Holtz-Bacha, C. & Koch, T., ‚Der Merkel-Faktor—Die Berichterstattung der Printmedien ueber Merkel und Schroeder im Bundestagswahlkampf 2005', in C. Holtz-Bacha (ed.) *Frauen, Politik und Medien*, Wiesbaden, Verlag fuer Sozialwissenschaften, 2008, pp. 49–70.

Holtz-Bacha, C. & Koenig-Reiling, N. (eds), *Warum nicht gleich? Wie die Medien mit Frauen in der Politik umgehen*, Wiesbaden, Verlag fuer Sozialwissenschaften, 2007.

Jamieson, K.H., *Beyond the Double Bind: Women and Leadership*, New York, Oxford University Press, 1995.

Klaus, E., Roeser, J. & Wischermann, U., 'Frauen und Geschlechterforschung. Zum Gesellschaftsbezug der Publizistik und Kommunikationswissenschaft', in C. Holtz-Bacha, A. Kutsch & W. Langenbucher (eds) *Publizistik Sonderhefte 5. Fünfzig Jahre Publizistik*, Wiesbaden, Verlag fuer Sozialwissenschaften, 2006, pp. 354–369.

Luenenborg, M., Roeser, J., Maier, T., Mueller, K. & Grittmann, E., ‚Merkels Dekolleté als Mediendiskurs. Eine Bild-, Text- und Rezeptionsanalyse zur Vergeschlechtlichung einer

Kanzlerin', in M. Luenenborg (ed.) *Politik auf dem Boulevard? Die Neuordnung der Geschlechter in der Politik der Mediengesellschaft*, Bielefeld, transcript, 2009, pp. 73–102.

Mulvey, L., 'Visual pleasure and narrative cinema', *Screen*, 16:3 (1975), pp. 6–18.

Norris, P. (ed.), *Women, Media, and Politics*, Oxford, Oxford University Press, 1997.

Pantti, M., 'Portraying politics: Gender, Medien und Politik', in C. Holtz-Bacha & N. Koenig-Reiling (eds.) *Warum nicht gleich? Wie die Medien mit Frauen in der Politik umgehen*, Wiesbaden, Verlag fuer Sozialwissenschaften, 2007, pp. 17–51.

Pfannes, P., „*Powerfrau', ‚Quotenfrau', ‚Ausnahmefrau'…? Die Darstellung von Politikerinnen in der deutschen Tagespresse*, Marburg, Tectum, 2004.

Roeser, J., ‚Der Pressejournalismus als Konstrukteur maennlicher Dominanz', in Journalistinnenbund (ed.) *Praesenz von Frauen in den Nachrichten. Medienbeobachtungen 2005*, Bonn, Journalistinnenbund e.V., 2006, pp. 27–37.

Schaeffer-Hegel, B., *Frauen mit Macht: Zum Wandel der politischen Kultur durch die Praesenz von Frauen in Fuehrungspositionen*, Pfaffenweiler, Centaurus-Verlag, 1995.

Schmerl, C., *In die Presse geraten. Darstellung von Frauen in der Presse und Frauenarbeit in den Medien*, Koeln, Boehlau, 1989.

Schmerl, C., "'Tais-toi et soi belle!" 20 Jahre Geschlechterinszenierungen in fuenf westdeutschen Printmedien', *Publizistik*, 47 (2002), pp. 388–410.

Sreberny, A. & Van Zoonen, L. (eds), *Gender, Politics and Communication*, Cresskill, NJ, Hampton Press, 2000.

Stern, 'Koenigin der Macht', 17 April 2008, pp. 20–21.

Sterr, L., *Frauen und Maenner auf der Ttitelseite. Strukturen und Muster der Berichterstattung am Beispiel einer Tageszeitung*, Pfaffenweiler, Centaurus, 1997.

SUPERillu, 'Merkel modisch auf dem Gipfel', 17 April 2008, pp. 86–87. *die tageszeitung*, 'Hurra, 2 Jahre Silas', 5 April 2008, p. 1.

Die Zeit, 'Wettbruesten. Was es mit Angela Merkels Dekolleté auf sich hat', 17 April 2008, p. 12.

SECTION II

EMBODIED PERFORMATIVITIES

SECTION II

EMBODIED PERFORMATIVITIES

CHAPTER FIVE:
HOLLYWOOD, RESISTANCE AND TRANSGRESSIVE QUEERNESS: RE-READING *SUDDENLY, LAST SUMMER* (1959), *THE CHILDREN'S HOUR* (1961) AND *ADVISE & CONSENT* (1962)

Frederik Dhaenens, Daniel Biltereyst and Sofie Van Bauwel

Introduction

Martha: 'I feel so damn sick and dirty I can't stand it anymore!'
(*The Children's Hour*, 1961)

Towards the end of William Wyler's *The Children's Hour* (1961), the character of Martha (played by Shirley MacLaine) seems to be caught up in distress and self-loathing. She has just come out of the closet as a lesbian to her friend Karen (Audrey Hepburn), using words and sentences that imply a painfully negative self-image. She sobs and is looking away from her confidente with whom she has fallen in love. Karen doesn't know what to say, but a close-up allows the observer to read her expression as pitiful. After the dramatic coming-out sequence, Martha flees to her room and eventually hangs herself. Although *The Children's Hour* is often used as a key example of the stereotypical representation of the pitiful and suicidal queer (see Russo, 1981; Barrios, 2003), the movie is one of the first major Hollywood productions explicitly featuring a lesbian main character.

Queer characters had been removed from the big screen during the Production Code era, as homosexuality was seen by the Production Code Administration (PCA, 1934–1968) as a sexual perversion. Although *The Children's Hour* is often described as regressive in its representation of homosexuality (see Russo, 1981), we argue that the film's text allows itself to be read as an emancipatory statement, a reading that goes beyond the

stereotypical surface and is based upon textual elements that defy the Production Code. In this article we argue that Martha's outburst and suicide can be interpreted as a critique of a hegemonic discourse on homosexuality. In the same period, other films featuring gay characters also allow for a non-hegemonic reading. Drawing on poststructuralist queer theory, which stresses a set of distinctive theories contesting essentialist notions relating to gender, sexuality and identity (see Butler, 1990; De Lauretis, 1987; Sedgwick, 1985), this article concentrates upon the representations of gay characters in a set of landmark Hollywood films dating from the end of the 1950s and the early 1960s. Inspired by Alexander Doty's work on the subtle ways of expressing homosexuality in film texts (Doty, 2000), we consider movies as spaces where queer resistance can potentially take form, despite being filtered by institutional and other constraints. One of these constraints is censorship, which in the case of Hollywood relates to the PCA's prohibition of the depiction of sexual perversion. A few movies dared to undermine this code, but Joseph L. Mankiewicz's *Suddenly, Last Summer* (1959), William Wyler's *The Children's Hour* and Otto Preminger's *Advise & Consent* (1962) are often cited as the films that challenged and softened the Code's prohibition on representing sexual aberrations (Barrios, 2003). We will look at how the rejection of a hegemonic notion of heteronormativity was, or is, inscribed in these film texts. After discussing this concept of resistance and the importance of integrating queer theory into film studies, we will elaborate on the role of queer resistance. We will then explore the implications of the downfall of the Production Code at the end of the 1950s. Drawing upon a queer theory perspective, we will finally analyse the three movies as potential spaces of resistance.

Film studies; representing and reading queer

Queer theory has not only established its worth within gender research and poststructural theories, but has also become a useful framework for film studies. Frederik Dhaenens, Sofie Van Bauwel and Daniel Biltereyst (2008) mapped the concept of queer theory, situating its roots in the late 1970s when the notion of homosexuality began to be questioned, radically changing gay and lesbian studies (e.g. Creekmur & Doty, 1995). At this time, homosexuality began to lose its essentialist and uniform connotation, and homosexual desire came to be positioned in a social and historical context (for an overview see Seidman, 1996). Gradually, class, race, ethnicity and nationality were integrated into the debate about identity (Seidman, 1995: 116). Social constructivism was the dominant approach or paradigm within which identity and sexual orientation were discussed. It was stressed that socially recognized sexual orientations vary culturally and historically, and that in cultures where the categories of heterosexuality and homosexuality are acknowledged, sexual behaviour can move between categories or incorporate both (McIntosh, 1997: 365–366). Queer theory also draws upon the work

of the literary and film theorist Teresa de Lauretis (1987), who highlighted that early feminist theory continued to think in terms construed by patriarchies, creating women as a universal sex category (see Benhabib et al., 1995; De Vos & Van Bauwel, 2002). Drawing on Foucault's technology of sex (1976), de Lauretis suggested that there is a technology of gender that is the product of hegemony. Although the gathering of women under the category 'woman' has its emancipatory purposes, such as the claiming of equal rights, it constructs boundaries and consolidates the binary opposition between men and women which upholds the promotion of exclusion and misrepresentation. Judith Butler (1990), regarded as one of the major queer theorists, drew a comparison between the categories 'woman' and 'gay', raising an issue that is of the utmost importance in feminist and queer communities regarding the necessity of understanding how these fixed categories are produced and reiterated in society. Queer theory and queer politics react against these normalized hierarchies and identity politics, conducting research outside the boundaries of predefined gay or lesbian communities (Seidman, 1995: 118–126; Stein & Plummer, 1996: 134–135).

Queer theorists not only challenge the hetero/homo opposition, but notions of heteronormativity as well. To this day, the dominant discourse in contemporary society is that of heteronormativity, which is embedded in political, social and cultural institutions. Jonathan Katz (1995) stressed the 'construction' of this discourse by referring to the invention and emergence of heterosexuality in the twentieth century as a fixed and normative sexuality. Queer theorists aim to resist heteronormative notions by, for instance, 'queer reading' the texts produced by these institutions. For example, a queer reading of popular culture products reverses the hegemonic meanings embedded in these texts (Gross, 1998). Alexander Doty (2000: 2) emphasized that the practice of queer reading is not so much about making a text queer, but rather about trying to study how a text is—or might be—understood 'as queer'. Queer readings enable homosocial and homosexual traces in major Hollywood film productions such as *The Wizard of Oz* (Victor Fleming, 1939) to be revealed. Dhaenens et al. (2008) suggested that queer scholars are not the only ones who are able to read against the grain. Inspired by Henry Jenkins' (1992) groundbreaking work on the 'slash fiction' of *Star Trek* (1966–1969), they referred to fan fiction produced by active audiences who imagined a romantic and sexual relationship between the characters of Kirk and Spock, or to the internet as offering this form of slash fiction through contemporary popular series such as *Lost* (2004).

Some film scholars have also referred to examples of contra-hegemonic readings, in terms of sexuality, by historical audiences. Richard Barrios' (2003: 192) study on queer representations in Hollywood up to the 1960s, for instance, revealed how particular audiences in the 1940s were already openly 'queering' preferred readings. One of his most convincing examples is that of the Paramount picture *The Uninvited* (Lewis Allen, 1944), which was seen by large groups of gay spectators, mostly women, and ultimately became a lesbian cult movie. This ghost story, which is sometimes compared to

Hitchcock's *Rebecca* (1940), was known for featuring a strong, gothic lesbian character, Miss Holloway (White, 1999). While critics praised and audiences liked the movie, the Legion of Decency, a collectivity of Catholic movements which act against films that offend Christian morality and decorum, addressed the PCA regarding 'certain erotic and esoteric elements in this picture' (quoted in Barrios, 2003: 191). But neither the PCA nor the studios and producers were aware of (or willing to read) the queer subtext. This example illustrates how audiences can read the text against the grain, thus queering film content. In a way, Hollywood's tight internal censorship forced filmmakers to think through the polysemic character of the movies, requiring them to get around the PCA's definition of sexual perversion. It was during the downfall of the PCA, more specifically the end of the 1950s and the beginning of the 1960s, that more explicit queer representations found their way to the big screen.

PCA, sex perversion and queer representation

In his critical examination of traces of queerness in American cinema, David M. Lugowski (1999: 12) argued that Hollywood was 'at its most queer from early 1932 to mid-1934.' Lugowski claimed that this pre-code period, which announced the end of the Studio Relations Committee (SRC, 1930–1934) and preceded the more severe PCA, contained a rich reservoir of queer imagery (see also Doherty, 1999: 120–105). Consonant with this view on transgression, we can see the end of the 1950s and the early 1960s as another crucial era in representing gender issues, and queerness in particular. Homosexuality, lesbianism and other forms of sexual non-heteronormativity were usually considered to be flatly in violation of the Code's clause on sexual perversion (Gardner, 1987: 210). In the mid-1950s, any references whatsoever, be it in the form of dialogue or otherwise, to homosexual relationships were still considered to be problematic.

In the PCA archives, many examples can be found which illustrate the administration's dubious readings of queerness. In March 1955, for instance, in one of the many letters concerning *Rebel without a Cause* (Nicholas Ray, 1955), PCA boss and 'Hollywood conscience' Geoffrey Shurlock (Schumach, 1964: 42) wrote to Warner Bros., arguing that 'it is vital that there be no inference of a questionable or homosexual relationship between Plato and Jim'.[1] Some years later, when the PCA was negotiating Hitchcock's *North by Northwest* (1959), Shurlock objected that 'if there is any inference whatever in your finished picture that this man is a homosexual, we will be unable to approve it'. In this and other letters to MGM, Shurlock kept complaining that the 'flavor of homosexuality' around the Leonard character had to be removed.[2] Another oft-quoted example of the PCA's hypersensitive reaction towards homosexuality at the turn of the decade was Kubrick's *Spartacus* (1960), more specifically the bathing scene where Crassus

makes homosexual advances on his slave Anthony. The PCA had great difficulties with this scene and demanded that 'the dialogue and action "indicating" that Crassus is a sex pervert' should be cut.[3]

In the late 1950s, filmmakers began testing the limits of the Production Code in a more offensive or manifest manner. A landmark movie on the level of queer representation was the sophisticated sex farce *Some Like It Hot* (1959), where Billy Wilder explicitly thematized transvestism, lesbianism, homosexuality, same-sex desire and the performativity of gender roles. Wilder was a master at bypassing the Code, using carnivalesque parody and suggestion as a lever for ensuring that the PCA would accept the movie. Once the PCA had given *Some Like It Hot* a seal of approval, Shurlock had to defend his decision. Upon its release, Bishop McNulty attacked the film in a letter to the PCA, condemning its '"transvestism" and the consequent inferences to homosexuality and lesbianism', arguing that 'this is the most flagrant violation of the spirit and the letter of the Production Code' (Biltereyst, forthcoming). Shurlock's reaction to this complaint was that it was a 'hilariously funny movie', and he referred to the fact that 'girls dressed as men, and vice versa has been standard theatrical fare as far back as "as you like it"'.[4]

Another key picture, released in 1959, where homosexuality was explicitly thematized and where it even functioned as a narrative motor, was Joseph Mankiewicz' *Suddenly, Last Summer*. We will come back to this film later in this paper, but *Suddenly, Last Summer* sharply illustrated how ingenious filmmakers, scriptwriters (Gore Vidal and Mankiewicz) and producers (Sam Spiegel) could make the PCA accept a picture openly dealing with homosexuality. Based on Tennessee Williams' original short play, the movie tells the story of Sebastian, a gay man who ends up being killed due to his sexual desires. The filmmakers decided not to focus upon Sebastian's troubled psychological state of mind, but instead chose to tell the story from the perspective of Catherine, his niece, who unknowingly accompanied him in his search for young boys. Inspired by the PCA's objection that Sebastian's homosexuality could be 'inferred but not shown' (Russo, 1981: 116), Vidal and Mankiewicz decided not to show Sebastian at all. In the film, Sebastian finally pays for his 'sins' with his life, while the movie is surrounded with horror-like issues such as cannibalism, psychopathic sexual desire and madness.

Some Like It Hot was a comedy, of course, and *Suddenly, Last Summer* turned out to be a rather grotesque horror picture, but both films were clearly indicative of a gradual change in the PCA's policy regarding the queer imagery that was accepted within certain generic and moral boundaries. Responding to a continuing effort by filmmakers and companies to deal with issues of non-heterosexual relationships and queerness in a more adult and serious manner, the PCA clearly adopted a more tolerant approach. A landmark in this regard is the Administration's decision to weaken its position on the representation of homosexuality. In October 1961, the PCA amended the Code in order to permit movies to display 'sex aberration', so long as it was treated with care. In a public announcement, the PCA declared that 'in keeping with the culture, the mores and values

of our time, homosexuality and other sexual aberrations may now be treated with care, discretion and restraint' (Russo, 1981: 121–122).

Two crucial movies in this transgression or slowly changing representation of queerness in Hollywood cinema were *The Children's Hour*, directed by William Wyler, and Otto Preminger's *Advise & Consent*, both released in 1961. The first film was about two female teachers (Audrey Hepburn and Shirley MacLaine) who are accused of lesbianism, thereby risking their jobs and their friendship, and was based on a controversial stage play written by Lillian Hellman.[6] Wyler had already shown interest in the play in 1936, and started to adapt it into a screenplay. Because of the Production Code, he changed Hellman's plot into a heterosexual love affair, playing upon the accusations of a relationship between Martha and Karen's fiancé. As well as removing the suicide, the producers also decided to turn the title into the less controversial *These Three* (1936). These and other changes underlined the PCA's ultimate power, but even though the play's sharp edges were removed for the screen adaptation, some critics and scholars praised *These Three* for containing traces or retaining 'possibilities of secret homoeroticism' (Barrios, 2003: 183). More than twenty years later, United Artists and Wyler were ready to tackle Hellman's play less obliquely. At a time when the PCA's amendment had not yet been accepted and the performance of lesbianism was still forbidden, it came as no surprise that PCA boss Geoffrey Shurlock first wrote to Wyler that 'inasmuch as the story deals with a false charge of homosexuality between two female leads, we could not approve it under the present code regulations' (quoted in Gardner, 1987: 192). United Artists, though, which was preparing more pictures with risqué stories and images of homosexuality, immediately reacted by contacting Eric Johnson, head of the Motion Picture Association of America under which the PCA operated. The company threatened to release the picture without PCA approval, but also underlined that there would be no suggestion or clear acts of homosexuality on screen. Finally, by October 1961, the PCA gave the movie the green light, ultimately leading to *The Children's Hour*'s reputation as the film that triggered the amendment.

Another United Artists' movie that dealt with homosexuality overtly was Otto Preminger's *Advise & Consent*. Preminger had been one of the prime Hollywood filmmakers who had defied the Production Code with a series of controversial films such as *The Moon Is Blue* (1953, for reasons of sexuality), *The Man with The Golden Arm* (1955, openly dealing with drug use) or *Anatomy of a Murder* (1959, portrayal of rape, nakedness, violence). With *Advise & Consent*, which was based on the Pulitzer Prize winning novel by Allen Drury (published in 1959), Preminger added a new controversial picture to the list with which he would challenge the PCA. The production of *Advise & Consent*, which openly dealt with homosexuality in Washington DC's high political circles, was accompanied by a publicity campaign about breaking the code. Released only three months after *The Children's Hour*, the film also contained a suicide caused by a false accusation of homosexuality (a politician is blackmailed by an opponent on

the basis of a supposed homosexual encounter in his past). The picture also notably contained the portrayal of a gay bar, including the whole (until then unknown or never shown) atmosphere of a hidden subculture (Russo, 1981: 141). Although the film had received an official seal after the new code amendment, as well as a sufficient amount of publicity and critical attention, *Advise & Consent* turned out to be quite disappointing at the box office (Barrios, 2003: 314). Whether this was related to the representation of queers is not relevant to this article, but by 1962 Hollywood pictures dealing with matters of homosexuality, lesbianism or any other portrayal of non-heterosexuality still seemed to be confined within the boundaries of genre (an aura of horror, comedy, etc.) and morality (punishment, negative tone). However, given the slow change in the production codes in terms of representing queerness, one might question whether these pictures had to be read so negatively.

The queer is dead (long live the queer)

Transitional queer movies such as *Suddenly, Last Summer*, *The Children's Hour* and *Advise & Consent* have often been regarded as representing homosexuals as pitiful and self-loathing. Yet, following the work conducted by scholars such as Doty (2000) on more subtle, complex and 'non-straight' readings of texts, we would like to analyse the three films in a more positive, destabilizing sense. More specifically, we would like to illustrate how these pictures can be seen as spaces of queer resistance in which queer characters are portrayed in an emancipatory light.

It should be acknowledged that these films all feature gay characters whose bodies are used as discursive articulations which deconstruct dominant notions of queerness. Yet, they differ from one another in the actual materialization of these bodies. *Suddenly, Last Summer*, for instance, does not even feature a 'living' queer character, as Sebastian is already dead at the beginning of the movie. He is only present through the stories of his family and once as a vague character in a visualization of his niece's memory. And even in this memory he is not granted a face and nor is he included in the end credits. Sebastian is merely a queer phantom, whose representation depends on his family's remembrances and his personal belongings. *Advise & Consent* and *The Children's Hour* on the other hand do credit actors who portray queer characters. Indeed, both queers are the main characters and are represented by well-known performers (Shirley MacLaine as Martha in *The Children's Hour*, and Don Murray as Brigham in *Advise & Consent*). These films not only granted queers a face, but let queer roles be performed by good looking young actors. In a similar way, Martha is neither predator nor butch, whereas Brigham does not correspond to the stereotypically effeminate pansy. In contrast, *Suddenly, Last Summer*'s Sebastian could be interpreted as a more clichéd dandy. In a way he lives up to a stereotypical image of the queer that is not being countered as he

remains faceless, whereas Martha and Brigham are more non-stereotypical 'everyday' characters who function as a negation of dominant stereotypes. Martha is introduced as a caring and devoted teacher, who runs a private school with her best friend Karen (Audrey Hepburn). The opening sequences show the women to be very much alike. Both are feminine yet do not appear to be passive. Furthermore, they run a successful private school on their own.

Similarly, Brigham is portrayed as a masculine, ambitious and self-assured senator who (to an even greater extent than the character of Martha) is portrayed as a rather powerful member of a heteronormative society. Brigham is a happily married man and father, living in an expensive house in suburbia. Sebastian, in contrast, is quickly set outside the borders of heteronormativity. His mother talks about him in terms of being 'different', and even though she utters it with pride, he is constructed as the 'Other' from the beginning of the movie. We also come to learn that Sebastian used to live in the *garçonnière* in the back garden of his mother's mansion, where he could meet his friends in private. He is also portrayed as a poet who did not need to work for a living. These elements are used to reiterate the idea of Sebastian as an outsider.

Whereas Martha is handed the responsibility of teaching children and Brigham is chosen by the state to function as its representative in the Senate, Sebastian does not 'participate' in society. By rendering him physically almost invisible throughout the film, the erasure is nearly complete. As such, whereas Sebastian is kept in the margins, it seems that *The Children's Hour* and *Advise & Consent* feature 'queer' characters who are fully integrated in society and, on a more cinematographic level, in the film. In this respect we should point to the fact that the sexual identity of the three queer characters is initially constructed as asexual or heterosexual, perhaps as a postponement of their queer desire.

Each film actually chooses to use a clear and straightforward love plot on queer desire that structures the narrative. *The Children's Hour* introduces the story by focusing on the reaction of society towards homosexuality prior to Martha coming out. The film starts with one of the pupils spreading a rumour about her teachers being lovers. It then depicts the misery brought to the women as a result, with consequences such as mockery, the loss of a lawsuit and the retreat of the children from the school. The rumour even affects Karen's fiancé, who is fired from his job as a doctor as a result of his connection to the two women. It is remarkable that those who resent the queers seem to have never met them. Accordingly, they are resenting the unknown. And even though it is never stated as such, those who represent society in the film tend to assume despicable perversion when thinking of the women as lesbians. In the coming out scene at the end of the movie, it is revealed that the 'everyday' character Martha is indeed harbouring homosexual feelings for Karen. But society does not seem to need a queer truth, since it trusts one girl's statement to reinforce its opinions based on hegemonic notions of queerness. The latter clearly appears in scenes where the mothers send their husbands to school to fetch the

children in order to avoid physical contact with the women, while the husbands avoid eye contact with them. The avoidance of any 'physical' confrontation with queerness can be read as necessary so as to avoid dissonance in their opinions inspired by hegemonic notions concerning homosexuality. Martha even mocks the stereotypical imagery when she says to the staring grocery boy: 'I've got eight fingers, you see. And two heads, I'm a freak!' Yet, the film itself does not avoid the queer and relocates it onto one of its main characters. Before Martha comes out of the closet, the picture depicted the inordinate societal consequences of being thought of as gay. However, by queering Martha, the audience becomes involved, since the queer is no longer constructed as the invisible Other but as a subject.

Advise & Consent similarly constructs the queer as a subject in order to defy society. But whereas (the thought of) being gay was more central to the plot of *The Children's Hour*, *Advise & Consent* primarily focuses on a scandal concerning a man named Leffingwell who is nominated by the president as secretary of state. Brigham is a senator belonging to the Presidential Party who is selected as chairman of a subcommittee that has to decide whether to oppose or support the nomination. When the controversial nominee is accused of being a communist, the chairman delays making the decision. This forces the pro-Leffingwell senator, Van Acker, to anonymously blackmail Brigham about something that happened in the latter's past, which will gradually be revealed as an affair he had with another man in Hawaii. Again, queer identity is stalled. But whereas *The Children's Hour* more directly discussed the position of society towards queers, this film mimics society's point of view by not daring to speak its name. The gay secret is only uncovered by small plot elements such as Brigham asking his secretary for the address of a man named Ray Shaf with whom he was stationed in Hawaii. Another scene in which the queer secret is unveiled takes place in New York City where we are introduced to Ray, portrayed as a queer man in a gay bar, who seems to have been close to Brigham. A further scene of this kind occurs when Brigham's wife receives a photograph of her husband and another man, presumably Ray, accompanied by a good-bye letter from Brigham to his male lover. Even though Brigham is not physically present in the scene, this confession functions as a coming out.

Similar to *The Children's Hour*, Preminger's picture focuses on the relationship between queers and society. Aside from the fact that the gay affair comes across as being worth a blackmail operation, it was also considered by the character of Senator Van Acker as one man's 'Achilles heel'. As such, the deviancy surrounding the New York City gay scene in the film can be read as part of a dominant discourse that looks upon queers as the weak spot of society, directing them to the margins. At this point, the film has created Brigham as a subject, and he internalizes society's fear due to his inability to tune his queerness in with his other identity traits, including high social status. The character's inability to transgress the dominant notion of incompatible identity traits eventually leads to suicide. Accordingly, both films represent a homophobic society that opposes

queerness on the one hand, but clearly feature queer subjects who are part of that society on the other. Using this more complex, even dialectical position on rejecting but also performing queerness, these films clearly criticize a society where notions of identity are, or seem to be, stable. Consequently, the movies also denounce ideas that equate queerness with deviancy from what is considered to be normal behaviour.

Suddenly, Last Summer, in contrast, lacks such a queer subject. Here, the gay character has died before the film even begins. Still, the movie succeeds in incorporating queerness as a core plot element. The question here is whether an absent queer character can evoke a similar societal critique. We have already argued that Sebastian is only described by his family, and the audience therefore depends on their testimonies to get to know him. The movie's plot is completely focused on Catherine (Elizabeth Taylor), the sick niece of Violet Venable (Katharine Hepburn). The film further introduces a doctor named Cukrowicz (Montgomery Clift), who is invited by Violet to talk about her niece. Even though the first dialogues construct Sebastian as different, the film does not use queerness as a plot element and thereby 'delays' the explanation of otherness. Moreover, the film never constitutes queerness and instead uses metaphors and queered accessories to construct Sebastian as a gay character, namely in the following scene where the mother and the doctor find themselves in the *garçonnière*. As well as their conversation, the camera focuses on the decoration of the main room where they are talking. Mankiewicz shows a picture of a naked black man, posters and drawings of other nudes, as well as a statue of a male torso and a huge painting of Saint Sebastian. Whereas the film lacks a physical queer character, the gay iconography on display seems to replace the 'missing' queer body. It also allows us to read these artefacts as expressions of queer desire. Even though the queer body is missing, the queer desire that comes from the body is still on display. The movie even starts by showing the objects of affection in his private room, which are affirmed as such in Catherine's confessions. Halfway through the film she happens to remark that Sebastian was 'fed up with the dark ones, famished for the light ones', which could imply a changing taste for men. His homosexual longing is also illustrated when Catherine reveals to the doctor that she and Violet were procuring men for Sebastian on their holidays, but she says it implicitly: 'We were decoys. He used us as bait. We procured for him.'

The societal critique of the film is embedded in the impossibility of expressing this desire. This becomes poignant in the final sequence in which Catherine retells what happened during the holiday when Sebastian was murdered. Although this sequence has been much analysed in terms of cinematography, editing and with regard to its portrayal of cannibalism (for instance, Ohi, 1999), it is also a pivotal moment in the queer representation of Sebastian. A visualization of Catherine's memories is simultaneously encompassed in the shot that frames her in a close-up. It is in her traces of memories that the audience 'sees' Sebastian, albeit with an invisible face. Whereas they emphasize his physical body, these scenes also function as a dialogue between his desiring body

and the frustration that this desire cannot be materialized. We are faced with an isolated man who needs women to 'procure' men for him on the beach and who is faced with unrequited love as the men are only physically interested in Catherine, as illustrated by the shots of them gazing at her wet bathing suit. Sebastian eventually uses his wealth to keep the men interested in him, but this already unsatisfying situation culminates in the cannibalistic scene in which he is colonized by troupes of men who, craving his wealth, eventually devour him.

Not only does *Suddenly, Last Summer* end with the death of Sebastian, *Advise & Consent* and *The Children's Hour* also perform the suicide of their queer characters. Vito Russo (1981) has analysed these self-destructions, constructing them as essential to the films' depiction of homosexuality as evil. Although Russo's reading is evident on the basis of the rudimentary plots, it should also be acknowledged that the reasons for self-destruction are constructed as being located outside the 'queer'. Death can be read as the most absolute act of queer resistance against a system in which the non-normative is not even able to 'breathe'.

Conclusion

> Ellen: 'If they are threatening you through me, it can only mean one
> thing; it's about a woman, isn't it?'
>
> (*Advise & Consent*, 1962)

During the late 1950s and the beginning of the 1960s, mainstream cinema defied the PCA as more and more films were being distributed that transgressed the boundaries of the Code. *Suddenly, Last Summer, The Children's Hour* and *Advise & Consent* were among the first to openly portray queer characters and thematize their desires, which had long been regarded by the PCA as sexual perversion. Although by 1961 the PCA had attenuated its position on this point, leading to the emergence of more adult-orientated movies performing queerness, the depiction of homosexuals still continued to be quite negative and punitive. Despite this situation, as we have tried to indicate, films such as *Suddenly, Last Summer, The Children's Hour* and *Advise & Consent* contained images or traces of resistance against a heteronormative society. Drawing upon queer theory and using textual analysis, we have tried to examine queerness in terms of exposing a societal critique. Here, we first referred to the structure of these films, where the queer plot element was used to elaborate on the issue of how society deals with this issue. Secondly, we indicated how each film used its queer characters to oppose stereotypical imagery concerning the queer body. The queer subjects presented were also used to contradict dominant discourses on homosexuality, while the idea of a queer phantom was utilized to underscore the impossibility of an exclusively heterosexual society. The three movies do not openly justify

the queers' deaths, nor do they argue that queer subjectivity should be equated with self-loathing or self-pity. On the contrary, the movies show the ultimate consequences of being part of a homophobic society. Moreover, even though these films depict a society that tries to exclude queerness, the role of the queer phantom in *Suddenly, Last Summer* illustrates the impossibility of erasing the queer, as the dead character and his queer desire are similar to ghosts which are continuously present throughout the picture.

Endnotes

1. See letter by Geoffrey Shurlock to first name Warner, 22 March 1955, PCA file on *Rebel without a Cause,* Margaret Herrick Library, PCA collection, Los Angeles.

2. See letter by Geoffrey Shurlock to first name Vogel, 23 September 1958, PCA file on *North by Northwest,* Margaret Herrick Library, PCA collection, Los Angeles.

3. See letter by Geoffrey Shurlock to first name McTaggart (Universal), 29 September 1958, PCA file on *North by Northwest*, Margaret Herrick Library, PCA collection, Los Angeles.

4. See letter by Geoffrey Shurlock to Rev. first name Little, 18 March 1959, PCA file on *North by Northwest,* Margaret Herrick Library, PCA collection, Los Angeles.

6. The play premiered in 1934 and ran for two years on Broadway and elsewhere.

References

Barrios, R., *Screened Out*, London, Routledge, 2003.

Benhabib, S., Butler, J., Cornell, D. & Fraser, N. (eds), *Feminist Contentions: A Philosophical Exchange*, New York, Routledge, 1995.

Biltereyst, D., 'Censorship, negotiation, and transgressive cinema: Double indemnity, *Some Like It Hot* and other controversial movies in the USA and Europe', in K. McNally (ed.) *The Billy Wilder Reader*, Jefferson, McFarland Publishers, 2009: in press.

Butler, J., *Gender Trouble: Feminism and the Subversion of Identity*, London, Routledge, 1990.

Creekmur, C.K. & Doty, A. (eds), *Out in Culture*, Durham, NJ, Duke University Press, 1995.

De Lauretis, T., *Technologies of Gender*, Hampshire, MacMillan Press Ltd, 1987.

De Vos, P. & Van Bauwel, S., 'Essentialisme en politieke identiteit: De impasse van een feministische probleemstelling', in A. Van den Brande (ed.) *Identiteiten. Functies en dysfuncties*, Gent, Academia Press, 2002, pp. 83–106.

Dhaenens, F., Van Bauwel, S. & Biltereyst, D., 'Slashing the fiction of queer theory: Slash fiction, queer reading, and transgressing the boundaries of screen studies, representations, and audiences', *Journal of Communication Inquiry*, 32:4 (2008), pp. 335–347.

Doherty, T., *Pre-code Hollywood: Sex, Immorality, and Insurrection in American Cinema, 1930–1934*, New York, Columbia University Press, 1999.

Doty, A., *Flaming Classics*, New York, Routledge, 2000.

Foucault, M., *Histoire de la sexualité, vol. 1: La volonté de savoir*, Paris, Gallimard, 1976.

Gardner, G., *The Censorship Papers. Movie Censorship Letters from the Hays Office, 1934–1968*, New York, Dodd, Mead & Company, 1987.

Gross, L., 'Minorities, majorities and the media', in T. Liebes and J. Curran (eds) *Media, Ritual and Identity*, London: Routledge, 1998, pp. 87–102.

Jenkins, H., *Textual Poachers*, New York, Routledge, 1992.

Katz, J.N., *The Invention of Heterosexuality*, Chicago, University of Chicago Press, 1995.

Lugowski, D., 'Queering the (new) deal: Lesbian and gay representation and the depression-era cultural politics of Hollywood's Production Code', *Cinema Journal*, 38:2 (1999), pp. 3–35.

McIntosh, I., *Classical Sociological Theory*, Edinburgh, Edinburgh University Press, 1997.

Ohi, K., 'Devouring creation: Cannibalism, sodomy, and the scene of analysis in *Suddenly, Last Summer*', *Cinema Journal*, 38:3 (1999), pp. 27–49.

Russo, V., *The Celluloid Closet*, New York, Harper & Row Publishers Inc., 1981.

Schumach, M., *The Face on the Cutting Room Floor: The Story of Movie and Television Censorship*, New York, William Morrow, 1964.

Sedgwick, E., *Between Men*, New York, Columbia University Press, 1985.

Seidman, S., 'Deconstructing queer theory or the under-theorization of the social and the ethical', in L. Nicholson & S. Seidman (eds) *Social Postmodernism*, Cambridge, Cambridge University Press, 1995, pp. 116–141.

Seidman, S. (ed.), *Queer Theory. Sociology*, Cambridge, Blackwell, 1996.

Stein, A., & Plummer, K., '"I Can't Even Think Straight": "Queer" Theory and the Missing Sexual Revolution', in S. Seidman (ed.) *Queer Theory. Sociology*, Cambridge, Blackwell, 1996, pp. 129–144.

Warner, M., *The Trouble with Normal*, Cambridge, Harvard University Press, 1999.

White, P., *Uninvited: Classical Hollywood Cinema and Lesbian Representability*, Indiana, Indiana University Press, 1999.

CHAPTER SIX:
POLITICAL BLOGGING: AT A CROSSROADS OF GENDER
AND CULTURE ONLINE

Olena Goroshko and Olena Zhigalina

Introduction

With the increase in the popularity of the internet and its impact on social development, research into the changes it has brought about is becoming more important. Indeed, the internet generates such a wide variety of new phenomena of both a social and psychological nature, such as virtual personas, virtual communities, virtual offices, e-societies and e-governments, that studies of its influence is some of the most crucial work taking place today.

The term 'cyber-politics' was recently coined by a number of academics and politicians (among them Kevin A. Hughes, John E. Hill, Tom Price, Ed Schwartz and W. Van DeDunk), and is being widely employed across the world to analyse internet use in terms of political activity (Perlmutter, 2008; Rozel & Semiatin, 2008). The concept embraces all forms of social software, including journalism, fundraising, blogging, volunteer recruitment, voting, campaigning and organization building. The net is becoming a more prominent venue for the airing of any political issue and agenda, and with each election the use of the internet reveals itself as an increasingly important way for key political actors (candidates, opinion leaders, political influentials and office-holders) to communicate with constituents, citizenry and the public at large (*Political Influentials*, 2004).

Political blogging

A great variety of web genres are used for political communication on the internet, including emails, discussion groups, webpages, blogs and online news groups. All contain cutting-edge opportunities provided by web 2.0 technologies. While analysing perspectives and issues of online media research, it is notable that blogs have received far less scholarly attention than other forms of computer-mediated communication (CMC) (e.g. personal websites). This lack of interest is even more pressing with regard to the non-English speaking internet (Goroshko & Zhigalina, 2009; Khitrov, 2005; Kluver et al., 2007). Of all of the genres used in cyber-politics, blogs in particular are a cheap and convenient tool via which opinion leaders can disseminate and update useful information, while simultaneously and quickly providing expertise, networking and material incentives to consolidate a constituency and complete a political campaign (Tremayne, 2007).

Barbovschi (2008: 2) argues that a working definition of the political weblog might include the unedited voices of political actors, specialist/conventional journalists (i.e. individuals with journalistic credentials and an affiliation to a traditional media outlet), opinion leaders, politicians, politically informed non-journalists (i.e. non-journalist individuals who blog extensively on various political topics) and popular bloggers.

One could argue that opinion leaders, informal leaders or influentials have much more impact than official political functionaries when it comes to disseminating information, arguments and a particular mentality (*vox populi*) on the internet. The opinion leader is an individual who acts as an intermediary, agent or active media user who interprets the meaning of media messages or content for lower-end consumers thereof (readers of blogs who constitute their target audience, e.g. friends' lists). Usually, the opinion leader is held in high esteem by those who accept his or her points of view and, accordingly, he or she has more authority and influence than politicians in a network society. The ability of an actor—be it a company, individual, government or other organization—to participate in the network is determined by the degree to which he or she can contribute to its goals. Moreover, this new environment requires skilled, flexible actors for any form of social communication, including cyber-politics (Castells, 2000: 12).

Why opinion blogs have been selected for our research
Although there has been a tendency to see personal campaigning as being concentrated in presidential political systems, where individuals are directly elected to high office (Stanyer, 2008; Papacharissi, 2004; Trammell, 2004), there is a widely observed trend towards such an approach in parliamentary democracies. Party leaders have assumed an increasingly central position in their parties' campaigns for office, and have come to embody their respective parties and dominate national media campaigns. At the same time, there has been a move towards greater self-disclosure by these leaders as well as an increase in personal attacks on their rivals.

Candidate-centred or personal campaigning is an increasingly common feature of elections in many democracies (Stanyer, 2008). The term usually refers to two key developments in electioneering, namely the degree to which leading political actors, rather than their parties, have become the visible focus of election campaigns, and the extent to which personal information and imagery about a candidate or party leader, rather than policies, have become a major element of such contests. While the first trend can be seen most clearly in presidential elections in the United States, where candidates use electronic media 'to sell' themselves to voters, the second encompasses candidates' biographies, appearances, beliefs, tastes, values and any past or current misdemeanours; in other words, any information about the candidates themselves, rather than their records or what they propose to do if elected. Accordingly, it is clear that political blogging has become an integrated part of candidate-centred campaigning, both on and offline.

The following question then arises: 'Why has the blogosphere assumed such an important role among other types of political media (which represent communication vehicles owned, ruled, managed or otherwise influenced by political entities aiming to propagate the latter's views)?'

We aimed to find an answer to this question:

- First of all, blogging is an extremely effective instrument for social networking. This makes it indispensable for online campaigning and personal image promotion.

- Blogging also allows for an alternative form of direct and informal communication that does not rely on the official (sometimes politically biased) mass media.

- Simultaneously, the personal blog is a platform that can be used for advocacy, i.e. to make people aware of impending congressional votes and to encourage them to call or email their representatives.

- Additionally, the blog provides information, the opportunity for fundraising, and the platform for lobbying for legal action, identifying potential party members or consolidating political audiences and partisans.

- Blogs are gradually being used not only as a means of self-advertisement, image-promotion or for consolidation of political efforts, but they are also a helpful tool for professional communication of any kind, especially in terms of constituency consolidation and the organization of voluntary-based activities by ordinary citizens (Tremayne, 2007).

Gendered blogging

The research conducted by Calvert and Huffaker (2005) examines online identity and language use among male and female teenagers who created and maintained weblogs. Online identity and language use are investigated in terms of the disclosure of personal information, sexual identity, emotive features and semantic themes. The study reveals that both groups presented themselves similarly in their blogs, often revealing personal information such as their real names, ages and locations. It was also found that males, more than females, used emoticons, employed an active and resolute style of language and were also more likely to present themselves as gay. These data contrast with other results where the intensive use of emoticons is fixed as a female computer-mediated communication (CMC) characteristic (Witmer & Katzman, 1997; Wolejszo, 2003).

In Huffaker's MA thesis (2004), bloggers' identities were studied in terms of the disclosure of personal information, online name choice, avatar selection and emotive features, common blog topics, blog characteristics, blog abandonment rates and frequency of use. Language use was also explored with regard to word counts and semantic themes. The data obtained again show that teenagers reveal a considerable amount of personal information in their blogs, including their name, age and location, as well as contact details in the form of an email address, an instant messenger moniker or a link to a personal homepage. The content of the blogs typically reflected what is expected to have an impact on a teenager's life, such as school, intimate relationships, sexual identity and even music. Contrary to the author's prediction, the results revealed that there are more gender similarities than differences in blog use. However, some gender variations were noted in terms of emotive features, sexual identity, language use and components of personal information. Males average more emoticons in their posts than females, and they also reveal their sexuality more often, commonly expressing their sexual identity or 'coming out'. Moreover, males disclose their location more often than females, while women present a link to a personal website more frequently. Finally, males use more active and resolute language in their blogs than females do (Huffaker, 2004: ii–iii).

Nowson's attention also turned to gendered blogging, where quantitative methods are exploited to research gender differences in language use. The data demonstrate that women are found to write more in their blogs than men. More generally, and using the British National Corpus, it is also revealed that women are more contextual, except in the least contextual of genres (academic writing) where there is no difference between the sexes. 'The study concludes by confirming that both gender and personality are projected by language in blogs; furthermore, approaches which take the context of language features into account can be used to detect more variation than those which do not.' (Nowson, 2006: iii)

The Perseus Survey of 4.12 million hosted weblogs testifies that most of them are seldom seen and are quickly abandoned; men 'skip' blogs more often than women, while

women create them much more frequently than men (The Blogging Iceberg, 2004: 5).

Pedersen and Macafee (2007) asked whether blogging in the United Kingdom, which started later than in the United States, reproduces the gender differences in blogging behaviour and the gender inequalities in recognition that have been observed in research based largely on US bloggers. They studied 48 female and 48 male British bloggers in terms of their blogging practices and attitudes. Their work revealed that blogging is mainly a leisure practice for both men and women, and both sexes experience the same range of satisfaction from the activity. Simultaneously, more women use blogging as an outlet for creative work, whether as a hobby or a livelihood. The results obtained completely confirm the hypothesis that the gender differences found in earlier, mainly US, studies are replicated in the British context. According to Pedersen and Macafee:

> the evidence found supports several of the reasons that have been advanced in the past for the lower profile of women bloggers: more personal content and orientation towards the social aspects of blogging, as opposed to a male emphasis on information; lesser technical sophistication; and a greater preference for anonymity. (2007: 1)

An analysis by Schler et al. (2005) of a corpus of 10,000 blogs, covering nearly 300 million words, revealed significant differences in writing style and content between male and female bloggers, as well as among authors of different ages. Such differences can be utilized to determine an unknown author's age and gender on the basis of a blog's vocabulary. The sample of bloggers was formed taking into account a variety of demographic features. The study reveals that teenage bloggers are predominantly female, while older exponents are almost always male. Moreover, within each age group, male and female bloggers write about different things and use different blogging styles: male bloggers of all ages write more about politics, technology and money than their female counterparts. In their turn, female bloggers gossip about their personal lives, and use a much more personal writing style than men do. The authors conclude that 'for bloggers of each gender, a clear pattern of differences in content and style over age is apparent' (Schler et al., 2005: 5).

The authors also argue that in spite of gender, 'writing style grows increasingly "male" with age: pronouns and assent/negation become scarcer, while prepositions and determiners become more frequent' (Schler, 2005: 7). Additionally, they consider that blog words present a definite hallmark of youth, while hyperlink usage increases with age. Content also evolves with age in ways that could have been anticipated (Schler, 2005).

These data run contrary to Herring and Paolillo's (2006) results, where no correlation was found between bloggers' gender, content and writing style.

Gendered political blogging

As for gendered political blogging, the examination conducted by Harp and Tremayne (2006) testifies that only 10 per cent of the top bloggers are female. A discourse analysis of bloggers' explanations of gender disparity revealed three dominant reasons for this:

- women don't blog about politics;

- female blogs lack quality; and

- top bloggers do not link to women's sites.

Authors have exploited network and feminist theory to interpret these findings and offer recommendations for increasing the representation of female voices in the world of internet political blogging (Barabási, 2002; Barabási & Albert, 1999; Watts, 2003; Kramarae 1998).

Culture and political blogging

The theoretical analysis of work in the fields of internet studies, CMC and internet linguistics reveals that this topic has been successfully studied when it comes to the English-speaking internet, but is still under-researched in a non-English-speaking context (i.e. the Russian-speaking internet, coined in this work as the Slavic web) or from a comparative perspective. CMC and internet research findings also reveal that the internet is not a culturally neutral medium: there are a great number of differences in information presentation, interaction and design, etc. that are conditioned by culture and language (Danet & Herring, 2007; Herring, 2007; 2008b). It is for this reason that cross-cultural, comparative research is proposed to investigate the peculiarities of political blogging on the net. It is necessary to add that almost no work in this area within the Slavic context has been conducted (Goroshko, 2008). Thus, comparative research may not only advance the Western paradigm of the developments in cyber-politics in terms of cutting-edge opportunities in online campaigning, but might simultaneously provide the foundation upon which to advance this discipline beyond an English-speaking knowledge area.

Intersectionality on the net

There is much debate in both gender studies and the social sciences in general about the nature and perception of gender. One of the latest approaches in this area is based on the notion of *intersectionality*. This supposes that gender lies at the crossroads of social

factors such as power, class, race and nationhood. Gender is thus presented as being the result of convention and strongly conditioned by these factors (Cranny-Francis et al., 2003). These views on gender have influenced the most recent ideas regarding gendered virtual and cultural political communication, as well as identity issues (Goroshko, 2006; 2008; Goroshko & Zhigalina, 2009).

Research design

The aim of this study is to elucidate the effectiveness of political communication through blogging on the Russian and English-speaking internet and to explore a possible link with gender.

A weblog is defined in this study as a webpage with minimal to no external editing, which provides an online commentary that is periodically updated and presented in reverse chronological order, with hyperlinks to other online sources.

Our research examines the content and features contained in blogs in terms of interactivity, linguistic design and structure. It is assumed that the spirit of interactivity is fostered through text messages and technical features (Trammel et al., 2004; 2006). The study reveals that a modern campaign requires not only cutting-edge and issue-driven websites, but also sites which offer interactivity and invite user participation (Trammel et al., 2004: 240).

Our blog sample was retrieved from political blogging directories, and comprises twenty blogs. We used a rating criterion for the Russian-speaking net to select the necessary sample. The full list of researched blogs can be found In Appendix 1 at the end of this chapter. They can be summarized as follows:

- five English-speaking male blogs (US and UK opinion leaders);

- five English-speaking female blogs (US and UK opinion leaders);

- five Russian-speaking male blogs (Russia, Ukrainian and Byelorussian opinion leaders); and

- five Russian-speaking female blogs (Russia, Ukrainian and Byelorussian opinion leaders).

This study uses the quantitative content analysis webstyle method to review blogs located on the political internet. Webstyle is a content analysis tool that is often used to examine website content in political campaigning (Banwart, 2008; Herring 2008a). The approach is a direct adaptation of the videostyle methodology, which consists of

a 'systematic instrument for analysing [the] self-presentation style' of candidates in advertisements (Banwart, 2008: 10). Accordingly, the method is grounded in Goffman's (1959) ideas of self-presentation and is used to review how candidates seek to 'personalize' themselves to the voters. The use of webstyle allows for the examination of the interactive capabilities of blogs as well as an analysis of the blog owners' organization of the targeted virtual community and the way that this has an impact on their constituencies. Specifically, the verbal content analysed in webstyle includes the textual, video and audio elements available on the website (Banwart, 2008). The verbal categories to be examined include the issues addressed, the use of negative attacks and appeals, candidate characteristics and the identification of office and party affiliations.

The non-verbal content investigated includes the photographs of the candidate and others that can be found on the blog site. Non-verbal categories cover the images' settings, who is pictured, eye contact, facial expressions, body movement/posture and attire, while production categories examine the presence and type of graphics featured on the website (ibid.). Blog colour palette is also analysed, and Page Rank and Alexa Traffic Rank indicators are counted with the purpose of 'measuring' a blog's relative importance and popularity on the net, as well as its availability to ordinary internet-users.

Structural blog characteristics and formal indicators of interactivity are traced and analysed by looking into factors such as the presence of an archive within the blog, the number of comments per post and the number of friends a blog owner has (Herring et al., 2004). A list of examined blog features is contained in Appendix 2.

Results and discussion

The study of political blogging reveals that male political blogs dominate; just as in real life, there is a prevalence of male-dominated political discourse both on the Russian- and English-speaking internet (Goroshko, 2006; 2008). Content analysis of blog rubric titles reveals that 70 per cent of male and female titles are identical. However, there is a wider diversity thereof in the English political blogosphere (see blogs by Iain Dale, Virginia Foxx or Arnold Schwarzenegger) than in the Russian domain. It is interesting that the English sample blogs contain rubrics which present their owners in different social and political roles which clearly indicate their party identity. This is almost completely absent on the Slavic net. Furthermore, English blogs maintain such rubrics as *multimedia, interact* and *donate* (Arnold Schwarzenegger or Rick Perry blogs) as a way of attempting to elicit concrete actions from visitors.

The study of thematic feelings and imagery on the websites examined herein shows that male political blogs use more self- and member-centred approaches to the information posted online. This situation is especially pronounced in the English-speaking blogosphere. Male political blogs also seem to be more conceptual, entailing a clearer

and more efficient formulation of mission statements and objectives, the principles of social activity, as well as comments about and analysis of everyday political and public events. However, when compared to female blogs, they are seen as being more boring and excessively politicized. The information on male pages recalls the motto, 'It is more important to present yourself instead of lending an ear to somebody.' Men underscore the distance between the elected official and the visitor. This pattern is particularly evident in their biographies and descriptions of activities.

Our analysis also revealed tendencies to focus on the accomplishments and professional success of members in very reserved and formalized ways. Also common is the selection of photographs (which occupy a large amount of space) where the figure of the male blog owner is set against images of the national landscape or the ordinary electorate. Sometimes, other VIPs surround this figure. Our data completely confirm the results obtained by Jarvis & Wilkerson (2005: 10). These authors explored the World Wide Web homepages of members of the US House of Representatives from 1996 and 2001, examining content, structure and congressional photographs. Testifying that: 'in 1996, almost all of the photos were suit-and-tie headshots in front of U.S. flags or the Capitol, a trend still evident in 90% of the sites five years later' (ibid.), they argue that emphasis on the congress member in the biography and images contributes to member-centered sites, and that office-holders pay less attention to the visitor than in other related forms of communication. This choice thus, allegedly, emphasizes the trappings of the office, signifying the position of the representative rather than his or her relationship with constituents (ibid.).

Male bloggers also exercise more symbolic capital in their blogging practices, which becomes apparent in the blogs of key political office-holders and speakers (Medvedev, Obama and Pelosi). There is a list of instructions on Dmitrij Medvedev's blog about how to blog properly. The list of friends also serves as an original moderator, allowing or not allowing comments on the post.

The most popular and visited blogs are the property of high-office holders and celebrities. Those by Obama, Pelosi, Schwarzenegger and Medvedev have the highest Page Ranks, equating to six or seven. (Page Rank is a link analysis algorithm used by the Google internet search engine. It assigns a numerical weighting from zero to ten for each webpage on the internet, with the purpose of 'measuring' its relative importance. In other words, this Page Rank denotes a site's importance in the eyes of Google.)

The research conducted indicates that English-speaking political bloggers (opinion leaders) are more open to the public than their Russian counterparts. The information provided in such blogs is also much more personal and open to ordinary citizens. As for gender-balanced personal information, only Arnold Schwarzenegger's blog contains details 'About Arnold' and 'About Maria'. In turn, the information about Maria (first lady of California) is more diverse and voluminous than that concerning her husband, containing sections such as *WE Serve*, *WE Empower*, *WE Inspire* and *WE Include*.

Figure 1: Arnold Schwarzenegger's blog maintaining the rubric *About Maria*

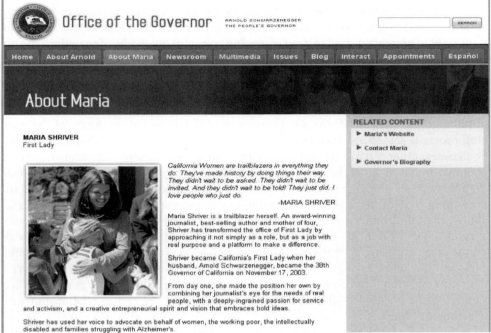

As for graphical objects, there are more photos and images in the English-speaking blogs. There is no gender difference in the use of graphics containing complicated web designs, logos, etc. Only party cues are registered in this research, and this feature is also more pronounced in English-speaking male blogs, being attributable to a member-centred strategy for presenting political information online, which has also been noted in previous studies (Jarvis & Wilkerson, 2005; Goroshko, 2008).

Moreover, English-speaking blogs can be viewed as an integrated part of the virtual political office and not as a separate diary on the net. For example, Dmitrij Medvedev's blog has no links to either his personal homepage (if it exists at all) or official Kremlin portals. In contrast, male English-speaking bloggers demonstrate a deep immersion in virtual surroundings. The Barack Obama blog demonstrates this perfectly.

The differences between two political blogospheres—English and Russian—can also be seen. On the whole, the structural analysis of English blogs reveals that their rubrics typically include the following items: *News, Biography, Photo Gallery, Speeches,*

My Position, Elections, Hot Topics, More about Me, etc. Indeed, the number of rubrics frequently exceeds twenty. Russian blogs, on the other hand, only maintain the rubrics suggested by the blogging software utilized, and their number is kept to a minimum. English blogs also include more rubrics concerning legislation, state and political concerns, as well as constituent services. However, the information content analysis of these English blogs reveals that the site audience is required to understand the inner workings of Congress.

Russian blogs contain more issues (posts) and comments and there are fewer links to external internet resources. These results stand in sharp contrast to the Russian political net, and might be explained by the influence of the national political culture or the peculiarities of local cyber-politics. Nevertheless, the Russian blogosphere looks increasingly user-friendly, but further research is required to clarify this point.

Figure 2: Barack Obama's blog start page with *Obama Everywhere* section

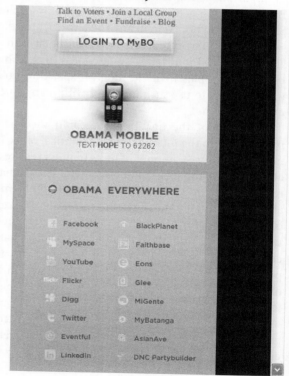

It is common for English political sites, in contrast to the Slavic internet, to contain a blog kids' page, with entertaining and educational information for children and their parents. By placing this rubric on the website, the blog owner is obviously emphasizing values such as family, home and children, thereby providing a positive image of him/herself as a respectable member of a particular community. This rubric also helps to attract a much more age-differentiated audience, which includes children and teenagers.

In Slavic blogs this information is almost completely lacking. It is also surprising that in contrast to the Slavic political blogosphere, the English version displays great sensitivity to different age groups and their problems. The Arnold Schwarzenegger or John Boozman blogs are the best examples of sites which contain information about how to care for generations from young to old, with such rubrics as: *Budget, Jobs and the Economy, Education, Energy and the Environment, Health, Military and Veterans, Public Safety, Water Management and Levees* (Arnold Schwarzenegger's blog) *or 3rd District Issues, Agriculture, Education Reform, Faith-Based Organizations, Health Care, Homeland Security, Illegal Drugs, International Relations, Iraq, Job Creation, Medicare, Prescription Drugs, Protecting the Ozarks, Retirement Security, Second Amendment, Tax Relief, Trade, Transportation, Values Legislation, Veterans' Affairs, War on Terror, Water Quality* (John Boozman's blog), etc. There is effectively only a cultural and not a gender gap in this area: Slavic blogs do not contain any socially orientated information at all.

Another unexpected revelation was that only Slavic politicians (Russian female) allow the use of four-letter, swear words in their blogs (see, for example, Darja Mitina's blog start-up page). In the English-speaking political environment, it is considered inappropriate to use such language within any sort of civilized discourse, including the political internet.

As for links, the qualitative research shows that English-speaking blogs are well integrated into the internal (virtual political office [portal] of their owners) and external net. There is a vast amount of links to press releases, constituent services, state problems and concerns and legislation issues, etc. The primary goal is to provide direction to the required resources, not to interpret or clarify them. Accordingly, the data posted on the internet are usually lacking in interpretation, background description, bloggers' editorial input or legislator commentary. This research goes a long way towards confirming the study by Jarvis and Wilkerson, which argues that all information located on political congressional homepages 'is not anchored by an authorial voice...the information presented is more meaningful for visitors who already have a thorough understanding of current events, the duties of federal government, and the organisation of the House of Representatives' (Jarvis & Wilkerson, 2005: 12).

The Slavic political net is more arranged and accessible to fresh netizens (newbies) as well as inexperienced users; it looks more interpretative and user-friendly, as mentioned earlier. This might be partly explained by the low level of IT development in this language segment on the net.

The English-speaking blogosphere has more visual information and the Russian one contains more verbal texts. The study also reveals that both male and female English-speaking blogs are more colourful, with diverse imagery, than their Slavic counterparts. Almost every site has many images of local geography, slides of the representative's state and of sightseeing in the United States in general. On these sites, cutting-edge multimedia opportunities (web 2.0 services) are realized to a great extent, a situation that is probably explained by the leading positions of the United States and the United Kingdom in the IT and internet sectors. Additionally, technological factors have a huge impact both on the format of information located on the internet, as well as on the use of multimedia in blogs. The blogging services used (like LiveJournal.com and Blogsport.com) also greatly influence the types of information presented on the net (e.g. rubrics for friends and communities are only provided by LiveJournal Services).

On the Ukrainian blogosphere it is possible to trace the impact of the e-media corporate culture that provides hosting facilities to bloggers (compare Mustafa Nayem, Oksana Bilozir or Inna Bogoslovskaya's blogs, which are hosted by *Ukrainskaja Pravda* Online).

As regards colour design, Slavic sites are more laconic and reserved. Male sites tend to be presented in blue and grey shades, while the English blog palette includes colours like pink, grey, yellow and blue. Pink as a background colour is only used by Sandra Gidley (MP for Romsey since 2000) confirming the well-known stereotype that pink is a representation of femininity in culture and society. By contrast, the blue hues of Iain Dale's blog represent the same stereotype in inverse form.

The analysis of site owners' photographs reveals both cultural and gender peculiarities in this type of imagery. The attributes of national and state identification are very prevalent on the North American political internet, and provide a consistent background for the site owners' images.

The Ukrainian, Bielorussian or Russian politweb almost completely lacks this dimension. As regards photos, almost all of the American male images are suit-and-tie headshots in front of US flags or the Capitol. One might consider that this tendency highlights a distance from the audience rather than a connection. Slavic photos are less official, and the female images are not as static and reserved. They are vivid, more colourful and strive to bring about the immersion of virtual visitors into the virtual site environment. These female pictures appear to disclose the inner personal lives of blog owners so as to eliminate the social barriers between the latter and the blogs' virtual audience. Again, culture either emphasizes or blurs gender meanings, exploiting virtual reality quickly and effectively.

Limitations

This study has a number of limitations, the main one being the size of the sample. Future research into gender influences on blogging practices may wish to adopt a

different approach to understanding the political internet. Indeed, it may be useful to examine the impact of all aspects of identity formation (social background, ethnicity, age, etc.) in this area through the utilization of more qualitative and quantitative approaches that are based on the use of ethnomethodology and statistical analysis. This may be a more effective way of understanding the complex processes such as gender and culture underlying the formation or construction of virtual identities in cyber-politics.

The research also reveals that longitudinal observations are required if the political internet is to be examined more deeply. The research which one of the writers of this paper conducted in 2007 claims the following:

> it is remarkable that only American sites maintain blogs as a tool for communication. There aren't any blogs on the Ukrainian political sites. It enables us to testify that blogging hasn't yet become a popular social practice as in the West (Goroshko, 2008: 654).

Currently, however, the situation is changing dramatically.

The descriptive nature of such studies doesn't facilitate a more thorough understanding of cyber-politics, including political webpages. More research is needed to analyse not only blog structure and the information posted, but also the use of blogs from blog-visitors' perspectives.

Conclusions

This research did not find any serious gender differences concerning the number of links and their usage, unlike previous studies (Miller & Mather, 1998; Goroshko, 2006). External links (outside the body of the blog, indicating other internet resources) dominate internal ones in practically all of the blogs in our sample. All of the blogs studied are updated on a permanent and regular basis (this was traced by using press releases or news rubrics with an indication of the exact date and time). Only two (current and former) female US secretaries of state have abandoned their blogs.

Our main results indicate that culture and technologies have a far greater impact on political blogging than the gender of blog owners. The comparison between two blogospheres shows clearly that culture and IT may increase, strengthen or neutralize and diminish gender performances on the internet. Gender in itself presents a rather fluid social construct, appearing in one situation and almost disappearing in other circumstances. This confirms the famous notion of the *nomad* used by Rosi Braidotti to explore the fluidity of gender (Braidotti, 1994). The nomadic subject, says Braidotti, is fiction which enables one to think about and beyond well-known categories such as

class, race, ethnicity, gender, age and so on, without being confined or limited by them. It enables one to think of the individual subject in relation to many of these categories at once, even where they sometimes contradict each other. Braidotti argues for 'blurring boundaries without burning bridges' (ibid.: 4).

And, in an afterword, it should be noted that the question 'How best to facilitate political blogging?' remains unanswered. The findings of this research reveal some weak points in political blog functioning, and the challenge that thus arises concerns the best way to address these.

As a way of dealing with the problems highlighted, male bloggers should think more about narrowing the distance between their public personae and the online audience, providing more opportunities for direct communication with ordinary internet users. English IT blog software designers and bloggers should, in turn, consider how to develop more user-friendly virtual surroundings, not only for themselves, but also for ordinary people without special training in political office functioning. The Russian political blogosphere needs to become more professional and socially and age-sensitive to the everyday problems that ordinary people experience, and should also learn how to exploit more of the cutting-edge media opportunities provided by the net so as to increase blog interactivity and accessibility.

Many CMC researchers testify that the majority of site visitors mention the convenience of the internet, the ability to search for new sources, the capacity to be able to 'obtain information from the Net not available elsewhere' and the opportunity to voice opinion online thanks to the 'multimedia capabilities of the Net' as factors in their decision to use it (Foot & Schneider, 2002: 2).

However, the cyber-politics perspective is in the hands of all of the political stakeholders who are working to develop new ways of reinvigorating social capital by exploring the new opportunities for the superhighway environment that the internet presents. 'Whether or not the promise of this new medium is fulfilled depends on access to the medium beyond the upscale citizens who predominantly use it' (Kern, 1997: 1248), although, of course, many problems remain unresolved in this area and future tendencies are not easily predicted.

References

Barabási, A.-L., *Linked: The New Science of Networks*, Cambridge, Perseus Publishing, 2002.

Barabási, A.-L. & Albert, R., 'Emergence of scaling in random networks', *Science*, 286:5439 (1999), pp. 509–512.

Barbovschi, M., 'Romanian political blogs—New loci of expression and participation? An analytical framework for the investigation of the political blogging space as a new form of public sphere', 2008, http://eprints.lse.ac.uk/21562/. Retrieved 13 April 2009.

Banwart, M.Ch., 'Webstyle. Encyclopedia of Political Communication', *SAGE Journal*, http://www.sage-ereference.com/politicalcommunication/Article_n709.html. Retrieved 22 May 2009

Braidotti, R., *Nomadic Subjects: Embodiment and Sexual Difference in Contemporary Feminist Theory*, New York, Columbia University Press, 1994.

Castells, M., *The Rise of the Network Society, 2^{nd} edn*, Oxford, Blackwell Publishing, 2000.

Cranny-Francis, A., Warning, W., Stavropoulos, P. & Kirkby, J., *Gender Studies: Terms and Debates*, New York, Macmillan Palgrave, 2003.

Danet, B. & Herring, S.C., 'Multilingualism on the internet', in M. Hellinger & A. Pauwels (eds) *Language and Communication: Diversity and Change. Handbook of Applied Linguistics 9*, Berlin: Mouton de Gruyter, 2007, http://pluto.mscc.huji. ac.il/~msdanet/papers/multiling.pdf. Retrieved 24 April 2009.

Foot, K.A. and Schneider, S.M. (2002). 'Online Action in Campaign 2000: An Exploratory Analysis of the U.S. Political Web Sphere', *Journal of Broadcasting and Electronic Media*, 46:2 (2002), pp. 222-244.

Goffman, E., *The presentation of self in everyday life*, New York, Doubleday, 1959.

Goroshko, O., 'Netting Gender', in H. Schmidt, K. Teubener, N. Konradova (eds) *Control + Shift. Public and Private Usages oft he Russian Internet*. Norderstedt, 2006, pp. 106-119.

Goroshko, O., 'Virtual political office where culture and gender meet', *The Handbook of Research on Virtual Workplaces and the New Nature of Business Practices*, Hersey/London, Idea Group Inc., 2008, pp. 636–662.

Goroshko, O. & Zhigalina, O., 'Political communication on the RuNet – Blogs by leaders of opinion', *Russian Cyberspace*, 1:1 (2009), pp. 81–100, http://www.russian-Cyberspace.com/issue1/goroshko_and_zhigalina.php?lng=English. Retrieved 2 June 2009.

Harp, D.M. & Tremayne, M., 'The gendered blogosphere: Examining inequality using network and feminist theory', *Journalism & Mass Communication Quarterly*, 83:2 (2006), pp. 247–264.

Herring, S.C., 'Web content analysis: Expanding the paradigm', in J. Hunsinger, M. Allen & L. Klastrup (eds) *The International Handbook of Internet Research*, Springer Verlag, http://ella.slis.indiana.edu/~herring/webca.2008.pdf. Retrieved 13 April 2009

Herring, S.C., 'Language and the internet', in W. Donsbach (ed.) *International Encyclopedia of Communication*, Oxford, Blackwell Publishers, pp. 2640–2645, http://ella.slis.indiana.edu/~herring/lg.inet.pdf. Retrieved 22 May 2009.

Herring, S.C., Paolillo, J., Ramos-Vielba, I., Kouper, I., Wright, E., Stoerger, S., Scheidt, L.A. & Clark, B., 'Language networks on LiveJournal', in *Proceedings of the Forty Hawaii International Conference on System Sciences (HICSS-40)*, Los Alamitos, CA, IEEE Press, 2007, http://www.blogninja.com/hicss07.pdf. Retrieved 22 May 2009.

Herring, S.C. & Paolillo, J.C., 'Gender and genre variation in weblogs', *Journal of Sociolinguistics*, 10:4 (2006), pp. 439–459.

Herring, S.C., Scheidt, L.A., Kouper, I. & Wright, E., 'Longitudinal content analysis of weblogs: 2003–2004', in M. Tremayne (ed.) *Blogging, Citizenship, and the Future of Media*, London: Routledge, 2006, http://ella.slis.indiana.edu/~herring/tremayne.pdf. Retrieved 30 March 2009.

Huffaker, D.A. & Calvert, S.L., 'Gender, identity, and language use in teenage blogs', *Journal of Computer-Mediated Communication, 10*:2 (2005), http://jcmc.indiana.edu/vol10/issue2/huffaker.html. Retrieved 22 May 2009.

Huffaker, D., *Gender Similarities and Differences in Online Identity and Language Use among Teenage Bloggers* (Master's Thesis), Washington, DC, Georgetown University, 2004.

Jarvis, S.E. & Wilkerson, K., 'Congress on the Internet: Messages on the homepages of the U.S. House of Representatives', *Journal of Computer-Mediated Communication*, 10:2 (2005), http://jcmc.indiana.edu/vol10/issue2/jarvis.html. Retrieved 4 June 2009.

Kern, M., 'Social capital and citizen interpretation of political ads, news, and web site information in the 1996 presidential election', *The American Behavioral Scientist*, 40:8 (1997), pp. 1238–1249.

Khitrov, A., *Blog as a Cultural Phenomenon*, 2005, http://www.ecsocman.edu.ru/images/ pubs/2008/03/21/0000321728/05-Hitrov.pdf. Retrieved 21 November 2007.

Kluver, R., Foot, K., Jankowski, N. & Schneider, S., *The Internet and National Elections: A Comparative Study of Web Campaigning*, Routledge Research in Political Communication, New York, Routledge, 2007.

Kramarae, C., 'Feminist fictions of future technology', in S.G. Jones (ed.) *Cybersociety 2.0 Revisiting Computer-Mediated Communication and Community*, New York and London, Sage, 1998, pp. 100–128.

Miller, H. & Mather, R., *'The presentation of self in WWW home pages', in Proceedings of the IRISS'98 Conference*, Bristol, UK, 1998, http://ess.ntu.ac.uk/miller/cyberpsych/ millmath.htm. Retrieved 22 August 2005.

Nowson, S., *The Language of Weblogs: A Study of Genre and Individual Differences* (Doctoral Thesis), University of Edinburgh, 2006.

Papacharissi, Z., 'Campaigning online: The American Presidency meets the Internet', paper given at the Association of Internet Researchers 5.0 annual conference, Brighton, England, 2004.

Pedersen, S. & Macafee, C., 'Gender differences in British blogging', *Journal of Computer- Mediated Communication*, *12*:4 (2007), http://jcmc.indiana.edu/vol12/ issue4/pedersen.html. Retrieved 13 July 2008.

Perlmutter, D.D., 'Political blogging and Campaign 2008: A roundtable', *International Journal of Press/Politics*, 13 (2008), pp. 160–172.

Political Influentials Online in the 2004 Presidential Campaign, Institute for Politics, Democracy & the Internet, George Washington University, 2004.

Rozell, M.J. & Semiatin, R.J., 'Congress and the media', *Encyclopaedia of Political Communication*, 2008, http://www.sage-ereference.com/politicalcommunication/ Article_n114.html. Retrieved 22 December 2008.

Schlerl, J., Koppell, M., Argamon, Sh. & Pennebaker, J., *Effects of Age and Gender on Blogging*, 2005, http://lingcog.iit.edu/doc/springsymp-blogs-final.pdf. Retrieved 22 December 2008.

Stanyer, J., 'Candidate-centered communication', *Encyclopaedia of Political Communication*, 2008, http://www.sage-ereference.com/politicalcommunication/Article_n70.html. Retrieved 22 May 2009.

The Blogging Iceberg: Of 4.12 Million Weblogs, Most Little Seen and Quickly Abandoned, According to Perseus Survey, 2003, http://findarticles.com/p/articles/mi_m0EIN/is_2003_Oct_6/ai_108559565/. Retrieved 18 June 2007.

Trammell, K.D., *Celebrity Blogs: Investigation in the Persuasive Nature of Two-Way Communication regarding Politics* (Unpublished Doctoral Dissertation), University of Florida, 2004.

Trammell, K.D. et al., 'Evolution of online campaigning: Increasing interactivity in candidate web sites and blogs through text and technical features', *Mass Communication & Society*, 9:1 (2006), pp. 21–44.

Trammell, K.D. & Kaye, D., 'Blogs, blogging', *Encyclopaedia of Political Communication*, 2008, http://www.sage-ereference.com/politicalcommunication/Article_n49.html. Retrieved 22 May 2009.

Tremayne, M., 'The web of context: Applying network theory to the use of hyperlinks in journalism on the Web', *Journalism & Mass Communication Quarterly*, 81:2 (2004), pp. 237–253.

Tremayne, M., 'Examining the blog-media relationship', in M. Tremayne (ed.) *Blogging, Citizenship, and the Future of Media*, New York and London, Routledge, 2007, pp. ix–xvii.

Watts, D., *Six Degrees: The Science of a Connected Age*, New York, W.W. Norton and Co., 2003.

Witmer, D.F. & Katzman, S.L., 'On-line smiles: Does gender make a difference in the use of graphic accents', *Journal of Computer-Mediated Communication*, 2:4. (1997), pp. 19–57, http://www.ascusc.org/jcmc/vol2/issue4/witmer1.html. Retrieved 12 October 2005.

Wolejszo, S., *Gender Trouble and the Construction of Gender Identity on Internet Chat Sites* (Master's Thesis), University of Manitoba, Canada, 2003.

Appendix 1: List of sample blogs

Blog Owner with URL	Google Rank Indicator	Alexa Traffic Rank Indicator
Russian-speaking male bloggers		
Dmitriy Medvedev (http://community.livejournal.com/blog_medvedev/)	7	91
Sergey Mironov (http://sergey-mironov.livejournal.com/)	5	91
Boris Nemtsov (http://b-nemtsov.livejournal.com/)	5	91
Malyshevskiy (http://malishevsky.livejournal.com)	3	91
Mustafa Nayem (http://blogs.pravda.com.ua/rus/authors/nayem/)	4	5.711
English-speaking male bloggers		
Barack Obama (http://my.barackobama.com/page/content/hqblog)	6	8.325
Rick Perry (http://www.rickperry.org/blog)	4	1.297.952
Arnold Schwarzenegger (http://gov.ca.gov/blog)	7	728
Jonh Boozman (http://www.boozman.house.gov/blog/)	6	6.975
Iain Dale http://iaindale.blogspot.com/	6	66.354
Russian-speaking female bloggers		
Olga Abramova (http://olga-abramova.livejournal.com)	2	91
Oksana Bilozir (http://blogs.pravda.com.ua/authors/bilozir/)	5	5.711
Inna Bogoslovskaya (http://blogs.pravda.com.ua/rus/authors/bogoslovska/)	2	5.711
Darja Mitina (http://kolobok1973.livejournal.com/)	5	91
Masha Gajdar (http://m-gaidar.livejournal.com/)	6	91
English-speaking female bloggers		
Hillary Clinton (http://www.newsgroper.com/hillary-clinton)	3	332.058
Condoleezza Rice (http://www.newsgroper.com/condoleezza-rice)	3	332.058
Virginia Foxx (http://www.virginiafoxx.com/blog/)	3	7.612.513
Nancy Pelosi (http://speaker.house.gov/blog/)	7	6.975
Sandra Gidley (http://romseyredhead.blogspot.com/)	5	14.215.846

Appendix 2: List of research items in sample blogs

Name of Blog Owner	User-friendly URL	Archive	Bio	Hobby/ Interests	Hyperlinks (in posts)	Personal photo/ Image	About myself	Video (in posts)	Images (in posts)	Colour	Comments per post	Last update	Last topic
Dmitriy Medvedev	+	-	-	-	-	+	-	+	a lot	beige	501	20.06	laws for non-commercial organizations
Sergey Mironov	+	+	+	-	-	+	-	-	-	blue	46	23.06	laws concerning retirement pensions
Boris Nemtsov	+	+	-	-	+	+	+	+	+	white	118	8.06	Putin and Lukashenko
Malyshevskiy	+	+	-	-	+	+	-	+	a lot	grey	11	21.06	Che Guevara's grand-daughter
Mustafa Nayem	+	-	-	-	-	+	-	-	A little	White and purple	78	22.05	bilingualism
Barack Obama	+	-	-	-	+	-	-	+	+	dark blue	284	22.06	Tobacco Control Act
Rick Perry	+	-	-	-	+	+	+	+	+	white	necessary to register	22.06	raising money for the governor's re-election
Arnold Schwarzenegger	-	-	-	-	-	+	+	+	-	beige	no option for comments	8.06	digital textbooks
Jonh Boozman	+	+	+	-	+	+	-	-	+	white and beige	0	9.06	president promises concerning 600,000 jobs
Iain Dale	+	+	+	+	+	+	+	+	A lot	Blue and white	86	25.10.2007	what we did this year
Olga Abramova	+	+	-	-	-	+	+	-	-	**light blue**	**9**	**20.06**	**prices in Belarus vs prices in Russia**
Oksana Bilozir	-	-	-	-	+	+	+	-	+	white	36	18.05	sanctions against students from Donetsk
Inna Bogoslovskaya	-	-	-	-	-	+	+	-	-	beige	66	17.06	media and reforms
Darja Mitina	-	+	-	-	+	+	-	+	+	white	31	23.06	elections in Tegeran
Masha Gajdar	+	+	-	-	+	+	-	+	+	white and red	62	5.06	ICQ in the government of Kirov district
Hillary Clinton	-	-	-	-	+	+	+	+	+	white and light purple	4	22.12.2008	the necessity to end the 'hamburglary'
Condoleezza Rice	-	-	-	-	+	+	+	+	+	white and light purple	1	30.12.2008	expensive clothes
Virginia Foxx	+	+	-	-	+		+	+	+	white and dark purple	no option for comments	4.02.2009	Winston-Salem Journal: 'Foxx is right'
Nancy Pelosi	+	+	-	-	+	-	+	+	+	white and dark blue	0	23.06	House consideration of the American Clean Energy and Security Act
Sandra Gidley	-	+	-	-	+	+	+	-	-	light pink and dark pink	no option for comments	19.06	the next speaker

CHAPTER SEVEN:
XXY: REPRESENTING INTERSEX

Begonya Enguix Grau

The notion of hermaphroditism, generally understood as the combination of two sexes in one body, has historically been associated with the impossible, the unintelligible, the mythological, the fantastic and the monstrous; in short, with natural errors. Hermaphrodites are considered to be:

> true symbols of transgression…an offence to the order of nature and its laws and to the judicial order of society, as they transcend the limits of gender, the division between sexes, which are a source of familial roles and social convention. (Vázquez and Moreno, 1997: 185)[1]

Intersex is the medical category which corresponds to biological variations in sex. 'Hermaphroditism' and 'intersex' are blanket terms used to denote a variety of congenital conditions in which a person has neither the standard male nor the standard female anatomy.

Hermaphroditism has remained out of bounds of our social and representational imaginations,[2] and film approaches to intersex have been rare. However, other topics, such as transsexuality, homosexuality or transvestism, are often represented in the media. Consequently, the Argentinian film, *XXY*, directed by Lucía Puenzo and inspired by a short story written by Sergio Bizzio ('Cinism') is quite exceptional, since it focuses on a subject which has not been widely dealt with before. *XXY* premiered in Argentina on 14 June 2007 and in Spain on 11 January 2008. Awarded the Goya—the Spanish Film Academy Award—in 2008, the picture was acclaimed by Spanish critics as the first to dare to explicitly address this contentious topic.

According to the synopsis on the official webpage, Alex, a fifteen-year-old teenager, hides a secret. Soon after her birth, her parents moved from Buenos Aires to an isolated country house on the coast of Uruguay. The story starts with the visit of some friends, a couple and their teenage son, Alvaro. Alvaro's father is a plastic surgeon. Alvaro and Alex feel attracted to each other, precipitating the disclosure of the secret.[3]

This synopsis introduces us to most of the elements that have accompanied intersexuals since the recent domestication of sexed bodies in the nineteenth century: exile, secrecy, hiding, isolation, shame, confusion, monstrosity, danger, castration, biomedical discourse and transformation.

We have based our study on a detailed qualitative content analysis of the selected film, paying attention both to script and images. Having first classified the topics related to intersex that are present in the movie, in a second stage we proceeded to analyse how such matters are dealt with and the way they are framed. The topics considered were codified under a series of signifying categories—mainly sex and truth, gender, medical protocols and social pressure—on the basis of our long-standing experience in ethnographic fieldwork in the area of sex, genders and sexualities.

Binarism, bodies and truth

> Gender norms (ideal dimorphism, heterosexual complementarity of bodies, ideals and [the] rule of proper and improper masculinity and femininity, many of which are underwritten by racial codes of purity and taboos against miscegenation) establish what will and will not be intelligibly human. (Butler, 1990: xxv)

Gender norms exist within a binary system where two sexes are symbolically connected to two genders and two sexualities (one of them stigmatized). This binarism has served the purpose of constructing opposing definitions of what being male and female and masculine and feminine means, and is based on an 'unquestionable biological and objective reality'—sex—which sustains and intersects a social construction—gender—that is closely related to it. But, as Fausto-Sterling remarks, neither sex nor nature are 'real', and nor are gender and culture constructed: 'our very real, scientific understandings of hormones, brain development, and sexual behaviour are, nevertheless, constructed in and bear the marks of specific historical and social contexts' (2000: 29).

Vázquez & Moreno (1997), Herdt (1993), Trumbach (1993), Laqueur (1994) and Weeks (1989), among others, show how specific historical and social contexts produce social conceptions of sex, gender, body and sexuality. In the Western tradition, there have historically existed (and sometimes coexisted) at least three models of representation of sex: a unisex model that was predominant among the Greeks and Renaissance physicians;

a hegemonic model of three sexes (men, women and hermaphrodites, all capable of sexual interaction with each other) that existed until the beginning of the eighteenth century (Trumbach, 1993: 112); and a binary system that begins to be shaped during the eighteenth century and becomes hegemonic in the 1800s. With regard to gender, for Trumbach 'the paradigm of two genders founded on two biological sexes began to predominate in Western culture only in the early eighteenth century' when a transition occurred from a 'two genders—three sexes' system (feminine/masculine, male/female, hermaphrodite) to a 'four genders—two sexes system' (men, women, sodomites and sapphists—male/female), where two of the genders were legitimized and the other two were stigmatized (1993: 111):

> hermaphrodites, on the other hand, were obliged to permanently choose one gender or the other for themselves and then to take sexual partners only from the remaining opposite gender. If hermaphrodites moved back and forth in their gender, their sexual relations could then be stigmatised as the crime of sodomy. (Trumbach, 1993: 112–113)

In the case of sexual ambiguity, parents or godparents decided which sex and gender the newborn was assigned, a decision that was not based on any positivist knowledge. If physical transformations of the subject's body took place during adolescence, it was only at the time of marriage that the affected individual chose which sex and gender he or she wanted to be. Changes in behaviour, implying a change in the decision, were condemned under civil and canon law (Vázquez & Moreno, 1997).

Until the change in paradigms that started to occur in the eighteenth century, the term 'hermaphrodite', apart from naming a third sex, was interchangeably used to refer to homosexual men (particularly passive males, as it was thought that they had become women) and extremely active women. Those who transgressed the sex and gender roles, and whose behaviour combined what was socially considered to be masculine and feminine, were reclassified as 'hermaphrodites'. For example, in 1731, Pulteney's use of the term clearly refers to an effeminate male who desires sex with other men and has no reference to the biological condition of his body (Trumbach, 1993: 111). Therefore, at some stage in Western history, the term was used to refer to sex duplicity as well as to gender and sex roles.

In the eighteenth century, the idea that a person cannot simultaneously be a man and a woman becomes progressively dominant, and the third sex is questioned. Parsons' (1741) echoing of the Enlightenment view that there are only two anatomies on the basis of which two genders are founded pointed towards the idea of a 'true' sex (Trumbach, 1993: 117). By the dawn of the twentieth century, physicians are recognized as the chief regulators of sexual intermediacy (Fausto-Sterling, 2000: 41), replacing lawyers and judges who, until the early nineteenth century, had been the

primary arbiters of intersexual status. This shift in specialization on intersex is part of the general context of the progressive medicalization of sexuality, as well as the construction and consolidation of the category of 'deviants' that was sharply analysed by Foucault (1984) as being closely related to the general concern about sex and sexuality which brings about some scientific progress in the knowledge of bodies. In the last third of the nineteenth century, the tools for the microscopic examination of gland tissue and later of the endocrine system were developed. These examinations contributed to the increasing sophistication of the techniques of diagnosis and the taxonomies of hermaphroditism, generating an enormous scientific production on the topic. Nevertheless, this 'explosion of knowledge' on hermaphrodites did not lead to uniform criteria with which to determine their 'true sex', nor did it imply the acceptance of the possibility of sexual duplicity (Vázquez and Moreno, 1997: 220). However, it dissolved the association of hermaphrodites with the 'fantastic' or 'mythological' thanks to the 'discovery' of many physically hermaphroditic subjects due to the rise of gynaecology at the end of the nineteenth century.

In 1933, Sigmund Freud acknowledged a significant human desire to know with certainty what sex a person belongs to: 'when you meet a human being, the first distinction you make is "male or female?", and you are accustomed to making the distinction with unhesitating certainty' (1933: 113, quoted in Harper, 2007: 1). Freud's text continues by describing sex as a biological fact, with anatomy as stable, binary and indisputable (he subsequently distinguished between *anatomical sex* and the less fixed notion of *gender*). The consideration that only one true sex exists, alongside the hegemonic politics of truth,[4] are challenged by intersex and transsex. Intersex represents a notable repost to the 'unhesitating certainty' that Freud described as customary: uncertainty of sex—especially in the newborn—activates parental and cultural shame, guilt and panic. The secrecy and stigma surrounding intersex perpetuates the perception of monstrosity, indicating to intersexed people that their 'defect' is so monstrous that it should be erased (Harper, 2007: 2).

> The *customary* sexing of the body is simple: it works within a binary framework based on sex complementarity and mutual exclusion. Primary signification of sex is usually via consideration of either genitalia or gonads or karyotype, with arguably at least some concern for heterosexual reproduction. A sense of bodies as ontologically and historically stable and knowable, fixed and immutable is perpetuated, and the custom of sex identification is essentialist and absolutist. (Harper, 2007: 79)

But complete maleness and complete femaleness represent the extreme ends of a spectrum of possible bodies. That these ends are the most common has lent credence to the idea that they are not only natural (that is, produced by nature), but normal (that

is, they represent both a statistical and social ideal). Knowledge of biological variation, however, allows us 'to *conceptualise the less frequent middle spaces as natural although statistically more unusual*' (author's emphasis) (Fausto-Sterling, 2000: 76).

In fact, intersex is more common than Down's syndrome, but is much more taboo and much more misunderstood (Harper, 2007: 25). One out of every 100 children are born with bodies which differ from what is considered to be a 'standard' male or female (Fausto-Sterling, 2000) and, according to Diamond, one of 2,000 are born with clearly ambiguous genitals, corresponding to 2 to 3 per cent of the population (Cucchiari, 1981: 33). In the United States, between 100 and 200 children undergo surgery to carry out sexual reassignment every year (Harper, 2007), and approximately one in 1,700 newborns have karyotypes other than XX (female) or XY (male) (Blackless in Harper, 2007). Fausto-Sterling (2000: 51) believes that the current incidence of intersex in 1.7 per cent of all births will increase due to in vitro fertilization and environmental pollutants. Moreover, this author also suggests that twelve people in every million exhibit 'true hermaphroditism': gonadal intersex is a more common index of 'true hermaphroditism' than mythological 'genital duplicity', as only 25 per cent of intersexuals are born with genital ambiguity (Briffa in Harper, 2007: 69).

Around sixty to seventy per cent of 'true hermaphrodites' are genetic females with an XX karyotype. Occasionally, an additional Y chromosome is present (XXY) or a chromosomal mosaic occurs. Hormonal influences and/or imbalances in the internal reproductive apparatus are also indexical of intersex. In summary, intersex is a condition of the whole person, not just the genitalia (Briffa in Harper, 2007: 69).

Biotechnology and knowledge

Domurat Dreger (1999) traces the evolution of intersex and defines three different 'ages' in its management: the age of gonads (1896), the age of surgery (1950s) and the age of consent (1990s). In 1896, Blacker and Lawrence established that the anatomical nature of the gonads alone (ovarian or testicular) determines a subject's 'true' sex independently of other anatomical parts.[5] Consequently, the only 'true hermaphrodite' was that subject whose gonads—upon microscopic verification, generally conducted on corpses—were confirmed to contain both ovarian and testicular tissue.[6] By 1915, increasingly advanced technologies allowed the discovery of 'true live hermaphrodites'. Despite sex having been established as being 'determined by the obvious predominance of characteristics, especially the secondary, and not by the non-functional sex-glands alone, for this is neither scientific nor just' (Bell, quoted in Domurat Dreger, 1999: 10), only two 'true' sexes were still considered to exist.

'Normalizing' genital surgery in intersexed infants with ambiguous genitalia has been practised since the 1950s (Harper, 2007: 17), giving birth to the age of surgery.

Exemplifying the idea that there must be a 'true' sex in each body, surgical proceedings posit that bodies, as the 'locus' of sex and gender identity, must have a socially acceptable appearance.

Although the symbolic association between sex and gender is deeply internalized in Western thought, in 1972 the sexologists John Money and Anke Ehrhardt popularized the idea that sex and gender are separate categories. Sex, they argued, refers to physical attributes and is anatomically and physiologically determined. Gender was considered to be a psychological transformation of the self (the internal conviction that one is either male or female (gender identity)) and the behavioural expressions of that conviction. According to Money, all children are psychosexually neutral at birth and, therefore, can be virtually turned into either gender as long as the sexual anatomy is made to appear as reasonably believable for that reassigned gender. For Money, echoing Freud, the presence or absence of the penis is the critical anatomical factor (Kipnis and Diamond, 1999: 176) with which to determine gender and sex in intersexed newborns. In general, protocols establish that genetic females should always be raised as females, preserving reproductive potential, regardless of how severely the patients are virilised. But in genetic males, the gender of assignment is based predominantly on the size of the phallus (Fausto-Sterling, 2000: 57). It is considered that in newborns an 'acceptable' clitoris measures up to 1 cm and an 'acceptable' penis 2-2.5 cm. If the clitoris is longer or the penis is smaller, newborns' sex is reassigned and their penis/clitoris is adapted to the standard size. Therefore, 'the worries in male gender choice are more social than medical' (Fausto-Sterling, 2000: 57- 58). This reduction of the complexity of the self to the appearance of one's genital anatomy is highlighted and denounced by Harper (2007).

In contrast with Money's ideas, the endocrinologist Milton Diamond believes that there exists a hormonal basis of gender identity, an internal truth and necessity that no amount of socialisation can reverse. Considering the theory of psychosexual neutrality at birth untenable, since children are not infinitely malleable in terms of gender formation, Diamond has been battling with Money for several years (Kipnis and Diamond, 1999).

Money and Diamond's views highlight the complexities in the sex/gender system and in sex and gender identity determination. They both defend surgical sex reassignment, but whereas Money's emphasis lies on anatomy, Diamond's is on hormones.

In summary, medical protocols on the classification of non-standard sexual anatomies are not clearly established. In some cases, external genitalia determine sex identity. In others, as the International Olympic Committee's tests indicate, genetic sex is determinant.[7] In the very recent, highly controversial, case of the South African athlete Caster Semenya, the only information published up to the time that this article was written[8] revolved around the fact that she has testicles and produces high levels of testosterone, characteristics that lead the *Daily Telegraph* to award her 'hermaphrodite' status.[9]

> In our work, we find that doctors' opinions about what should count as 'intersex' vary substantially. Some think you have to have 'ambiguous genitalia' to count as intersex, even if your inside is mostly of one sex and your outside is mostly of another. Some think your brain has to be exposed to an unusual mix of hormones prenatally to count as intersex, so that even if you're born with atypical genitalia, you're not intersex unless your brain experienced atypical development. And some think you have to have both ovarian and testicular tissue to count as intersex. (Intersex Society of North America, 2009)

So, nature does not always decide where the category of 'male' ends and the category of 'intersex' begins, or where the category of 'intersex' ends and the category of 'female' starts. Sex and gender assignment is sometimes a process that requires active and precise medical decisions and interventions.

For the last twenty years, broadly speaking, the older technocentric treatment has evolved into a newer, ethically informed, patient-centred approach (Domurat Dreger, 1999), thus giving birth to the age of consent. Critical voices against surgical proceedings are progressively being heard (e.g. Chase & Fausto-Sterling) and many reference books on intersex have been published (Domurat Dreger, 1999; Fausto-Sterling, 2000; Kessler, 1998 and others). Publications divulging many cases of unsuccessful sex reassignments— such as the paradigmatic case of two male twins, one of them reassigned as a woman who ended up committing suicide (see Kipnis and Diamond, 1999; Butler, 2004)—have drawn attention to the dangers of taking decisions on behalf of patients.

Intersex is progressively being de-pathologized and made visible. The Intersex Society of North America (ISNA), founded in 1993, has been a cornerstone of this process.

> Although a child should be given a sex assignment for the purposes of establishing a stable social identity, it does not follow that society should engage in coercive surgery to remake the body in the social image of that gender. Such efforts at 'correction' not only violate the child but lend support to the idea that gender has to be borne out in singular and normative ways at the level of anatomy. Gender is a different sort of identity, and its relation to anatomy is complex. (Fausto-Sterling, 2000: 63).

XXY:[10] Sex and truth, gender, medical protocols and social pressure

As we have seen, intersexed bodies threaten chaos, disrupt order and trouble our cultural 'norms'. Intersex is a hidden and taboo medical category without social correspondence in our culture. But intersexuals exist despite surgery, shame and silence (Harper, 2007: 13).

We can infer from the title of the Argentinian film *XXY* that Alex is a XXY baby. By parental decision, Alex is not surgically reassigned at birth. Her mother (Suli), who wished to have many daughters, decides to raise her as a girl, thus reinforcing the idea of the necessity for a gender to inform the growing up process (gender of raising), although this decision is never made explicit, nor is it explained or indeed justified in the film. The secrecy and shame that surround these cases lead the family to seek exile in an isolated environment where, apparently, life goes by calmly until Alex is fifteen.

Ramiro, Erika and their son are invited by Suli to spend a few days with them. She wants Ramiro to have a look at Alex, although we still do not know 'what is wrong' with her. We are only allowed a glimpse of Ramiro in his car examining Alex's photos and a book called 'Origins of Sex', written by Alex's father, Kraken, a biologist (min. 3.55').

The medicalization of sex and the protocols of transformation of non-standard bodies are presented in the film through the character of the plastic surgeon (Ramiro), whose stance is shared by his wife (Erika) and by Alex's mother. Their intention is to finally make Alex's body socially acceptable, forcing it to conform to her 'true' identity.

Alex's body is subtly presented as thin and flat and ambiguous, and is never shown completely naked. The film is dominated by bluish colours which evoke softness and calmness and, at the same time, can convey masculinity.

Alex is fifteen and has never had sex: her first conversation with Alvaro is about masturbation. She is disoriented and fragile, her room is full of homeopathic remedies ('for people afraid to be hurt') and at the beginning of the film, instead of taking a pill (a corticoid, 'so I don't grow a beard'), she places it on her breast. We know then that there is something wrong and medicine is intervening: 'She's not taking them', her mother tells her father. Later, we learn that Alex is a hermaphrodite with a penis and a vagina, evoking mythological tales and fear of the unknown, but also inspiring attraction (Alvaro) and confusion (Alex and her relatives).

Disorientation, crisis and fear are represented in Alex's drawings, found by Alvaro in her room, as well as in two terms that are widely used in the film—'enemies' and 'endangered species'—clearly referring to social pressure. Alex's father works with turtles, an 'endangered species', but this term is used to metaphorically allude to hermaphrodites, endangered to the extent that surgical proceedings try to erase their existence as such. 'Enemies', as in a battlefield, is the term used to refer both to those who must not know about her 'secret' and to the war that intersexed people wage against the standard conceptions of sex, gender and body. The battlefield comes to life when physical violence is introduced in the film: Alex punches her friend Vando (the only friend who knows about her 'secret') and, as a result, gets 'excluded' from a sociability sphere by being expelled from school.

The relationship between hermaphroditism and monstrosity is treated in a very subtle way through secrecy, exile, social stigma and the apparent need for active intervention: only Alvaro seems to dare to address her directly over the issue. Alvaro is attracted to

Alex but, feeling something strange in her, declares: 'You're different, you're not normal. Why do people stare at you?'

The evocation of images, the escape to Uruguay and the punching of Vando allow us to empathize with Alex's turmoil, although we still do not know much about it. But soon Alex has sexual intercourse with Alvaro and seems to penetrate him, her father seeing it from a hidden corner. A storm follows. When her father tells his wife, he admits: 'We knew this would happen. She'll never be a woman even if a surgeon cuts her off.' This is the first clear reference to surgical sex reassignment. And Kraken's position seems to parallel that of Diamond, as he defends the idea that there appears to be an unavoidable 'inner truth' in Alex. Despite surgical interventions, she will never be what she is not. This 'inner truth' is unveiled by Alex's sexual role as inserter (regardless of the gender according to which she was raised) along with her decision not to take the pills she uses to stop virilization. These two scenes are the most explicit gendered scenes in the film and can be related to the Money/Diamond controversy mentioned above.

The tensions revolving around the convenience of surgical intervention arise as her mother insists that Alex be operated on (so as to convert her into a 'standard' woman), while her father opposes this move. At this stage, Kraken looks for informed counselling and visits a petrol station to talk to an employee. The employee happens to be a female-to-male intersexual, whose case had been published in a newspaper. Upon being asked by Kraken whether he had always known that he was not a woman, his answer is very direct: 'At sixteen I started taking testosterone, at seventeen I was operated [on]. I've had five operations. That is not normalization. That is castration.' This positions the film in the defence of arguments against surgical reassignment and close to the assumptions of the age of consent that Domurat Dreger (1999) describes.

After their sexual interaction, interrupted by Alex's father, Alex avoids Alvaro, but when they finally meet again, the dialogue is explicit:

> Alvaro: 'You're not.'
> Alex: 'I'm both.'
> Alvaro: 'But that's impossible.'
> Alex: 'You don't know what's possible…Go, tell everybody
> I'm a monster.' (min. 57.32')

Nearly an hour after the beginning of the film, this is the first scene to indicate exactly what 'the secrecy' is about, and the reference to monstrosity is central to the definition of the situation. Hermaphroditism and its intelligibility in our cultural context are here placed centre-stage. But that is not all; secrets are hard to keep.

When walking on the beach, three boys approach Alex and she is sexually attacked: it is when they realize she has a penis that we confirm our suspicion: 'She's got both, she's got everything, I want to see if it gets hard', they shout (min. 60.01').

These two scenes—Alex penetrating Alvaro and the rape on the beach by three local youths—disclose the secret through dramatization and violence. However, the scenes differ from each other to the extent that self-definition—'I am both'—in the scene with Alvaro (Alex in an active role) is turned into insult and stigma—'she has both'—in the scene on the beach (Alex in a passive role). Genitalia are presented as the defining criteria for the subject's individual and social definitions; that is, as key elements for identity construction. In the film, this oversimplification is associated with violence.

Appearing on the beach during the assault, Alex's friend Vando helps her, and both cry. Later, Alex's father faces the aggressors and for the first time talks about Alex as a man, while shouting: 'Stay away from my son!' He also strikes the surgeon when he tries to stop him from hitting the aggressors, and exclaims: 'You're like them!' The surgeon has become an 'enemy', one of those who do not understand, who do not accept difference, who do not respect non-standard bodies. The transformation of Alex's sex and gender is starting to be assumed by her father.

In the following scene, Erika informs Alex's mother of the necessity to operate on Alex, as the family cannot keep her in hiding forever. Suli answers: 'Hide her? Why? Do you think she's a freak?' It is then, at the very end of the film, that we learn that they considered operating on Alex when she was two days old—the sooner the better, protocols establish—but at the time she had seemed 'perfect' to Kraken's eyes.

After the attack, two male friends and one female pal accompany Alex. They are on the beach, and Alex and Vando pee standing up. Her process of 'male-ing' seems to be ongoing and profound.

Kraken tells her that he will look after her until she chooses who she wants to be, either man or woman, but she answers: 'And if there is nothing to choose?' He replies that 'everybody will find out', but she does not seem to mind: 'Let them.' Both characters represent attempts to negotiate tensions between consent and choice over the social need for a single sex and gender.

Ramiro, Erika and their son Alvaro are ready to leave. Alvaro and Alex admit that they have fallen for each other (despite Alvaro fearing himself to be 'a fag', as does his father), but Alex waves goodbye with these words: 'What do you regret most, not seeing me any more or not to have seen it? Do you want to see it?' Alvaro cries and leaves for the car.

While Alex and her father are walking together, she takes her father's arm and puts it around her shoulders. Despite this emotional ending, consisting of an expression of a parental support that has never floundered amidst doubts and difficulties, Alex's sentiment that he/she is a monster, a freak for exhibition, does not abandon us, leaving us with a sense of the extraordinary. Parental and cultural shame, guilt and panic are present: 'the secrecy and stigma surrounding intersex perpetuates the perception of monstrosity, indicating to intersexed people that their "defect" is so monstrous it should be erased' (Harper, 2007: 2).

Sexes, genders, sexualities: Final considerations

We do not know much about Alex: she has been raised a girl, and there is something 'special' about her. Her body is flat and thin, as yet bearing no sexual mark. It is through sexual activity that we learn that despite being a girl, she can penetrate a man. She has 'never done it', as she tells Alvaro the first time they meet, and when she has the opportunity, her choice is to penetrate violently rather than to be penetrated. This fact leads her father to believe she 'is' a man: from an active sexual role as inserter, gender and sex are inferred. Genitalia and sexual role are shown here as key features for identity construction. In terms of the latter, this reminds us of those systems in which the former was the determinant of the reclassification of the person according to 'hermaphrodite' status (prior to the eighteenth century); that is, when gender and sex roles were prioritized over sex in social classifications.

In a cultural context, where the system of sex/gender/sexuality is conceived as unidirectional and binary (men-masculine-heterosexual equated with an 'active' role; women-feminine-heterosexual equated with a 'passive' role), sexual activity in a girl like Alex is a double transgression: she is active with a man and she is active as a man. But homosexuality is never mentioned in the film in relation to Alex because at this stage she is still conceived as a girl; it is after the sexual act that her role is interpreted as the definitive sign that she is a man. In Alvaro's case, the result is different; his role as the one who is penetrated is considered to be the evidence that he is what his father feared, 'a fag'. Both Alex and Alvaro discover something relevant about themselves through sexuality: a sex act that apparently takes place between boy and girl ends up revealing that the girl has a penis and the boy is a homosexual. That act is central to the film and to the plot.

We have seen how, historically, hermaphrodites were tolerated if they chose one gender and did not change the roles assigned to it. In the film, however, and although it is through violence, Alex assumes both active and passive roles. The fact that the first act with Alvaro is violent but consented to differentiates it from her rape on the beach. In any case, it is again through sexual activity that we learn about the specificity of her 'identity'.

Apart from the centrality of sexuality for identity construction, pro- and anti-surgery positions are very well defined in the film. Within both positions, the underlying belief that there is only one true sex with corresponding anatomy (female for Alex's mother, male for Alex's father) is only questioned by the intersexed characters themselves, namely Alex, who is willing to refrain from choosing, and the female-to-male intersexual who refers to castration. They introduce a deep and subtle questioning of binarism, underscoring the need for the person's consent.

'Why do I have to choose?' asks Alex. She does not fear exclusion as a result of her decision to refrain from choice because intersex is not broached as extraordinary in itself, but in the reaction it provokes. The presence of two intersexed characters helps us understand that this is not such a 'strange' phenomenon. However, we do not know

where Alex's decisions regarding the refusal to opt for sex reassignment will take her. The film is open-ended because its primary focus lies in the presentation of intersex along with social reactions and protocols. Both social pressure and peer support are apparent: once Alex's close friends know about the issue, they give her their backing. Surprise, incredulity and mystery give way to comprehension, respect and help, and the result is a sense of 'normalcy' achieved through the visibility of difference.

This de-pathologization of intersex and normalization that the film seems to invoke is counterbalanced by some 'dramatic effects': only 25 per cent of intersexuals are born with genital ambiguity, but Alex seems to have 'both', something which is extremely rare, but is connected to popular and mythological images of hermaphrodites. Moreover, both of the organs, vagina and penis, are functional, as we learn from the two sex acts performed. Violence in those acts constitutes a dramatic element. In more general terms, the violence in the film is both implicit and explicit: the former in the terms used ('enemies', 'normal'), and the latter in the scenes of sex with Alvaro and the rape. Suspense, uncertainty and doubt are also used as dramatic elements. Terms like 'intersex', 'hermaphrodite' or 'surgery' are never explicit, despite cutting across the entire film's production. Alex itself is a name that can be used for boys and girls, in line with doctors' recommendations to resort to 'neutral' names in intersex cases.

Biology—as a reference to naturalized and essential identities—and medicalization are ubiquitous themes, not only due to Alex's transformations (as a result of puberty and assumption of her specificity), but also because of the characters' professions (Kraken and Ramiro).

Alex is a clear example of a non-standard body, non-standard sex and non-standard gender. In her story, we can clearly trace the tensions and conflicts over the historical need for the definition of a true sex, gender and body that was strengthened at the end of the nineteenth century by the modern state's disciplinary methods with which to control individuals and personal truths, the latter implying duplicity and the conscience that duplicity can exist in this particular case.

However, as already mentioned, the search and need for only one sex is paradoxical, as medical protocols are not definitive on the matter: the relation of sex to gender and of either one to anatomy, as exemplified by the Diamond/Money controversy, is not yet resolved. And it remains unsolved in the film: based on the same 'reality' (Alex's body), her mother sees a girl and her father a man. In this context, Alex poses the most relevant of questions, that of personal choice.

Although intersexed people generally identify themselves as men or women, Alex's potential desire to exercise the right to choose and change the gender according to which she was raised would not only question binarism, but also any permanence within the assigned gender. Her refusal to choose to change goes a step further, as permanence in one's gender was the condition for tolerance of hermaphrodites when the three sexes model was hegemonic, as previously explained.

If we read this film production in relation to the socio-cultural discourses on sexes, genders and bodies, we can easily align the characters according to the classical division between heroes—those who question and fight social conceptions (Alex, the other intersexual, her friends, her father)—and villains (assaulters and pro-surgery characters)—who are firm believers in the social need for one sex and the consequent requirement for surgical intervention to make non-standard bodies conform to socio-cultural standards. However, heroes are also prone to doubt and suffering, and need to overcome the deep-seated social conceptions of sex and gender that they have internalized. Harper (2007: 7) explains the situation as follows:

> The concept of a sexless utopia where gender is acted out rather than fixed (Butler, 1990) and is therefore always a work-in-progress (Kessler, 1998) and where the simple dichotomies of sex and gender, and the essentialisms of biological determinism, are destabilized within a biology increasingly understood as medically invented (Domurat Dreger, 1998a), remains peripheral to mainstream thought. Separation of sex from gender, so that, for example, a female (sex term) can operate as a boy or man (gender terms), and a male (sex term) can operate as a girl or woman (gender term) continues to present a cultural challenge in actuality (Diamond and Beh 2006).'

The film is deeply revealing and elicits conflicting feelings of exclusion, shame and courage. It escapes 'raw' exhibitionism (an easy resource) by very subtly treating delicate and profound issues. Only at the end do we learn that Alex was to have been operated on shortly after birth. Only at the end can the spectators establish connections between scenes and understand that medical protocols on intersex are based on surgical sex reassignment. Only at the end are all elements (surgery, gender, sex) fully comprehended and, only then, do we understand what 'abjection' means: 'it is thus not lack of cleanliness or health that causes abjection but what disturbs identity, system, order. What does not respect borders, positions, rules.' (Kristeva, 1982: 4).

Bodies which do not respect borders, positions and rules are bound to be reconstructed and redefined in order to make them intelligible. As a necessary condition for identity, sexed and gendered bodies become a place for control, oppression and resistance. This film faces and questions this reality.

Endnotes

1. All translations are by the author.

2. Harper's book (2007) references eight media productions on intersex in Britain from 1996 to date (TV dramas, documentaries, film epigraph).

3. `http://xxylapelicula.puenzo.com/main.html. Retrieved 1 October 2008.

4. Foucault defines the politics of truth as politics that refer to those relationships of power that circumscribe in advance what will and will not count as truth, which order the world in certain regular and regulatable ways, and which we come to accept as the given field of knowledge (in Butler, 2004: 58).

5. As two French experts observed, 'the possession of a (single) sex (as male or female) is a necessity of our social order, for hermaphrodites as well as for normal subjects' (Domurat Dreger, 1999: 9).

6. A 'true hermaphrodite' is typically defined as having both ovarian and testicular tissue, either presented separately as one testis and one ovary; or mixed as an ovary and an ovotestis; two ovotestes; a testis and an ovotestis; or one single ovotestis.

7. Genetic testing for athletes—particularly women—was incorporated in 1968 but abandoned in Sydney (2000). Nevertheless, the Beijing Olympic Games (2008) used these tests to confirm sex identity, see http://www.guardian.co.uk/sport/2008/jul/30/olympicgames2008.gender. Retrieved 1 May 2009.

8. October 2009.

9. See http://www.elpais.com/articulo/deportes/pudor/Semenya/elpepudep/20090910elpepudep_12/Tes (28 Spt 2009) and http://www.marca.com/2009/09/11/atletismo/1252661927.html. Retrieved 28 September 2009.

10. XXY karyotype is generally related to Klinefelter syndrome, not to intersex. Klinefelter's is quite common, occurring in 1/500 to 1/1,000 male births. Some people with Klinefelter's have ambiguous anatomy and some consider them intersex and do not identify them as 'male', but the Klinefelter Syndrome Association (UK) strongly asserts that 'we are male', although some develop female gender identities.

References

Bolin, A., 'Traversing gender: Cultural context and gender practices', in S.P. Ramet (ed.) *Gender Reversals and Gender Cultures*, London, Routledge, 1996, pp. 22–51.

Boswell, J., *Christianity, Social Tolerance and Homosexuality*, Chicago, University of Chicago Press, 1980.

Butler, J., *Gender Trouble*, New York, Routledge, 1990.

Butler, J., *Bodies that Matter. On the Discursive Limits of 'Sex'*, New York, Routledge, 1993.

Butler, J., *Undoing Gender*, New York, Routledge, 2004.

Cucchiari, S., 'The gender revolution and the transition from bisexual horde to patrilocal band: The origins of gender hierarchy', in S. Ortner and H. Whitehead (eds) *Sexual Meanings. The Cultural Construction of Gender and Sexuality*, Cambridge, Cambridge University Press, 1981, pp. 31–79.

Diamond, M., 'Management of intersexuality: Guidelines for dealing with persons with ambiguous genitalia', *Archives of Pediatrics and Adolescent Medicine*, 151 (1997), pp. 1046–1050.

Diamond, M. & Sigmundson, H.K., 'Sex reassignment at birth: Long term review and clinical implications', *Archives of Pediatrics and Adolescent Medicine*, 151 (1997), pp. 298–304.

Domurat Dreger, A.D., 'Ambiguous sex or ambivalent medicine?', *The Hastings Center Report*, 28:3 (1998), pp. 24–35 (see www.isna.org).

Domurat Dreger, A.D., *Hermaphrodites and the Medical Invention of Sex*, Cambridge, MA, Harvard University Press, 1998.

Domurat Dreger, A.D., *Intersex in the Age of Ethics*, Maryland, MD, University Publishing Group, 1999.

Enguix, B., 'La construcción del sexo', in *Actas del IX Congreso de Antropología de la Federación de Asociaciones de Antropología del Estado Español*, Barcelona, Institut Català d'Antropologia, 2002 (CD).

Fausto-Sterling, A. et al., 'How sexually dimorphic are we? Review and synthesis', *American Journal of Human Biology*, 12 (2000), pp. 151–156.

Fausto-Sterling, A., *Sexing the Body. Gender Politics and the Construction of Sexuality*, New York, Basic Books, 2000.

Foucault, M., *Historia de la sexualidad. La Voluntad de Saber*, Madrid, s. XXI, 1984.

Foucault, M., *Herculine Barbin llamada Alexina B*, Madrid, Revolución, 1985.

Gregori Flor, N., 'Los Cuerpos ficticios de la biomedicina. El proceso de construcción del género en los protocolos médicos de asignación de sexo en bebés intersexuales', *AIBR, Revista de Antropología Iberoamericana*, 1:1 (2006), pp. 1–5 (e-edition).

Halberstam, J., 'The transgender gaze in *Boys Don't Cry*', in N. Mirzoeff (ed.) *The Visual Culture Reader*, London, Routledge, 1998, pp. 669–676.

Hall, S. (ed.), *Representation. Cultural Representation and Signifying Practices*, London, Sage, 1997.

Harper, C., *Intersex*, Oxford, Berg, 2007.

Herdt, G., *Third Sex, Third Gender. Beyond Sexual Dimorphism in Culture and History*, New York, Zone Books, 1993.

Intersex Society of North America, www.isna.org. Retrieved 1 May 2009.

Kessler, S.J., *Lessons from the Intersexed*, London, Rutgers University Press, 1998.

Kipnis, K. & Diamond, M., 'Pediatric ethics and the surgical assignment of sex', in A.D. Domurat Dreger, *Intersex in the Age of Ethics*, Maryland, MD, University Publishing Group, 1999, pp. 173–195.

Kristeva, J., *Powers of Horror: An Essay on Abjection*, New York, Columbia University Press, 1982.

Laqueur, T., *La construcción del sexo. Cuerpo y género desde los griegos hasta Freud*, Madrid, Cátedra, 1994.

Laurent, B., 'Sexual Scientists question medical treatment of hermaphroditism', *The Treatment of Intersexed Infants*, 1995, http://songweavr.com/gender/intersex.html. Retrieved 5 May 2009.

Mathieu, N.C., *L'Anatomie politique: Categorizations et ideologies du sexes*, Paris, Côte Femmes, 1991.

Meñaca, A., 'Presentación: Género, cuerpo y sexualidad. Cultura y ¿naturaleza?', *AIBR, Revista de Antropología Iberoamericana*, 1:1 (2006), pp. 1–5 (e-edition).

Nanda, S., 'Hijras: An alternative sex and gender role in India', in G. Herdt (ed.) *Third Sex, Third Gender*, New York, Zone Books, 1993, pp. 373–418.

Pare, A., *Monstruos y prodigios*, VI, Madrid, Siruela, 1993.

Piñuel Raigada, J.L., 'Epistemología, metodología y técnicas del análisis de contenido', *Estudios de Sociolingüística*, 3:1 (2002), pp. 1–42.

Ramet, S.P. (ed.), *Gender Reversals and Gender Cultures*, London, Routledge, 1996.

Rubin, G., 'The traffic in women: Notes on the political economy of sex', in R. Reiter (ed.) *Toward an Anthropology of Women*, New York, Monthly Review Press, 1975.

Samango-Sprouse, C., 'The hidden disability: Sex chromosome variations', *News Exchange*, 4:4 (1999), www.genetic.org. Retrieved 10 May 2009.

Stolcke, V., 'Is sex to gender as race is to ethnicity?', in T. del Valle (ed.) *Gendered Anthropology*, London, Routledge, 1993, pp. 17–37.

Trumbach, R., 'London's Sapphists: From three sexes to four genders in the making of modern culture', in G. Herdt (ed.) *Third Sex, Third Gender*, New York, Zone Books, 1993, pp. 111–136.

Weeks, J., *Sex, Politics and Society: The Regulation of Sexuality since 1800*, New York, Longman, 1989.

United Kingdom Intersex Association, www.ukia.co.uk. Retrieved 1 October 2008.

Vázquez, F. & Moreno, A., *Sexo y razón. Una genealogía de la moral sexual en España*, Madrid, Akal, 1997.

Weininger, O., *Sexo y carácter*, Buenos Aires, Losada, 2004. http://xxylapelicula.puenzo.com. Retrieved 1 November 2008.

Zhang, L., 'One game, different players: The coverage of 2008 Olympics by three Chinese newspapers', in *Proceedings of the ICA Conference*, Chicago, International Communication Association, May 2009.

Chapter Eight:
Disciplining Fantasy Bodies In *Second Life*

Georgia Gaden and Delia Dumitrica

Introduction

> 'Big breasts, long legs and pumped-up pectorals—that's what the avatars in *Second Life* seem to be all about.'
>
> (Delia, December 2007)

If you join the popular virtual world *Second Life* (SL), you may find yourself—as we did—in a place that is both familiar and surreal. That we live in a world where a sexualized appearance still matters is old news. That you can buy a 'skin' with genitalia remains (at least for now) bizarre. In SL, this surrealism becomes not only possible but suggested through a complex web of technical constraints and social dynamics as the means for an authentic life, freed from the restrictions of physical corporeality. Constructed as 'a real world, only better' (Ondrejka, 2004), where better stands for an 'almost unlimited freedom' to create and appropriate virtual bodies (SL Frequently Asked Questions), SL promises self-fulfillment through personal agency. Yet, what exactly does it mean to be a creative agent shaping your (virtual) body in this environment?

Here, we propose a reading of the creation and maintenance of our virtual bodies as a process of self-discipline as well as creativity. While virtual environments may provide self-fulfillment for some, this does not necessarily mean that they are spaces of freedom. We argue that SL rests upon and reinforces an essentializing vision of gender as a male/female dichotomy, informed by both patriarchal and postfeminist neo-liberal discourses. It is *within* this vision of gender that we can exercise our agency for moments of personal gratification, perceived empowerment and resistance.

Second Life is a three-dimensional environment, accessible via the internet, where users interact in real time. Boasting 12.5 million registered users in January 2008 (SL Blog, Key Economic Metrics), SL has been widely advertised as an alternative reality and not a game. This means that it is offered as a platform for anyone interested in doing something in-world, with many institutions, ranging from businesses to higher education establishments, investing in a virtual presence. Our analysis is based on six months of collaborative autoethnographic research in SL (from November 2007 to April 2008).[1] Captivated by the buzz of the discussion going on about this new 'world' (in both academic and media contexts), we joined it with the purpose of trying to understand more about the dynamics of gender and agency in this environment. We kept journals detailing our experiences and thinking during this time, and met frequently to discuss our thoughts.

Our discussion is framed by Foucault's concept of 'Technologies of the Self' (Foucault, 1988). Here, Foucault juxtaposes the Greek and Roman philosophies of 'caring' for the self with the Christian ethic of 'purifying the self' in an exploration of the 'history of how an individual acts upon himself' (Foucault, 1988: 19). If the first consists largely of processes of introspection to improve the self, the second concerns the constant surveillance and confession (oral and written) of the self so that it can be disciplined (Foucault, 1984; 1988). Foucault proposes that we think of such practices, including the more physical ones of acting upon our bodies (e.g. early Christian practices of self-flagellation or cilice-wearing), as both means through which we assert ourselves as free agents, and as ready-made models that are 'proposed, suggested, imposed upon [the individual] by his culture, his society, and his social group' (Foucault, 2003: 34).

In his earlier work, Foucault was preoccupied with the disciplinary dimension of the relationship we have with our own bodies (Foucault, 1975; 1978; 1979; 1980). In the context of modernity, he argued, the body becomes a crucial resource and a subject of power. Increasingly, an institutionalized medical discourse turns the body into an object of study, which is fragmented into parts, dissected and classified as normal/ abnormal. Gradually, this discourse comes to control the body by providing standards and norms through which it comes to be evaluated and, ultimately, shaped. As this discourse spills over from the particular institutions promoting it (the hospital, the prison or the school) to everyday life, it contributes to a 'state of conscious and permanent visibility [of the body—our note] that assures the automatic functioning of power' (Foucault, 1979: 202). This Panopticon model, as he calls it, may at first be imposed on the individual, but with time it becomes internalized, and self-disciplining the body becomes an end in itself; the 'glorification of the body beautiful' (Foucault, 1980: 56).

Following Foucault, we hold that our relationships with our own bodies cannot be divorced from the power configurations of our societies. It is this arrangement of power that creates and legitimizes certain discourses about the desirability, the aesthetics and the ethics of the body. As we internalize these discourses, we act upon our bodies, shaping them towards an ideal that is simultaneously of our own making and a normative model through which we

become enrolled in existing power arrangements. In his later work, Foucault had become more interested in the recuperation of desire and pleasure through our bodies, as a means of escaping this oppression. Somewhat enigmatically, he advices us to create the self—and by implication, the body—as a 'work of art', refusing to buy into the dominant discourses and instead reshaping them into something of our own making (Foucault, 1984; 1988).

Here, we draw together these concepts: the technologies of the self, discipline and self-surveillance, and the opportunity for creativity and resistance in our engagement with our own experiences in SL. What is, we ask, the role of wider discourses about gender and beauty as we immerse and embody ourselves in a virtual world? And what is the role of these discourses in the technical design of the world itself? How do acts of disciplining your virtual body to become a member of that virtual world interplay with the moments of creativity, personal gratification, play and resistance to the normativity of the world? In exploring these questions, we focus on three inter-related moments that framed our experience of SL: the creation of our avatars, their subsequent modification to 'fit' in with the world we began to know and our own perceptions of the other avatars we encountered.

Creation of avatars

> 'After spending some frustrating 30 minutes trying to get some decent clothes on, and after realizing that I cannot change my shape so easily, I started wandering.'
>
> (Delia, 6 November 2007)

In November 2007, we became SL 'newbies' (new users).[2] The moment of creating an avatar is crucial: it is the first act of participating in an as yet unknown world, and is instrumental in creating expectations and framing behaviour in this new place (Axelsson, 2002). In fairness, we did not come to the world with clean slates, but brought with us both our previous knowledge of online avatars and virtual games, and our expectations of what SL was supposed to be like.[3] Our understanding was that in many such environments, the construction of gendered avatar bodies remained connected to a predominantly heteronormative male gaze (Berger, 2002; Corneliussen and Mortensen 2006; Cassell and Jenkins, 1999; Grimes, 2003; O'Riordan, 2006; Reinhard, 2006; Schleiner, 2001; Schröder, 2008; Zdenek, 1999). However, SL was first introduced to us as a place of opportunity and empowerment. From the outset, the process was one of learning; not only did we have to get accustomed to manipulating our avatars, but we also had to negotiate the integration of our previous knowledge and expectations with a recognition of the recommendations and structural configurations of the platform.

After selecting names for our avatars, we were prompted to 'choose one of the many different styles we have created for you. And remember, there are [an] almost unlimited number of choices of how you can look after you enter *Second Life*' (SL Select an Avatar). In spite of this expectation of (almost) endless possibilities, we were in fact required to choose between a rather predictable male/female pair.[4] The initial avatar selection page depicted two figures in silhouette, with options for default avatars likewise presented in two columns. The presentation and construction of 'male' and 'female' avatars followed a normative gender discourse. The 'female' physiognomy was marked by prominent eyes with long eye-lashes and red-coloured lips, while the silhouette had a smaller waist to hip ratio, thin arms and long hair. The 'male' form was generally marked by the absence of the 'female' features, with the occasional facial hair add-on; the silhouette was also bigger and taller, with broad shoulders, well-shaped arms and short hair.

We put our avatars together by selecting from the pre-determined options provided by the SL platform. In this process, we certainly possessed some agency in our choices; for instance, Delia, who wanted to experiment with gender swapping in this environment, chose a 'male' avatar. By successfully representing our digital bodies, we established ourselves as skilled social actors, able to navigate through the various models provided—we were participating in the social dimension of the environment. Our recognition of the options provided by SL as specifically 'male' and 'female' derived from our own understanding of 'real life' (RL) gender discourses investing specific physical parts as hypersexualized gender markers. The avatars were not textually labeled; we read and interpreted these cues. Our RL experiences as heterosexual women, expected to fulfill certain ideals of feminine beauty in a Western cultural environment, framed this interpretation, and we drew upon this knowledge in order to make sense of the milieu we were entering and negotiating.[5]

Our response to the experience of avatar creation in SL was two-fold: on the one hand, the pre-determined options and our familiarity with the forms presented to us made creation easy. Bringing our nascent avatars into being might be read as a technology of our virtual selves in the most obvious, formative way. However, as Foucault notes, 'The self is not clothing, tools, or possessions. It is to be found in the principle which uses these tools, a principle not of the body but of the soul' (Foucault, 1988: 25). At this point, our actions upon and with our avatars had produced, for us, a feeling of a lack of control. We had joined SL to play with gender representation and we were disappointed by the predictability of the options. It also reminded us of our imagined audiences. While Delia was concerned with being cool and fashionable, Georgia created an avatar with a plain appearance. This too was a deliberate choice, an act of resistance against the perceived hegemony of a particular vision of beautiful, gendered bodies in SL. Throughout, we could not unhinge ourselves from the belief that physical appearance would be important, that it would *count* in the social landscape we were entering, that it might frame our interactions with other 'people' in SL, that our self-presentations would be interpreted by these people and that it was up to us to control these responses as much as we could.

Modification of avatars

Our preoccupation with the appearance of our avatars did not stop with their creation. As we began to suspect, even in our first days in SL, understanding that your appearance tells other people who you are applies equally to a virtual presence.[6] Particularly in a world like SL, your visual appearance says a lot about you (Boellstorff, 2008; Castronova, 2004; Webb, 2001) although not necessarily in terms of representing your RL looks, but rather in terms of your competence in the environment:

> The girls are dancing [in a SL night club], with lascivious moves, scantily dressed. I feel I'm under-dressed for this place…I tried to change my outfit but I'm not happy with the options embedded in the system…As I tried to improve my clothes, I realized that I cannot really do that without technical skill. (Delia, 16 January 2008)

> I have been wanting to do something with [my avatar's] appearance and tomorrow I think I will go to a sandbox and try to figure out how to unpack those free clothes I got ages ago. Really, I find the time consumed doing these things very frustrating…I wonder if I will always feel an outsider in SL because my avatar betrays my lack of commitment to the 'game'. (Georgia, 27/28 February 2008)

For both of us, modification of our avatars followed observations of our sense of their inadequacy. We compared ourselves, not only to the other avatars we saw, but with the images advertising avatar body-parts and clothing for sale which were prevalent throughout the environment. These images were almost exclusively of Barbie-and-Ken-like bodies: large breasts and tiny waists, broad shoulders and muscular physiques. The relentless parade not only provided powerful visual cues for our interpretation of the milieu (Dumitrica & Gaden, 2009) but also gave us clear and familiar standards against which to measure our own digital bodies. In this setting, 'commitment' represents more than a determination to participate; it also stands for a knowledge of both the mores of social interaction and the technical infrastructure of the platform. As we gained experience in SL, we increasingly re-constituted our avatars in relation to what we observed and experienced, becoming aware that a sloppy example signalled a lack of skill and experience of the game: when 'you look like a newbie, you look like you do not have the skill, there's nothing special about you' (Delia's diary, 16 January).

In SL, there are three main ways of modifying avatars. First, and most easily accessible, was the standard avatar modification editor provided by the platform. This allowed us to change our facial features, hair and body-shape, and also afforded us a basic repertoire of clothing and gestures (neatly divided into 'male' and 'female'). Secondly, we could learn

how to make our own 'skins' and clothing using yet another graphic editor tool provided by the platform. However, it transpired that in spite of our being somewhat experienced with such tools, the SL version proved difficult to master. Using it required not only a more advanced level of technical skill, but also the willingness and resources to invest our time and energy into learning how to make realistic body parts or clothes. Finally, we could buy anything that pertained to our virtual physical appearance, or occasionally get it for free from various shops. Shopping is big business in SL[7] and buying such virtual enhancements requires financial investment on the part of the user.[8] Interestingly, this is also the route often recommended in literature produced by enthusiastic residents of SL:

> if I were you, I'd come up with the $10 or $20 it costs to buy a skin and shape designed by a talented SL artist…the constraints of current SL rendering possibilities…along with the huge number of interacting variations, not to mention possible limitations to your talent as a sculptor and make-up artist, make it quite time consuming to create your ideal look. (Mansfield, 2007: 55)

We modified our avatars using a combination of the items/options available by default and by picking up free goods, mostly obtainable at freebie malls and other shopping/social locations. Delia, in particular, often scoured these places looking for additions to her avatar's inventory. However, as our journals suggest, these options often seemed to lack the pizzazz or style of the more elaborate, costly items: 'I felt self-conscious in my jeans and t-shirt so I did some clothing work for my avatar…I felt like Molly Ringwald from *Pretty in Pink*.' (Georgia, January 2008)[9]

The modification of our avatars appeared to us to be part of the socialization within the world, framed by our initial impression of joining SL and reinforced throughout our journeys by comparisons with other avatars and by what we perceived as prevalent avatar shapes, parts and paraphernalia. Importantly, the parameters within which this modification was to take place were strongly suggested by the platform itself providing the categories through which we were to understand our virtual bodies: essentialized male/female shapes, attention to those body parts available for modification and the labels used for the animation scripts.[10] All of these constituted the pre-established social models at once suggested and imposed upon us (Foucault, 2003). Yet, such models are never fully hegemonic; they also create spaces and strategies of resistance. With a male avatar, Delia willingly bought into this understanding; it was, for her, more of a game and she found herself more willing to explore social areas and to interact with other avatars. On the other hand, Georgia found it less easy to play along; as she tried to strip her female avatar of her hypersexualized gender markers, she struggled with feelings of fear and isolation. She realized she was more comfortable exploring places requiring little social interaction. Our experiences and strategies emerged as processes of adapting to a world perceived as given.

And although these strategies could give us a sense of gratification and comfort, while we were active agents this didn't make us powerful vis-à-vis the structure. We were becoming proficient in the gender discourse embedded in SL, but we could not affect it.

Perception of avatar bodies

From the beginning of our journeys, we were 'looking' at other avatars through gendered lenses, unconsciously referring to them as 'she' or 'he', and becoming fixated on particular characteristics (those body parts and behaviours) as defining their gender:

> I found this female avatar…She has really big breasts, couldn't help noticing them, with the cleavage showing over her top. (Delia, 26 November 2007)

> The first things I saw were these two girls on the floor…Why do they have these long, slim legs?…Is this because what we all sell is appearance, sexualized appearance? (Delia, 2 January 2008)

The hypersexualization of avatars is not something specific to SL, but is common to many virtual environments (Reinhard, 2006; O'Riordan, 2006). In SL, it was not restricted to 'female' avatars but seemed to govern the appearance of many of the virtual bodies we encountered. For us, it was impossible to divorce this hypersexualization from our knowledge and experience of a patriarchal discourse, where women's bodies are transformed into sexual objects for the fulfillment of prescribed male desires. Our perceptions of other avatars made it clear to us that the dominant version of what it meant to render oneself successful (when in humanoid form) closely followed traditional (to us) models of masculinity and femininity. This understanding of what it meant to have a desirable (virtual) body was further solidified in our encounters with the economy of SL.[11] Some of the most popular places that we visited[12] were in fact virtual shopping malls where your avatar can purchase (or at times get for free) a variety of virtual items, ranging from a shape or skin to a script which makes your hair flow with the wind. These products are usually displayed in the form of large advertising billboards, which can be clicked on for more information or to engage in a transaction. From the very beginning, we noticed the sheer abundance of this kind of advertising for body parts and clothing, an abundance that reminded Delia of 'porn' because of the predominance of particular imagery:

> I glance over the posters on the walls. It's all about boobs and butts, about big eyelashes and round eyes, and, of course, Angelina Jolie's lips…so much sex-market around here. (Delia, 16 January 2008)

This visual bombardment served to reinforce in powerful terms (Dumitrica & Gaden, 2009) the norms of appearance in the SL environment. Re-reading our journals, we considered how the ubiquity of naked, sexualized bodies and body parts produced different reactions in us. On the one hand we wanted to fit in, and felt out of place. On the other, the appearance of other avatars and the prevalence of what we read as highly sexual imagery produced, especially in Georgia, the desire to protect her avatar (and herself) against unwanted sexual attention (whether this was a reality or not). In response, she modified how her avatar looked according to her own understanding of what kind of appearance might protect her in this way.

We soon noticed that the presentation of these virtual bodies was also characterized by an effort towards achieving a 'realistic' effect. In fact, this was often what largely distinguished a 'nice' avatar from a 'sloppy' one—again betraying the skill or material resources of the typist. As noted before, our rudimentary experiments with editing tools and freebie finds at the shopping malls in SL did not seem to compare favourably with the appearances of those we observed: our garb was poorly rendered, lacking detail, realism and animation. The 'realistic' faces and bodies we saw reminded us of airbrushed magazine images: flawless, without the imperfections and impurities which characterize human skin.

It was largely the perception of avatars (our own included) and the presence of avatar-related advertisements that became a 'mirror of the self' (Foucault, 1988: 25) through which we constructed our understanding of the culture of gendered bodies in SL and our positions therein. In this way, we interpreted what it meant to create and possess a successful body, trying to fit in while feeling uncomfortable with the norms of the milieu which seemed underpinned by discourses bringing together the hypersexualized body, its commodification and the importance of a successful body 'beautiful'. Whether we reproduced the seemingly dominant vision or resisted it, we had to adopt its perspective in order to make sense of the other avatars and, thus, the social landscape in SL.

Discussion

We began by asking what it means to be a creative agent intervening upon your body in a virtual environment such as SL, and how this connects to a (possibly) new understanding of gender. We would like to propose here that this creative agency cannot be divorced from a process of self-disciplining our bodies as we bring each (available) part in line with or against the normative gender discourses of the SL platform. In our experience, this normative gender discourse is intrinsically connected to the prevailing vision of gender within our RL social context, since designers often choose (whether consciously or not) to play upon stereotypes to make their products appealing (Zdenek, 1999) and we, as users, draw upon the conventions and understandings of our RL experiences.

As we have described, from the outset and throughout our journeys in SL, we acted upon our virtual bodies in various ways. And while we also work on our RL selves, in a virtual environment such as SL the promise is for a far wider scope of control and agency in this process. In the construction and maintenance of our virtual bodies we were, with every keystroke and mouse-click, bringing our virtual selves into being and negotiating these new bodies in this new environment. And, yet, although we could see possibilities for creativity, our observations and experiences suggested that the platform itself was built on a particular understanding of gender as an essentialized male/ female binary, paying obvious attention to particular body parts deemed, particularly in our own cultural context, to be markers of sexualized, desirable and fit gendered bodies.[13] In his discussion of technologies of the self (and in those of the others who contributed to the Vermont seminar of the same name), Foucault makes it clear that those employed by individuals are inextricable from their historical and cultural contexts. While the ancients, for instance, were concerned with private reflection—often through various forms of writing (letters and diaries for example)—the early Christians took a more public and corporeal approach whereby penitence 'must be visibly represented and accompanied by others who recognize the ritual…What was private for the Stoics was public for the Christians' (Foucault, 1988: 40). Our experiences in SL were likewise situated: closely related to neo-liberal postfeminist discourses in contemporary Western society, discourses which celebrate the same public production and consumption of the sexualized body as a mark of emancipation, symbolizing a choice for women to claim an empowered sexuality, and as a freedom from feminist recrimination (McRobbie, 2007). In this environment the onus is upon individuals to seize the opportunity to create themselves in the form of their own desire, to achieve goals and realize dreams, and to be *successful.* In RL, this individual responsibility rests upon an economic environment where 'the individual…has become his/her own branded commodity' (Ouellette & Hay, 2008: 105). Here, looking 'good' is part and parcel of a self-presentation which stands to determine personal as well as professional achievement and (by association) happiness, while consumption becomes associated with a sense of personal gratification and pleasure (Ouellette & Hay, 2008; Roberts, 2007). Through self-inspection, critique and extensive consumer activity we can produce a body worthy of admiration and respect, allegedly bringing to light our 'true' or 'authentic' self.

SL is presented as an environment where these possibilities are even more democratically available and where individual creativity reigns. Indeed, an environment like SL is particularly interesting because it presents opportunities for self-modification that are unavailable or perhaps simply more difficult in RL. As one of the numerous fashion orientated SL bloggers writes: 'in SL, unlike in RL, we can wear whatever we want, whenever we want, and we can change our look completely in a matter of seconds' (SL Fashion Addict, 30 November 2007). In SL, a typist can play with the appearance of their avatar, adding tattoos, changing hair colour, switching gender or race. However, as

we found in our explorations, this freedom becomes an individual responsibility to create and modify your avatar in relation to particular norms defining the 'beautiful avatar body'. These norms include elements of hypersexualism and gendered dichotomies that are familiar to us from RL, as well as aspects that are specific to the virtual realm, such as a particular understanding of 'realism' that is enabled through special effects (e.g. scripts for glittering or moving clothing). Participating in and stepping outside of these discourses (i.e. going beyond the basic defaults offered by the platform) require skill, time and even a monetary commitment that is simply unavailable to everyone. These skills and resources are the material enablers of a SL virtual class system. The technologies of the self we can practice upon ourselves through our virtual selves are thus disciplined through this class system.

The process of discipline with which we are primarily concerned here also lies in the very actions we performed upon our avatars. As we spent more time in the environment, observing other avatars and discovering the ways in which we could act in SL, we came to internalize an understanding of gendered beauty which seemed to be embedded in the platform and refined by the SL inhabitants. However, we were not only continually looking at other avatars. In SL, users are able to adopt a point of view whereby the display either appears as if through the eyes of their avatar or externally, looking at their avatar in action (from an adjustable distance), and we both found the latter perspective easier to use (especially as newbies, when manoeuvring was a challenge). Here, like the participants in makeover shows who are constantly encouraged to self-scrutinize using a variety of methods such as 'secretly shot' video footage, 360 degree mirrors and public displays in glass boxes (Ouelette & Hay, 2008; Roberts, 2007), we were confronted with our own physicality almost every moment we spent 'in-world'. This persistent visibility of our virtual selves reminded us when we did or did not 'fit in' with the picture and how we might be able to work on our avatar bodies. The constant scrutiny, which Foucault discusses as the new mode through which we create 'docile bodies' (1979: 137–138), became part of our own sense of self-esteem and worth, the mechanism through which we internalized the 'rules of the game'. Having our avatars at the centre of our perspective in SL felt like a virtual Panopticon in which we were both guardians and guarded:

> he who is subjected to a field of visibility, and who knows it, assumes
> responsibility for the constraints of power; he makes them play
> spontaneously upon himself; he inscribes in himself the power relation
> in which he simultaneously plays both roles; he becomes the principle of
> his own subjection. (Foucault, 1979: 203–204)

In this way, our experience and analysis suggest that the technologies we employ in the care and understanding of our gendered selves are engaged in a complex relationship with processes of discipline. SL was introduced to us as a place of opportunity and

freedom, and we acknowledge that these opportunities (although mediated as we have described) do exist and that our own experiences were not without moments of pleasure and creativity. Yet, as Kellner argues, the relationship between these personal moments and power configuration is more complex, as

> pleasures are therefore often a conditioned response to certain conditions and should thus be problematized, along with forms of behaviour and knowledge, and interrogated as to whether they contribute to the production of a better life and society, or help trap us into forms of everyday life that ultimately oppress and degrade us. (Kellner, n/a)

Indeed, as we worked on our virtual bodies, this work remained rooted within both the gender discourses of the environment and our offline contexts (which, for us, were inextricable), discourses that we were ultimately unable to affect but would always respond to even in our efforts at resistance.

Endnotes

1. For a more detailed description of method, see Dumitrica and Gaden (2009).

2. *Second Life* webpages have changed from that time. The process may no longer be identical to what we are describing here.

3. We were introduced to SL in the context of an academic conference (the 2007 conference of the Association of Internet Researchers), where it was showcased by a Linden Lab representative in terms of its potential for education.

4. In this paper, we will focus exclusively on humanoid avatars. Despite having both met several non-humanoid versions and reading about the existence of 'furry places'—places where non-humanoid avatars hang out—we did not see too many of them in our SL journeys.

5. It is important to point out that the creation of avatars is not, in itself, prescribing any role for either male or female avatars. It merely embeds those features of male/female bodies traditionally associated with normative gender discourses and a patriarchal power arrangement: muscular male bodies and smaller female ones.

6. For various discussions on the relationship between appearance and gender issues, see Keränen (2000), Finkelstein (2007).

7. The market of avatar bodies in virtual worlds has real monetary value in RL and is constantly growing. To give a sense of the magnitude of the SL market, the amount of USD exchanged in transactions over a month (January 2008) throughout the SL platform was around 2.2 million, while in-world sales in the same period amounted to $744,564 (SL Blog, Key Economic Metrics).

8. Beyond simply having money available to buy the currency used in this world, the user must own—and disclose—a credit card. We often forget that the availability of these cards is restricted to the industrialized world and the economic elite.

9. *Pretty in Pink* (1986) is a movie about American teenagers. The lead character, Andie (played by Molly Ringwald), makes many of her own clothes and does not fit in with the affluent kids at her high school.

10. In SL, various scripts are available to animate your avatar. For instance, in many locations, when you want to make your avatar sit down, you have a choice between a 'male' or a 'female' sitting pose. In other cases, scripts are used to animate the avatar's body parts, hair or clothes.

11. An interesting personal account about the economy of SL is provided by Ludlow and Wallace (2007).

12. In the first part of our journey, we tried to visit those places deemed 'popular' by the SL platform. The platform offers a map which shows popular locations, where popularity is defined by the number of avatars present there.

13. We should emphasize that we do not argue that SL is all about sex, nor that SL users are in the world for sexual purposes only. While everyone may come to SL with particular interests, and while there's an activity for everyone (from sex places to playing games or visiting virtual museums), our argument refers to the normative discourse of gendered bodies that frames the virtual existence in SL.

References

Axelsson, A.S., 'The digital divide: Status differences in virtual environments', in R. Schroeder (ed.) *The Social Life of Avatars: Presence and Interaction in Virtual Environments*, London, Springer, 2002, pp. 188–204.

Berger, A.A., *Video Games: A Popular Culture Phenomenon*, New Brunswick, Transaction Publishers, 2002.

Boellstorff, D., *Coming of Age in Second Life*, New Jersey, Princeton University Press, 2008.

Cassell, J. & Jenkins, H. (eds), *From Barbie to Mortal Kombat: Gender and Computer Games,* Cambridge, MIT Press, 1999.

Castronova, E., 'The price of bodies: A hedonistic pricing model of avatar attributes in a synthetic world', *Kyklos*, 57:2 (2004), pp. 173–196.

Corneliussen, H. & Mortensen, T., 'The non-sense of gender in neverwinter nights', in *Women in Games. Conference Proceedings 2005*, Dundee, University of Abertay Press, 2006, pp. 1-4.

Dumitrica, D. & Gaden, G., 'Knee-high boots and six-pack abs: Autoethnographic reflections on gender and technology in *Second Life*', *Journal of Virtual Worlds Research*, 1:3 (2009), pp. 1–23.

Finkelstein, J., *The Art of Self-Invention: Image and Identity in Popular Visual Culture*, Basingstoke, Palgrave Macmillan, 2007.

Foucault M., *The Birth of the Clinic: An Archeology of Medical Perception*, New York, Vintage Books, 1975.

Foucault, M., *The History of Sexuality, Vol. I: An Introduction*, trans. Robert Hurley, New York, Pantheon, 1978.

Foucault, M., *Discipline and Punish. The Birth of the Prison*, trans. Alan Sheridan, New York, Vintage Books, 1979.

Foucault, M., *Power/Knowledge: Selected Interviews and Other Writings 1972–1977*, Colin Gordon (ed.), trans. Colin Gordon, Leo Marshall, John Mepham & Kate Soper, New York, Pantheon Books, 1980.

Foucault, M., *The Foucault Reader*, in Paul Rabinow (ed.), New York, Pantheon Books, 1984.

Foucault, M., *Technologies of the Self: A Seminar with Michel Foucault*, in L.H. Martin, H. Gutman, P. Hutton (eds), Amherst, University of Massachusetts Press, 1988.

Foucault, M., 'The ethics of the concern of the self as a practice of freedom', in P. Rabinow & N. Rose (eds), *The Essential Foucault: Selections from the Essential Works of Foucault, 1954–1984*, New York/London, The New Press, 2003, pp. 24–42.

Grimes, S.M., '"You shoot like a girl!": The female protagonist in action-adventure video games', in *Proceedings of the 2003 DiGRA Conference Level Up in Utrecht, Utrecht, 2003*, http://www.digra.org/dl/db/05150.01496. *Retrieved 2 December 2007.*

Kellner, D., 'Media communications vs. cultural studies: Overcoming the divide', *Illuminations*, http://www.uta.edu/huma/illuminations/kell4.htm, date not available. Retrieved 17 May 2009.

Keränen, L.B., 'Girls who come to pieces': Women, cosmetics, and advertising in the *Ladies' Home Journal*, 1900–1920', in C.A. Stabile (ed.) *Turning the Century: Essays in Media and Cultural Studies*, Colorado, CO, Westview Press, 2000, pp. 142–165.

Ludlow, P. & Wallace, M., *The Second Life Herald: The Virtual Tabloid that Witnessed the Dawn of the Metaverse*, London & Cambridge, MIT Press, 2007.

Mansfield, R., *How to Do Everything with Second Life*, New York, McGraw-Hill Professional, 2007.

McRobbie, A., 'Postfeminism and popular culture: Bridget Jones and the new gender regime', in Y. Tasker & D. Negra (eds) *Interrogating Postfeminism*, Durham, NJ, Duke University Press, 2007, pp. 59–70.

Ondrejka, C., 'A piece of place: Modeling the digital on the real in *Second Life*', 2004, http://ssrn.com/abstract=555883. Retrieved 4 April 2008.

O'Riordan, K., 'Playing with Lara in virtual space', in D. Bell (ed.) *Cybercultures: Critical Concepts in Media and Cultural Studies. Vol I, Mapping Cybercultures*, London & New York, Routledge, 2006, pp. 247–259.

Ouellette, L. & Hay, J., *Better Living through Reality TV: Television and Post-welfare Citizenship*, Oxford, Blackwell Publishing, 2008.

Reinhard, C.L., 'Hypersexualised females in digital games: Do men want them, do women want to be them?', Paper presented at the annual meeting of the International Communication Association, Dresden, Germany, 2006, pp. 1–41, http://www.allacademic.com/meta/p89526_index.html. Retrieved 17 July 2009.

Roberts, M., 'The fashion police: Governing the self in *What Not to Wear*', In Y. Tasker & D. Negra (eds) *Interrogating Postfeminism: Gender and the Politics of Popular Culture*, Durham, NJ, Duke University Press, 2007, pp. 227–248.

Schleiner, A.M, 'Does Lara Croft wear fake polygons? Gender and gender-role subversion in computer adventure games', *Leonardo*, 34:3 (2001), pp. 221–226.

Schröder, A., '"We don't want it changed, do we?" Gender and sexuality in role-playing games', *Eludamos: Journal for Computer Game Culture*, 2:2 (2008), pp. 241–256, http://www.eludamos.org/index.php/eludamos/article/view/47/70. Retrieved 17 May 2009.

SL Fashion Addict, 'My name is Kets and I am addict', *SL Fashion Addict*, 30 November 2007, http://slfashionaddict.blogspot.com/2007/11/my-name-is-kets-and-i-am-addict.html. Retrieved 17 May 2009.

Second Life Blog, Key Economic Metrics through January 2008, 28 February 2008, https://blogs.secondlife.com/community/features/blog/2008/02/22/key-economic-metrics-through-january-2008. Retrieved 17 May 2009.

Second Life Frequently Asked Questions (n.d.), http://secondlife.com/whatis/faq.php. Retrieved 17 May 2009.

Second Life Select an Avatar (n.d.), http://secondlife.com. Retrieved 30 October 2007.

Zdenek, S., 'Rising up from the MUD: Inscribing gender in software design', *Discourse and Society*, 10:3 (1999), pp. 379–409.

Webb, S., 'Avatar culture: Narrative, power and identity in virtual world environments', *Information, Communication & Society*, 4:4 (2001), pp. 560–594.

SECTION III

GENDERED SOCIALIZATIONS

CHAPTER NINE:
REALITY TV'S CONTRIBUTION TO THE GENDER DIFFERENTIATION OF MORAL-EMOTIONAL REPERTORIES

Tonny Krijnen

Introduction

In its early days—the 1990s—reality TV evoked a great deal of debate (a case in point are programmes such as *Big Brother* and *Temptation Island*). Since then, the genre has widened and the term reality TV also incorporates factual programmes which 'give an unmediated account of events, often associated with the use of video and surveillance-imaging technologies' (Dovey, 2008: 136). Only the more extreme shows continue to be a topic of both academic and public deliberation. The arguments in the latter arena seem quite unambiguous: reality TV is accused of too much emotional display. Series and producers are said to be exploiting participants' genuinely held feelings in order to gain a few points in the ratings over their competitors. Additionally, or rather because of this 'emotion overload', reality TV is also regarded as one of the culprits to blame for society's moral decay. The genre's viewers are accused of gloating and experiencing *schadefreude* over the pain, humiliation and sadness of those taking part, which is interpreted as a sign of the devaluation of morality. Even though some academic studies of ethical issues focus on the richness of the genre and contradict these arguments (cf. Hawkins, 2001; Hill, 2005), reality TV as a questionable presence in society is more often acknowledged than denied. Two very important assumptions underlie these persistent arguments concerning the genre's suspicious content. First, and it may be superfluous to say so, the assumed relationship between the content and reception of reality TV is

unsophisticated: the content is thought to have a direct effect on the moral capacities of its viewers. Secondly, a false opposition between morality and emotions is constructed: when the content is emotional, it seems impossible for it to have a positive impact on its audiences' morality. In this chapter I take issue with both of these assumptions.

The starting point of my argument is that the content of reality TV is not necessarily bad or immoral. On the contrary, it can be seen as offering narratives for its viewers to engage with and employ to construct their own moral-emotional repertoires (cf. Krijnen & Tan, 2009). Furthermore, I will demonstrate how the imagination of emotions and morality in these shows, and the relationship between the two, is strongly gender-differentiated, shedding light on gender differences in moral-emotional repertoires. The primary research question is: *how is the relationship between emotions and morality imagined in the (Dutch) reality shows,* The Golden Cage *and* Farmer Wants a Wife, *and are these imaginations gender-differentiated?*

To answer this question, the content of the two reality shows referred to above—which present the extreme ends of the reality-TV spectrum—is analysed. *The Golden Cage* has been the centre of heated debate on a national and international level (Van de Velde, 2006; Wade, 2007). The programme is the primordial *Big Brother,* and situates ten participants (both men and women) in a luxurious villa. The last one standing wins the villa and 1 million Euros. The main difference to *Big Brother* is that the audience does not vote and the participants have to eliminate each other. Elimination in this case means that someone must voluntarily decide to leave. Because of this last feature, the show is often rejected for its immoral content as it is said to cause bullying and other malicious behaviour. The Dutch version of *Farmer Wants a Wife,* however, has been hailed by critics and audiences alike and is celebrated as an authentic, high-quality programme. The focus lies with single people (men) who look after a farm while looking for a partner, with the ultimate goal being to find love. After introducing themselves on TV, interested women can send a letter. The later episodes revolve around the farmers having to choose between the possible candidates. Starting with an initial ten, the farmers engage in different activities with the participants to decide which women they want to leave and which they want to stay, leading up to the final choice of one of them.

The programmes are different but also contain the traditional features of a reality show; they both provide factual entertainment, there is a psychological twist (in *The Golden Cage* participants have to eliminate each other, in *Farmer Wants a Wife* the farmer gets to choose the partner) and there is almost continuous video surveillance (Dovey, 2008). Therefore, analysing and comparing the two provides an excellent opportunity to investigate the gendered imagination of moral-emotional repertoires in the broad spectrum of reality television. To do so, however, it is necessary to carefully examine the assumptions underlying the evaluations of the genre.

Disentangling assumptions

The debates on the relationship between television and morality are flawed in two ways, namely by the presupposition of both an unsophisticated understanding of the link between television content and the reception thereof, as well as a false opposition between emotion and morality.

The relationship between content and its reception seems to be poorly understood in the public debates on morality and television. While in academia the concept of the 'hypodermic needle theory' is outdated (cf. McQuail, 2005), in the public arena the media are often understood as having direct effects in terms of either 'copy-cat behaviour' or a decline in moral values. In this chapter, reality TV's audience(s) are understood as heterogeneous and dynamic. Viewers actively engage with the moral and emotional content of the reality programmes they watch, employing their insights to construct moral-emotional repertories. Reality TV is understood as a narrative that offers its viewers an opportunity to reflect on moral decisions and choices and experience the consequences in terms of emotions without actually feeling them in real life (Rorty, 1989; Nussbaum, 2001). This enables the viewers to develop a moral-emotional repertory, a stock of beliefs and values that are primary to moral deliberations and choices in real life. The major difference as regards hypodermic needle theory is that the viewer does not passively incorporate ideas into his or her moral emotional repertories, but instead reflects on TV content with different results (as has been frequently shown by many scholars such as Ang (1985) and Liebes & Katz (1990)).

In accordance with the perspective on the active audience, the content of the TV narrative is pivotal for these experiments by the viewers. The observer can only try out moral situations and emotions that are imagined in the narrative (Nussbaum 2001). Therefore, it is important to study the content of reality TV on a moral and emotional level. Of course, individuals employ other narratives beyond televised ones, such as those deriving from family, friends, education and so on. Television, however, is one of today's most important suppliers (Allen, 1992; Gerbner, 1998).

In Nussbaum's (2001) and Rorty's (1989) formulation, the concepts of morality and emotion are laced together. When reflecting on moral issues the viewer takes into account the emotions experienced by all of the people involved. This junction alludes to the second misconception touched upon in the introduction: the false opposition between morality and emotion. Although this opposition seems to be natural, it is essentially constructed. Woven into the fabric of Western societies is what we might call the minimum conception of morality: 'the effort to guide one's conduct by reason—that is, to do what there are the best reasons for doing—while giving equal weight to the interests of each individual who will be affected by what one does' (Rachels, 2003: 14). Moral decisions are based on reason: there is one best way of acting and everybody's interests should be weighed equally.

The rational basis of morality, namely judiciously deciding which moral law applies, is the main focus of criticism. Nussbaum (2001) is one of the most important, contemporary critics in the field. According to her explanation of the intelligence of emotions, there are several reasons why feelings are strongly connected to rational moral thoughts. Emotions are not just about things, but are elicited by an object or situation that is of explicit value to a particular individual. This value is understood as the result of a complex set of (moral) beliefs about the object or circumstance. In other words, the emotion is often connected to a moral judgement. In this context, Nussbaum (2001) emphasizes the particularity of these beliefs and emotions and adopts a social-constructionist view. When employing her conception of morality, moral thought is understood as a process in which one imaginatively deliberates about the best reasons for conduct, while simultaneously taking into account all consequences and the feelings of all involved (including oneself).

Moral-emotional repertories are carefully constructed throughout life, and are therefore shaped by an individual's history and the social norms of the society he or she resides in. These repertories should be understood as they are situated. In terms of social norms, Nussbaum (2001) looks at different causes for variations in emotional repertories; physical conditions, religious beliefs, social practices and language are all reasons why variances are found between societies. However, she does emphasize that individual histories are just as important.

In line with academic work on emotions and morality, Nussbaum (2001) emphasizes gender-differentiated moral-emotional repertories, and integrates two disciplines through the connection of emotions to morality: psychology and moral philosophy. A lot of research on gender-differentiation in emotions has been conducted (Timmers, Fischer & Manstead, 2003; Fischer, Mosquera, Van Vianen, & Manstead, 2004; Jansz, 2000). Here, though, a distinction should be made between emotional experience and emotional expression. Psychologists such as Frijda (2007) and Oatley, Keltner & Jenkins (2006) have argued that emotional experience might be similar for each individual, but the expression of emotions can differ due to expectations of social consequences, norms and motives, all of which are gender-differentiated (Timmers et al., 2003; Fischer et al., 2004). Research on the expression of emotion reveals three ways in which this is gender-differentiated. First, differences are often found in what is called the display of powerful and powerless emotions. The former, such as anger and contempt, serve to demonstrate assertiveness and power, while the latter, such as sadness, fear, guilt and shame, reveal vulnerability and internal blame. Men tend to express powerful emotions more often than women. Secondly, differences in the expression of pro-social emotions, such as joy and empathy, are also found. These emotions serve to establish and groom affective ties. Women tend to express these feelings more often than men do. Thirdly, the amount of emotional expression is also gender-differentiated. In general, women show their emotions more often than men (Fischer et al., 2004; Jansz, 2000). These research results offer a perspective that is quite similar to Nussbaum's argument on gender differentiation in moral-emotional repertories.

Scholarly work on morality also highlights a distinction with regard to gender differentiation: a difference between moral values and moral deliberation. So far as the former are concerned, gender differences have rarely, if at all, been formulated. There is no reason to assume that women and men would have different moral values. When it comes to moral deliberation, however, Carol Gilligan (1982) argues for gender-differentiated moral orientation. One orientation—the ethics of justice—resembles the minimum conception of morality, while the other—the ethics of care—resembles Nussbaum's notion of morality. Men are more often orientated towards the former and women the latter.

How reality TV contributes, reflects or maybe even sustains the construction of these gender differentiations is studied in this chapter. Starting from a constructionist point of view that moral-emotional repertories are built throughout life, one wonders how they become gender-differentiated. The importance of contemporary narratives for the construction of these repertories, and reality TV's continuous display of emotions and (the breaching of) norms and values, turn it into an interesting case study which draws on what the genre offers its audiences in terms of moral-emotional repertories.

Researching the content

To answer the research questions, a qualitative content analysis of eighteen episodes of *The Golden Cage* and eight episodes of *Farmer Wants a Wife* was conducted. Since the duration of an episode of *The Golden Cage* is 25 minutes and those of *Farmer Wants a Wife* 55 minutes, this adds up to the analysis of equal amounts of broadcasting time (450 minutes of *The Golden Cage*, 440 minutes of *Farmer Wants a Wife*). All episodes were transcribed *ad verbum* and subjected to a computer-assisted content analysis (*Atlas.ti*).

The analysis focused on both verbal and visual content. The verbal aspect concentrated on moral expressions and moral statements made by the participants, which were reflections of the deliberations about what would be the most appropriate conduct in a certain situation, combined with the consequences for and feelings of all involved. Next, the transcripts were analysed for emotional expressions. Sometimes, for example, the participants explained quite elaborately how they felt about their own actions and those of others, as well as the circumstances they found themselves in.

The visual part of the analysis concentrated on the expressive aspect of emotion. How participants might experience feelings in moral situations is often simply unknown. Emotions are more frequently revealed by facial expressions and body posture than through language, and to analyse and identify these elements, Ekman's (1999) categorization of 'basic emotions' was taken as a starting point. These additional data were added to *Atlas.ti* as supplementary labels to the transcripts.

Further analysis was based on a grounded theory approach, and contained three phases: open coding, axial coding and selective coding (Strauss and Corbin 1998). In the first phase, open coding, all moral statements and moral and emotional expressions were coded. In the second stage, axial coding, patterns of relationships between moral expressions, emotional expressions and gender were outlined. Nussbaum's (2001) notion of the relationship between emotions and moral evaluation—emotions often communicate a deeply felt (moral) belief—was taken as a starting point. Similarities and differences between possible groups of statements or emotional expressions were noted. The final phase, selective coding, was aimed at the formulation of overarching concepts.

Before presenting the results, a cautionary note is in order. Emotion theory easily runs the risk of the essentialist determination of gender differences by suggesting that all women express emotions and moral issues in the same way, as do men. I have dealt empirically with this danger by investigating gender differences in their context, thus allowing for diversity within both groups. The results of the analysis give us a general idea of how gender differentiation in moral-emotional repertoires is constructed in reality television shows.

Imagining moral-emotional repertoires

The analysis of the episodes of *The Golden Cage* and *Farmer Wants a Wife* reveals a wide variety of feelings. In addition to Ekman's (1999) basic emotions (anger, disgust, fear, happiness, sadness, surprise, amusement, contempt, contentment, embarrassment, excitement, guilt, pride in achievement, relief, satisfaction, sensory pleasure, shame) more complex feelings were also displayed. There was, for example, not only a display of anger, but also frustration and irritation. Differences were found between the programmes in the kinds of emotions expressed. Powerful feelings were mostly observed (82 per cent) in *The Golden Cage*, while the largest element of powerless (79 per cent) and pro-social (71 per cent) emotions were on show in *Farmer Wants a Wife*. Striking as these differences may seem, the way in which the display of the various emotions is gender-differentiated in both programmes is surprisingly similar.

Of all the emotional expressions, 65 per cent were displayed by women and 35 per cent by men. The patterns of gender differentiation in the release of powerful, powerless and pro-social expressions were as expected. Of the total amount of pro-social emotions, 64 per cent were displayed by women and 36 per cent by men. Furthermore, women displayed 74 per cent of powerless emotions, while only 26 per cent were shown by men. And finally, the expression of powerful feelings was displayed by men and women 58 per cent and 42 per cent of the time, respectively. These results are in accordance with the observations of Fischer et al. (2004) and Timmers et al. (2003).

Additionally, women also revealed a wider range of emotions. In other words, individual female participants in *The Golden Cage* or *Farmer Wants a Wife* displayed all kinds of feelings, such as anger, joy, happiness, despair, gloating, fear and so forth. Individual male contestants, on the other hand, were seen to show a less diverse variety of different emotions. These results are also consonant with Fischer et al. (2004), Timmers (2003) and Jansz's (2000) work.

Interestingly enough, a more profound analysis reveals that gender differentiation does not stop at emotional expression, and in terms of moral-emotional repertories revealed itself during the study in three ways: how emotions were expressed, the event eliciting the emotion and the connection between emotions and morality.

Emotional expression

Although the gender differentiation in emotional expression was expected, a surprising distinction was found when the male and female participants of both reality shows displayed the same emotion. This was the case for both powerful and powerless feelings but not for pro-social ones, the latter being similarly expressed by both female and male contestants. For example, when the male participants displayed the powerful emotion of anger, this was usually combined with the use of swear words and threatening physical behaviour (leaning forwards, fists often raised). A good example is the confrontation between *The Golden Cage* participants, Huub and Brian:

Brian: 'I never spoke about your mother. What did you wanna do, you little turd?'
Huub: 'Little turd?'
Brian: 'You tiny, little turd. That's what you are, you can't do fuck against me.'
Huub: 'You need Jaap and Amanda.'
Brian: 'Oh you are such a sissy, you're peeing your pants right now.'
(*The Golden Cage*, 26 March 2006)

Competition between participants is of course embedded in the programme. The continuous quarrelling between Huub and Brian was their way of dealing with this and the rivalry they felt. On almost all occasions, they expressed their anger towards each other by calling each other names, belittling each other and (physically) threatening one another. Other male contestants displayed their anger in similar ways.

The female participants who display anger do not use swear words, but do use different body postures (typically pointing at each other). Natasia and Nena's discussion in *The Golden Cage* about the latter's dog is illustrative. Nena's dog came to see her for a day,

while Natasia's young son was also visiting. The dog was running around and Natasia was worried her son would be harmed by it. She is angry with Nena for not keeping her dog with her:

> Natasia: [raising her voice] 'Listen, you keep him with you. If he bites, we have a problem. No, no…it doesn't matter how often I need to say this, keep him with you…you need to be careful.' (*The Golden Cage*, 4 October 2006)

Instead of using swear words, Natasia threatens Nena only verbally (If he bites, we have a problem) and only raises her voice. Other female participants in the reality shows expressed their anger in similar ways.

Powerless emotions were also gender-differentiated in terms of their display. For example, the powerless feeling of nervousness was revealed by the female participants as rather positive excitement. For example, in *Farmer Wants a Wife*, there were a lot of nerves on show during the episodes in which the three women chosen by the farmer have a sleep-over at the farm. On these days, the farmer and the women get to know each other better, but the farmer also gets to choose which woman he wants to spend a weekend abroad with. At Martijn's farm, there are two women left. One of them is asked how she feels:

> Bibi: 'Still a really good feeling. Although, you start wondering more and more: how does he feel about me, and how does he feel about Marlies [the other woman].' (*Farmer Wants a Wife*, 22 October 2006)

Although Bibi feels nervous about the situation and the possible feelings that Martijn has for her, she is also very positive: she smiles and her eyes twinkle. Martijn, on the other hand, is also nervous but expresses this in a much more negative way. When the presenter, Yvon, asks him how he feels about the decisive moment (during which he has to announce his final decision) Martijn shows his nervousness in a pessimistic manner:

> Yvon: 'How are you doing?'
> Martijn: 'Bad.'
> Yvon: 'Why bad?'
> Martijn: 'This really heavy moment is coming up.'
> Yvon: 'So, you're really sick of it?'
> Martijn: 'Yeah, you guessed right. That's why it's bad.'
> (*Farmer Wants a Wife*, 5 November 2006)

Martijn is not smiling at all. His voice is trembling and he slumps in his chair. This difference in emotional expression is often explained by the kind of situation in which the emotion is elicited. In the above situation Bibi is nervous, but hopeful: she might be selected. Martijn, however, has to make the decision and, therefore, also has to disappoint someone.

While powerful emotions seem to be gender-differentiated in their expression, the expression of powerless feelings seems to be more context than gender-related. However, this context, namely that which elicits the emotion, is gender-differentiated in both reality shows and indicates a more complex pattern of emotional expression and morality.

Eliciting the emotion

In general, the male participants in both shows expressed powerful emotions in relation to competition, rivalry or revenge. We have already seen one example of anger between *The Golden Cage* participants, Huub and Brian, and the relation thereof to competition and rivalry. Another example is set by farmer Gerrit in *Farmer Wants a Wife*. During the sleep-over at his farm, the women have tried to talk about personal matters with him. Gerrit was frustrated by this and repeated several times that he did not want to talk about private aspects of his life. When the time comes for Gerrit to send one of the women home, he expresses feelings of revenge to presenter Yvon:

Voice-over:	'When the moment of truth has come, the anxiety can be tasted in the air. Gerrit, however, doesn't stop laughing.'
Yvon:	'They're nervous, Gerrit.'
Gerrit:	'Yes…can I enjoy myself for a moment!'
Yvon:	'Do you think that's nice? You pretend to find it difficult, but I suspect you're having fun at the moment.'
Gerrit:	'I'm going to take revenge now.'

(*Farmer Wants a Wife*, 15 October 2006)

Gerrit prolongs the moment of suspense because he wants to take revenge on all of the three women who stayed for the sleep-over and put him into a difficult position. During this scene Gerrit is smiling and is obviously enjoying his retaliation. Male participants seem to express powerful emotions mainly to exercise power in competition or situations that make them uncomfortable.

The expressions of powerful emotions by the female participants contrast with those of their male counterparts. The female contestants who express powerful feelings always do so in the context of setting limits and trying to maintain their (personal) boundaries.

An example, following on from the one referred to in the previous section (Natasia being angry with Nena), concerns Lieke. Lieke, who is one of the housekeepers in *The Golden Cage*, is engaged in a romantic relationship with Huub (later she will enter the show as a formal participant). Huub is not very faithful, and when Lieke questions him about this he explains that his behaviour is 'game strategy'. Huub says he has to pretend to like Amanda (Brian's girlfriend) so as to tease Brian. Lieke becomes angry with him, not because he is unfaithful, but because he is dishonest with her:

> Lieke: 'Yes, you can play your game…but this [meaning their relationship]
> is NOT a game.'
> Huub: 'No, this is not a game…'
> Lieke: 'You should not play me around anymore.'
> (*The Golden Cage*, 30 March 2007)

Lieke uses her expression of anger instrumentally to set personal boundaries: if Huub wants to maintain their relationship, he has to be honest with her. Expressions of anger and other powerful emotions by the female participants thus usually serve to set or maintain personal boundaries.

The context for the expression of powerless emotions is also gender-differentiated. The male participants in both series generally displayed powerless feelings in relation to goals in the programme or sometimes in life. *The Golden Cage* contestant Jaap, for example, is a student in real life. Upon his entrance in the game show, his university informs him that he cannot remain a student (due to his absence from lectures and exams). When Jaap receives the official letter stating this fact, he shows anguish and sadness:

> Jaap: 'This just costs me so much money…Well, I'll never go home
> now. I just don't have the money to go home…forever here…'
> Brian: '[trying to comfort Jaap] No man.'
> Jaap: 'I don't have a future outside anyway'
> (*The Golden Cage*, 2 April 2007)

Later on, in a moment by himself:

> Jaap: 'I just think this really sucks. I have a lot of bad luck. Of course
> I am also responsible, I know…But when you just look at the
> facts of my life, it's just simple bad luck.' (*The Golden Cage*,
> 2 April 2007)

Female participants, however, express powerless emotions more often in relation to dependency on someone else. Bibi's nervousness in the previous section is an example

of this; it is caused by her dependence on Martijn's decision. This dependency can also come across as an expression of sadness ensuing from missing someone outside the programme. This is how Natasia explains her feelings:

> Natasia: [crying] 'I miss my man. I miss his good advice. Yesterday, Brian told me this was a very tough lesson on never being impulsive again. Normally, I get angry with him, but he is just so right. You can't go back now. And I just really miss my man and I also told him this morning: Wilgo, I miss you, and, yes, this is true, I'm having a hard time.' (*The Golden Cage*, 2 October 2006)

In *The Golden Cage*, this situation occurred quite regularly. Due to the set-up and the duration of the show, participants more often expressed the feeling that they were missing someone from outside the series. Nevertheless, it is striking that none of the male contestants were shown displaying powerless emotions in this situation. These contextual features of gender differentiations in expressing feelings are related to the moral circumstances and decisions the participants have to deal with in both programmes.

Emotion in relation to morality

In both shows the male participants express more powerful emotions and explain these in terms of their orientation in respect of end goals. Both programmes showed the male contestants as being extremely focused on the project at hand: winning the competition (*The Golden Cage*) or finding a partner (*Farmer Wants a Wife*). This single-minded focus created the opportunity for the men to ground their (im)moral decisions in rational thought about the project. This enabled them to feel positive about their own negative behaviour. Huub's actions are an example. In his rivalry with Brian he decides to manipulate the feelings of Amanda, Brian's girlfriend. He does this deliberately: 'And then I just became really angry, smashing the doors and [saying]: you just go to this stupid ass Brian! And this morning, I just really touched her feelings. So yeah, I'm playing an ugly game.' (*The Golden Cage*, 30 March 2007)

That morning, Huub had tried to convince Amanda of her boyfriend Brian's inability to truly care for her. He added that he was only telling her this because he [Huub] *did* care. This conversation takes place while Amanda is lying in a dentist's chair with a metal device in her mouth, making it impossible for her to speak. Although as a viewer we might judge Huub's actions as immoral, because he is unnecessarily hurting Amanda's feelings and using her instrumentally to achieve his goal (the elimination of Brian), Huub views his own behaviour as a strategic tool in the game and, therefore, does not believe

that it is immoral at all. According to Huub, Amanda and the other participants are very much aware of being part of the game. He not only explains his actions as strategic, he also enjoys himself tremendously. In a similar vein, the farmers in *Farmer Wants a Wife* explain their decisions in terms of their goal: finding a partner. Illustrative is Gerrit's conversation with Inge, the woman of his choice. In the chat, Gerrit admits he has kissed Eva, one of the other women who stayed during the sleep-over. He regrets doing this, not because he hurt Eva (he gave her false hope that she would be selected), but because of the fear of not achieving his objective:

> Gerrit: 'I do make silly mistakes. I thought: now I lose Inge, because I kissed Eva. That would be my own stupid mistake. It would never work between us [Eva and he], but she is a very pretty woman with beautiful eyes. (*Farmer Wants a Wife*, 29 October 2006)

Gerrit frames his confession in terms of his emotions, fear of losing Inge, while glossing over his egotistical motivation to kiss Eva. This relation of emotions and moral decisions to goals was illustrative of the behaviour and actions of the male participants. Therefore, I would like to suggest that men's emotions, as shown on these programmes, might be described as goal-orientated, since they are closely related to projects and aims.

The female participants, in contrast, were shown to express emotions as related to the situation at hand. Instead of being focused on winning the competition or getting the farmer to fall in love with them, the women seemed to concentrate more on 'the here and the now'. In other words, female participants seemed more focused on 'surviving the programme' and the situations that they were manoeuvred into. Related to this, they are much more often depicted as feeling negative about negative actions. For example, in *Farmer Wants a Wife*, things go wrong when Eva is supposed to make dinner and Inge goes grocery shopping:

> Inge: 'Thai curry, this is Thai curry, isn't it?'
> Eva: 'But you also have another Thai curry, in a jar.'
> Inge: 'Sure, but I'm from Friesland and we don't have that kind of thing.'
> Eva: 'I should have known.'
> Inge: 'This is okay?'
> Eva: 'No, this really is not okay, really, it isn't.'
> Inge: 'Tjee, you're a bitch.' [throwing a bag of crisps at Eva's head]
> (*Farmer Wants a Wife*, 22 October 2006)

Obviously, the women are in competition because they would both like to be selected by Gerrit as the woman of his choice. Their argument, however, is based on disappointment

and unfamiliarity with the situation. Both feel bad about their fight, and their faces show worry and anxiety. Additionally, the female participants were sometimes shown to make moral decisions while expressing negative emotions. A very clear example is set by Trudy. Trudy and Anneke are two women at the sleep-over at Hans's farm. Hans is having trouble making a decision. Trudy has observed Anneke and has noticed that she has developed a serious crush on Hans. Since she is not sure about her own feelings, she decides to talk to Hans and convinces him to choose Anneke. Later on, she explains her decision in front of the camera. She cries while doing this:

> Trudy: 'The day before yesterday, I put Hans through his paces, how
> he felt about Anneke. Because I had already noticed that Anneke
> was developing something. But he didn't want to say anything…
> Yesterday afternoon, he had a really hard time. And we were alone
> for a moment and then I said: Hans, why don't you listen to
> your heart?…And then I told him: I am not allowed to tell you,
> but that [indicating Anneke] is the woman who fell for you.
> She is in love with you. Accept it. I'll survive.' (*Farmer Wants a
> Wife*, 5 November 2006)

Even though Trudy is not sure about how she feels (she might have developed similar feelings to Anneke), she sacrifices her opportunity to find a partner in order to give two other people a chance of love. This action might be judged as morally positive, despite Trudy's obvious feelings of sadness. This embeddedness of feelings and moral decisions in concrete situations was illustrative of the female participants in both shows. I would like to suggest that women's emotions, as shown in the two programmes, can be called 'concrete emotions'.

Conclusion

Although *The Golden Cage* and *Farmer Wants a Wife* might be regarded as two completely different reality shows, the gender differentiation in the emotional expressions therein is surprisingly similar. Returning to our main question: *how is the relationship between emotions and morality imagined in the (Dutch) reality shows* The Golden Cage *and* Farmer Wants a Wife, *and are these imaginations gender-differentiated?*, the conclusion can be drawn that reality TV offers a gender-differentiated perspective on moral-emotional repertoires. These results provide a starting point when it comes to reaching an understanding of how TV contributes, reflects and sustains gender differentiation in emotional expression. Male participants are shown as ultimately being focused on their goals, while the women are revealed to be focused on the 'here and now'. This difference

in focus is closely connected to their moral behaviour. While male contestants argue for their moral decisions in terms of the goals they have, their female counterparts do so by taking the social consequences thereof into account. The differences in the display of emotions are, therefore, easily understood in terms of their context. When your action is related to a certain goal and you are successful, the emotions are positive. When your action is tied in with the situation, that is, the 'here and now', as well as the relationship with others, feelings are closely connected to the specificity of the circumstance (you are either chosen as the partner or not).

Furthermore, our results also shed light on the complex intertwining of emotions and morality. If moral decisions are, indeed, strongly related to emotions, and if people differ as to when and how they experience feelings (goal-related or concrete), we may have gained insight into the difficult issue of why some people make immoral decisions. However, this study does not deliver any information about how emotions are experienced. Therefore, the intertwining of emotions and morality should be developed further in other research.

References

Allen, R.C. (ed.), *Channels of Discourse, Reassembled*, London, Routledge, 1992.

Ang, I., *Watching Dallas: Soap Opera and the Melodramatic Imagination*, London, Methuen & Co. Ltd., 1985.

Dovey, J., 'Reality TV', in G. Creeber (ed.) *The Television Genre Book*, 2nd edn, London, Palgrave MacMillan, 2008, pp. 134–145.

Ekman, P., 'Basic emotions', in T. Dalgleish & T. Power (eds) *The Handbook of Cognition and Emotion*, Sussex, John Wiley & Sons, Ltd, 1999, pp. 45–60.

Fischer, A.H., Mosquera, P.M., Van Vianen, A.E.M. & Manstead, A.S.R., 'Gender and culture differences in emotions', *Emotion*, 4:4 (2004), pp. 87–94.

Frijda, N., *The Laws of Emotion*, Mahwah, NJ, Lawrence Erlbaum Associates, Inc., 2007.

Gerbner, G., 'The stories we tell and the stories we sell', *Journal of International Communication*, 5:1&2 (1998), pp. 75–82.

Gilligan, C., *In a Different Voice: Psychological Theory and Women's Development*, Cambridge, MA, Harvard University Press, 1982.

Hawkins, G., 'Ethics of television', *International Journal of Cultural Studies*, 4:4 (2001), pp. 412–426.

Hill, A., *Reality TV: Audiences and Popular Factual Television*, London & New York, Routledge, 2005.

Jansz, J., 'Masculine identity and restrictive emotionality', in A.H. Fischer (ed.) *Gender and Emotion: Social Psychological Perspectives*, Cambridge, Cambridge University Press, 2000, pp. 166–186.

Krijnen, T. & Tan, E.S.H., 'Reality TV as a moral laboratory', *Communications—The European Journal of Communication Research*, 34:4 (2009), pp. 449–472.

Liebes, T., & Katz, E., *The Export of Meaning: Cross-cultural Readings of Dallas*, Oxford, Oxford University Press, 1990.

McQuail, D., *McQuail's Mass communication theory*, 5th edn, London, Sage Publications, 2005.

Nussbaum, M.C., *Upheavals of Thought: The Intelligence of Emotions*, Cambridge, Cambridge University Press, 2001.

Oatley, K., Keltner, D. & Jenkins, J.M., *Understanding Emotions*, 2nd edn, Malden/Oxford/Victoria, Blackwell Publishing, 2006.

Poole, R., *Morality and Modernity*, London & New York, Routledge, 1991.

Rachels, J., *The Elements of Moral Philosophy*, 4th edn, New York, McGraw-Hill Companies, Inc., 2003.

Rorty, R., *Contingency, Irony and Solidarity*, Cambridge, Cambridge University Press, 1989.

Strauss, A. & Corbin, J., *Basics of Qualitative Research: Techniques and Procedures for Developing Grounded Theory*, Thousand Oaks, CA/London/New Delhi, Sage Publications, 1998.

Timmers, M., Fischer, A.H. & Manstead, A.S.R., 'Ability versus vulnerability: Beliefs about men's and women's emotional behavior', *Cognition and Emotion*, 17:1 (2003), pp. 41–63.

Velde, F., van de, 'PvdA: Gedragscode tegen vernederende tv', *Elsevier*, 2006, http://www.elsevier.nl/nieuws/politiek/artikel/asp/artnr/119759/zoeken/ja/index.html. Retrieved 3 April 2008.

Wade, M., 'Reality check', *Scotland on Sunday*, 2007, http://scotlandonsunday.scotsman.com/realitytv/Reality-check.3327465.jp. Retrieved 2 March 2009.

CHAPTER TEN:
CASUALIZING SEXUALITY IN TEEN SERIES.
A STUDY OF THE GENDERED SEXUAL DISCOURSES IN THE POPULAR AMERICAN TEEN SERIES, *ONE TREE HILL* AND *GOSSIP GIRL*

Elke Van Damme

'Teens can learn about sex from the mass media. They've grown up as neighbours to the residents of Melrose Place on television, watching preening fictional characters swap sexual partners as casually as baseball cards.' (Sutton, Brown, Wilson & Klein, 2002: 26)

Introduction

Time and again, the mass media, and especially television and the internet, are held responsible for all kinds of social ills and negative behaviour involving children and teenagers (Gerbner & Gross, 1976; Morgan, 2007). Parents, politicians and academics are most concerned about young people since, at the age of eighteen, they spend more time in front of the television and at the computer than they do on any other daily activity (Ralph, Brown & Lees, 1999: 105; Weimann, 2000). Indeed, we could say that media are predominant in the everyday lives of teenagers (Osgerby, 2004: 6). These concerns about the possible effects and impact of media content are not new; anxieties have been around since the media's heyday, and we see the same tendencies reoccurring whenever a new form is developed. A similar fear has been expressed in the past about earlier types of media, such as films and comic books (Critcher, 2006), but the potential effects of new

mediums, like the internet and game consoles, are being studied as well in this respect (Mazzarella, 2007). According to several authors (Morgan, 2007; Signorielli, 2007; Bindig, 2008), television is still the primary storyteller, both in national and international terms, which is why it has quite possibly become one of the most common learning environments across the globe. The world of television shows us the workings of daily life and how society is organized and presented, primarily in the form of highly consistent and repetitive entertainment (Mirzoeff, 1998: 1, 6; Morgan, 2007). Buckingham (2003: 3–5) argues that despite not offering a translucent window to the world, the media shape a view of reality and give us tools to interpret our relationships and define our identities. Unlike cultivation theorists,[1] we do not think that young viewers adopt the reality represented on screen as their own, but instead believe that the role is more nuanced and complex, in what resembles the cultural studies' point of view. The media are not the only distributors of meaning; peers, parents and schools are other socialization agents in the lives of teenagers that we have to consider. Moreover, viewers are not passive victims of media content and are regarded as being media literate. It is, however, necessary to study the substance of contemporary media programmes directed at teenagers, since we live in a mediated reality. We agree with Bindig (2008: 5) that 'while it would be ridiculous to think that viewers imitate exactly what is portrayed in the media that surround them, it would be similarly naive to believe that the messages of the media are meaningless'. We can, therefore, say that youth media provides a site for teen identity construction (Bindig, 2008: 14) and the evaluation of teen television content is, therefore, absolutely crucial.

Gender and other ideological themes such as class and sexuality are intertwined and cannot be fully separated (Bindig, 2008: 21), which is why we will analyse the gender representations of a group of teenagers in the popular North American teen series *One Tree Hill* and *Gossip Girl*, with a specific emphasis on the relationship with sexuality. However, we first need to be acquainted with the meaning of our key concepts, gender and representation, as well as with an overview of the studies focusing on the portrayal of teens.

The social construction of gender

Although people often assume that we are born as male or female, an individual has to *learn* his or her gender identity and how to be a man or a woman. We follow a non-essentialist approach to gender and believe that it is through civilization and socialization that a human being is constructed as feminine or masculine (Lorber, 1997: 35; Gunter, 1995: 2). Gender is created and recreated out of human interactions and social lives, and is the texture and order of that social life (West & Zimmerman, 1987). Gender is thus socially constructed and cannot be equated with biological and physiological differences. A specific set of roles, created by cultural traditions, moral codes, the economy and politics (Jacobson, 2005: 6), is attached to gender identity. Those roles are not stable but differ

across time and space (Nayak & Kehily, 2008: 175). Adolescents develop their personal sexual behaviour according to the gendered scripts that society advocates. However, we do not perform gender so freely. School, parents, peers and the mass media are the agencies and tools that help us, and more specifically young people, to integrate into a gendered world. Gender is, therefore, both ascribed and achieved (West & Zimmerman, 1987). Moreover, ranked according to prestige and power in most societies, it is therefore unequal. Men are attributed greater worth and importance than women of the same race and class, even if their activities are similar or alike (e.g. the glass ceiling). Not only is this stratification reflected and constructed by the media (Lorber, 1997: 40–43), but they 'also contribute to the construction of hegemonic definitions that often appear to be self-evident...Generally, stereotyping in the media context follows patterns of power by diminishing those with little power and influence' (Jacobson, 2005: 5).

When assumptions are made about a person only on the basis of gender, we speak of gender stereotyping. Female stereotypes follow themes such as appearance, sexuality, relationships and traditional gender roles like housekeeping. The stereotyping of masculinity, on the other hand, is organized around coolness, aggression and violence (Jacobson, 2005: 6; 25–26).

Representation of sexual behaviour

In his work *Media Power and Class Power* (1986), Stuart Hall describes the ubiquitous visual culture as the 'machinery of representation'. Representation can be defined as a production of meaning through language; it connects meaning and language to culture. To make sense of these representations, we have to share the same conceptual maps and speak the same language (Hall, 2003: 15–31).

> Representation means using language to say something meaningful about, or to represent, the world meaningfully, to other people...Because we interpret the world in roughly similar ways, we are able to build up a shared culture of meanings and thus construct a social world which we inhabit together. (Hall, 2003: 15–18).

Although images can closely resemble the object to which they refer, they still exist in signs that carry meanings, thus requiring interpretation (Hall, 2003: 18). Media do not reflect or present reality; they instead interpret and represent a possible take thereon. Media representations of youth, then, are not a straightforward reflection of young people's culture and lifestyles either. 'Instead, they offer a particular interpretation of youth, constructing images of young people that are infused by a wealth of social meanings' (Osgerby, 2004: 60). The (content of) representations (is) are important since the media

can be powerful and educative instruments of (re)socialization, especially for teenagers who are at a very critical stage in the process of their identity construction (Wartella, 2007: 2). The construction of a self-identity is a lifelong and dynamic process, and youth is situated in a crucial phase of that course of construction. Exploring values and beliefs about relationships and sexuality, as well as developing a healthy understanding of their own gendered, sexual behaviour, is at the core of that identity construction in which the media targeted at teens may function as virtual tool kits of many different possible identities (Brown, Steele & Walsh-Childers, 2002: 12; Eyal, Kunkel, Biely & Finnerty, 2007: 316). Previous research (Brown, Childers & Waszak, 1990; Davis, 2004) confirms that television—among others—is an important source of information about sexual and romantic scripts, as well as norms about sexual behaviour. According to Buckingham (1993: 13), television functions 'as a symbolic resource which young people use in making sense of their experiences in relating to others and in organizing their daily lives'. Soaps and shows aimed at a teenage audience can therefore extend the repertoire of youthful knowledge about society and sex. In accordance with Cope-Farrar and Kunkel (2002), we define the representation of sex in this paper as:

> any depiction of talk or behaviour that involves sexuality, sexual suggestiveness, or sexual activities/relationships…To be considered sexual behaviour, physical actions must imply potential or likely sexual intimacy between the participants…Physical flirting or passionate kissing were included, depending on the context in which they were presented. (Cope-Farrar & Kunkel, 2002: 63).

The teenage world on television

Research about representations of youth proclaims a recurring duality in which a negative, stereotypical depiction refers to youth-as-trouble (youth crime, violence and sexual licence) and positive portrayals resemble youth-as-fun (freedom, hope and fun) (Hebdige, 1979; Osgerby, 2004: 71). Recent studies stress that sexual messages are more abundant among teens in popular programmes, and this sexual content has itself changed as well: characters have their first sexual encounter at a younger age, and these experiences do not necessarily take place within a committed relationship (Buckingham & Bragg, 2004). Concerns arise due to teenage sexual licence, and casual sex is seen as troubling, as is the increasing sexual content in teen television programmes (Eyal, Kunkel, Biely & Finnerty, 2007: 317). One of the concerns expressed is that today's sexual portrayals in the media are 'too explicit', 'too over the top' and 'too unrealistic' for young viewers (Ward, Gorvine & Cytron, 2002: 96). This 'hyper-sexual' media content, as Jacobson (2005) calls it, has to be put into perspective, in our opinion. There are

little or no explicit sexual representations visible in teen series, but sexual innuendo or talking about sexual relationships is presented more than ever before, as is implied sexual behaviour between characters. Where, in the 1990s, series like *Dawson's Creek* focused on the romantic and affective aspects of a relationship (Bindig, 2008), we note that the sexual aspect thereof has become one of the core subjects of recent teen series. Sexual relationships are often *just* for fun (no serious commitment), which makes us wonder whether we perhaps do need to reconsider sexual licence as part of youth-as-fun instead of youth-as-trouble (Hebdige, 1979).

Scholars tend to focus on children, while teenagers have received little attention in the past. For general findings about the portrayal of teenage girls and boys, we refer to Katherine Heintz-Knowles (1995; 2000) and others. It should be noted that most studies use quantitative content analysis instead of the qualitative approach we have utilized in our research. Young people in prime-time programmes are often portrayed in roles where they are coping with problems related to romance, friendship, popularity and family issues. Many of these difficulties were resolved without help from adults (Aubrun & Grady, 2000: 8). Heintz-Knowles (1995) argues that teenagers in entertainment television are not motivated or driven by school-related issues, but rather by peer relationships, sport and hobbies, family, and romance. In TV series, young people who are sexually active rarely take any precautions to protect themselves against pregnancy or sexually transmitted diseases. More importantly, these characters seldom experience negative consequences as a result of their sexual actions (Aubrey, 2004), and having sex is suggested as normative if you are in a committed relationship (Gunter, 1995: 5).

Upon taking a closer look at the results concerning female teen characters in fiction, we notice contradictory findings, both confirming and breaking gender stereotypes. Plots involving teenage girls are centred on dating and shopping (Signorielli, 2007: 174–175) and contain many stereotypical messages about relationships, careers and appearance. Female characters are often devalued as sexual objects (Bindig, 2008: 26) and are depicted as bad when they express their sexual desires openly. Remarkably, girls in teen programmes initiate sexual dialogue more than they initiate sex, but when they do the latter they experience more negative consequences than men do (Aubrey, 2004: 510). Boys, however, get more positive media messages about how to be a man, though stereotypes are found as well. On the one hand, male characters often have athletic, muscular bodies, which are highlighted by the clothes they wear, while on the other, their physical appearance is, in contrast to female characters, seldom the subject of discussion. Male characters are shown for their abilities and talents, not because of their looks.

A particularly worrying aspect in the portrayals has emerged in the context of images of sexual behaviour and sex (Gunter, 1995; Kellner, 1995), because both sex and sexuality are depicted in a clichéd and stereotypical way. A boy has sex with as many women as he can because a 'real man' never says no when the opportunity for sex arises (Brown, Steele & Walsh-Childers, 2002: 3; Signorielli, 2007: 174–175). This sexual double standard

results in men's sexuality being encouraged and rewarded and male characters are portrayed as active choosers ('predators'). This is in contrast to passivity, restriction and compliance for female sexuality (Aubrey, 2004: 506). 'The stereotypical media concept of sexuality is built around the female as the object of desire and the male as active chooser of object.' (Jacobson, 2005: 14) According to Schor (2004, quoted in Bindig, 2008: 16) 'teen media depict a manipulated and gratuitous sexuality, based on unrealistic body images, constraining gender stereotypes and, all too frequently, the degradation of women'. Studies focusing on gender representations in, for example, music videos confirm the presence of the same stereotypes that appear in other forms of popular media for both men and women (Kaplan, 1997). Those portrayals may function as role models for young people and contribute to their gender-role socialization and identity construction (Gunter, 1995: 4). As Jacobson (2005: 27–29) concluded, masculinity is depicted as superior to femininity, even in teen television series.

Looking into the teenage world of television series: Methodology

Textual analyses are usually interpretative and thus qualitative, and attempt to understand latent meanings of a text. This type of analysis is successfully transferred and incorporated into the area of film studies (Larsen, 2002: 117–120). The current type of film analysis is mostly based on narration, because of the narrative format of the studied programmes, and consists of an exploration of the levels of content and representational strategies used in the audiovisual text. Cinematographic elements have, however, been studied as well. We explored the representations of teen sexuality, with a specific emphasis on gender, by means of a qualitative textual film analysis (Bordwell & Thompson, 1993). Because of the importance of plot development and the evolution of characters in the series researched, we want to stress the importance of the use of our sample. This approximately eighteen hours of television fiction included sixteen *One Tree Hill* episodes (the first, eighth, sixteenth and final episodes of every season that had been released on DVD before June 2008) and eleven episodes of *Gossip Girl* (the first, fourth, eighth, twelfth, sixteenth and final episode of seasons one and two[2]).

One Tree Hill (OTH) first aired in the United States on 23 September 2003, and the seventh season is currently showing in North America on the free CW Television Network. The series has been nominated for a Teen Choice[3] award 23 times, and the fact that it has won twice[4] reflects its importance in popular teen media. The series focuses on the lives of some teenagers in Tree Hill, a small but eventful city in North Carolina. The storyline is developed around the high school basketball team and the different relationships, be they friendship, romantic or of a sexual nature, between the male protagonists, Lucas and Nathan, and their female (girl)friends, Peyton, Brooke and Haley. *Gossip Girl* (GG) was first shown on the same CW Television Network, on 19

September 2007 and the third season is currently being aired. The series has won eleven awards from sixteen nominations,[5] including the Teen Choice Awards for best breakout show and best television drama in 2008, which stresses the popularity of the series with teenagers. The programme tells the story of several teenagers (and their families), some of whom live on the Upper East Side of Manhattan, while others travel by train instead of being escorted in a limousine from Brooklyn to New York City. These teenagers are about to make the most vital decision in their young lives—which university to attend— while they also experiment with love, sex and drugs. *Gossip Girl* refers to the female voice-over who spreads gossip and rumours about the main female characters, Blair and Serena, and their male opponents, Chuck, Nate and Dan.

Sexual gender roles in *One Tree Hill* and *Gossip Girl*

The objectification of the self, the other and their sexuality

Several authors (e.g. Jacobson, 2005; Nayak & Kehily, 2008; Bindig, 2008) have concluded that female characters are often devalued as sexual objects, and *One Tree Hill* and *Gossip Girl* are no exceptions. We can distinguish different strategies through which this devaluation becomes visual in our research sample. Female characters regularly use their bodies to get what they want or to intimidate a man. Brooke, for instance, shows her underwear as a way of getting some painkillers from a young physiotherapist (OTH), and Blair—wearing a mini-skirt—exposes her long legs and underwear to drive Chuck crazy and win the contest they had organized (GG). No example of male characters using their physical attributes in similar ways is found in either research sample. The devaluation of female characters as sexual objects can also be observed when the camera wanders over a character's figure from head to toe, highlighting her thin, perfect body with screenshots. Female characters (e.g. Peyton (OTH) and Dorota (GG)) are also literally objectified in that, for example at a basketball game, they can unknowingly be the real trophy the boys are playing for. Furthermore, in *Gossip Girl*, female bodies and their sexuality are mentioned as part of a consumption culture ('goods' you pay for) or as a prize that can be claimed by males. During Ivy-week, for instance, the girls present are only paid for giving male attendants (sexual) pleasure and are mentioned in the same context as the food and drinks that are served. Blair organises a scavenger hunt at the prom for her boyfriend Nate: if he finds Blair before midnight, he can claim his prize. Chuck adds a bet to the hunt: if Nate does not find her in time, Chuck himself will collect it. We can link this with the active/passive distinction that is often negotiated between male and female characters and their sexuality (Mulvey, 1975; Jacobson, 2005), and the traditional gender roles according to which a woman is supposed to serve her man, even with her body. Serena, for example, wants to thank her partner Erin properly by having sex because he agreed to join her at an important charity event. Chuck abuses his dominant position and

physical power when he forces himself on Jenny. She voices her objections, but Chuck does not listen. In the end, she is saved by her brother (active heroic male versus passive female victim). Remarkably, the male characters in *Gossip Girl* are objectified as well, although in a more subtle and less explicit manner. Some teenage girls use these young men to make another jealous. Georgina, for instance, tries to sleep with Dan—Serena's boyfriend—because the two females are stuck in a fight and a competition over who can hurt each other the most. Sometimes, two teenagers use each other for their own reasons: Jenny is dating the rich but gay Asher to climb the social ladder. Asher, on the other hand, is using Jenny as well, to cover up his sexual orientation.

(The insinuation of) sexually active teenagers

The general impression given by the two series is that the represented youngsters are very sexually active. This impression is strengthened when we take a closer look at the recurring examples of casual sex in the programmes: Peyton wanted to have casual sex with Lucas; Brooke and Felix were friends with benefits (a friend you call when you want to have sex) (OTH); and Chuck has sex with several girls (at the same time) (GG). The 'having fun-element' is very important ('It's *just* sex.') in those kinds of sexual flings (cf. youth-as-fun versus youth-as-trouble, Hebdige, 1979). However, both series do also contain several examples of teenagers who do not rush into having sexual affairs with one another; here sex is portrayed as meaningful. This is addressed on the level of narration, namely in a conversation between Dan and Serena (GG).

Sex is commonly implied in both series but there are no overt portrayals of intercourse; this is probably due to the hour of programming, the target audience and the dominant norms and values. Silverman, Sprafkin and Rubinstein (1979) found that sexual behaviour was about to take place, or had just happened but was not seen, in prime-time programmes. Passionate kissing and embracing were the most common acts in our sample, and this confirms Cope-Farrar and Kunkel's findings (2002). When we note the sexual behaviour (from passionate kissing to sexual intercourse) in both series, girls initiate and take decisions on the matter (i.e. when it will happen). Serena tells Erin that she wants to have sex with him later that night (GG), and Brooke sets the rules and decides what a casual relationship between her and Lucas means. Marvin, who left Rachel behind in a motel room before they had sex, is a counterexample and also goes against the sexual double standard (see infra) (OTH); female sexuality as passive and restricted (Aubrey, 2004: 506) transforms into a more positive, active and emancipatory gender script. However, the 'problem' mentioned above regarding objectification of the female body and sexuality (of which both men and women are guilty) puts this female gender script into a more negative perspective.

In both *One Tree Hill* and *Gossip Girl*, having a (sexual) partner is an important contribution to the development of the youngsters' identities. This is especially the case when a relationship fails, and the (male and female) teenagers realize they have lost themselves while giving their heart to the person they loved. (Sexual) relationships

force teenagers to reflect upon who they are and who they want to be. Love is not always represented as negative; on the contrary, it is idealized in certain situations and portrayed as being able to survive and challenge anything. Dan addresses his relationship with Serena as the single greatest moment in his life, and he would do it all over again, even though they have broken up (GG). Sex is a normal step in a romantic relationship, which is taken rapidly and sometimes even hastily without talking it through with the respective partner. There are, however, two important exceptions in our sample of *One Tree Hill* episodes. First, Haley is afraid to have sex for the first time and decides to wait until she is married. Her partner, Nathan, has a hard time accepting this and visits porn sites to cope with his sexual feelings towards his girlfriend. Later, though, he admits that he wants to wait too and help her survive her fears. The second example is the 'Clean Teens', a group of teenagers (mostly girls) who are against sex before marriage. These youngsters are, however, mocked and looked upon as if they are freaks; the group is condemned to die out silently. The connection between sexuality and teenagers' groping boundaries, values and norms is drawn here. They are searching for their own sexual identity and relationships in a process that will allow them to define themselves and who or how they want to be. In *Gossip Girl* we found that having sex with your partner gives you a better social standing, but lying about it is unforgivable and results in a reduction of status (e.g. Jenny).

Different gender, different sexual standard?

The sexual double standard (Aubrey, 2004) is recognized in both series; a man is always in the mood for sex and never says no when he gets the opportunity to have it, an example being Lucas accepting Nicki's offer to go out with him and have sex later that night even though they had just met (OTH). In contrast to *One Tree Hill*, *Gossip Girl* contains some counterexamples which show the male characters refusing the opportunity of sexual interaction. Dan, for example, puts great value on sex and doesn't sleep around with random girls (GG). Brooke understands that Lucas cheated on her because boys screw you over all the time, but she does not understand why Peyton did so, thus implying the existence of a different standard for boys and girls (OTH). Girls who sleep with several boys are portrayed as slutty. This double standard is also discussed on the level of narration in the series: Haley, Peyton, Brooke, and Anna agree that they should stop living up to the double standards that are created by men and just be happy (OTH). Due to the use of a sample of episodes, however, it was not possible to investigate if their behaviour does indeed change or not.

Sexual interaction is once addressed as a statement in *Gossip Girl*: Lexie sleeps with men on a first date as a political comment against male domination. In light of the sexual double standard, the question is whether Lexie's statement has any result at all, confirming instead the double standard in what can be read as both an example of the objectification of the female body and sexuality, as well as of 'false' empowerment. Generally, men are easily seduced, and this is stated literally when Brooke shows her breasts to a group of

boys in a boat, telling Peyton that men are so easy (OTH). Even Dan (GG) addresses something similar when he tells Blair, who wants to seduce Chuck to win a bet, that: 'Chuck is still a man. Be present everywhere, it will drive him crazy.' This kind of sexual talk or sexual innuendo between characters is recurrent in both series; in the *One Tree Hill* research sample, this innuendo only appears between female characters, while in *Gossip Girl* we notice the same tendency, although we also found that Chuck has some sexually coloured conversations with Blair. We see the sexual innuendo between female teenagers as an emancipatory gender script in which teenage girls are depicted as active sexual creatures, instead of passive and compliant. Another positive and emancipatory gender script can be found in the sequence in which a female teenager (GG) conveys her impression of masturbation, a unique situation in the research sample from both series.

Idealising and 'casualising' sexual behaviour

Sexual intercourse is mainly depicted as unrealistic and idealistic, as illustrated by the following two examples. Haley and Nathan have sex two weeks after she gives birth, and when Brooke undresses in front of her boyfriend he declares it is the best day of his life (OTH). We found one example in *Gossip Girl* in which this idealisation of sexual intercourse is broken and the impression is given that sex can destroy any existing happiness between two characters: Serena does not want to rush things with Erin since the relationship is going well. Generally, however, sex goes smoothly and easily, and the use of condoms is never mentioned, nor indeed are any sexually transmitted diseases. This should be regarded as problematic, particularly the lack of references towards condoms in (casual) sexual relationships. The only negative consequence that is connected to sex in our sample is a possible (teen) pregnancy in *One Tree Hill*. The potential emotional impact of sexual interaction for both female and male teenagers is rarely addressed in either series, in accordance with the results obtained by Aubrey (2004). The only example is found in *Gossip Girl*, when Blair feels ashamed that she has lost her virginity to Chuck—who she is not dating—in the back of his limousine. Yet this can again be seen as rather stereotypical since emotions are, once more, connected to females.

Both series contain several other more traditional (and stereotypical) gendered discourses that we would like to address. Romantic relationships involve popular and attractive characters; physical appearance is of the utmost importance for *One Tree Hill's* teenagers (both girls and boys). The same applies to *Gossip Girl's* main characters, although financial wealth and status are added to that depiction. The same series shows Chuck as the stereotypical man who is afraid to commit to one woman; despite being in love with Blair, he leaves her behind due to his refusal to 'play husband and wife'. This leaves him alone with heartache and random girls. Three examples illustrate stereotypical representations of male teenage fantasies: Nate has a (sexual) relationship with an older married woman; Dan falls in love with a young female teacher who will suffer expulsion when the school board discovers their relationship; and Chuck (who is a minor) has

(paid) sex with several older women simultaneously (GG). This last example of the use of prostitutes and a threesome can be seen as both an incorporation of porn culture into the daily lives of youngsters as well as another attempt to 'casualise' (paid for) sex.

Conclusion

The analysis of sexual scripts in relation to gender in the series *One Tree Hill* and *Gossip Girl* revealed several stereotypical gender scripts, although more positive and emancipatory discourses regarding both female and male characters are found as well. Our data confirm previous research results, but put some of them in a different perspective. In general we can say that *Gossip Girl* contains more diverse, sexually gendered representations than *One Tree Hill*, even though paradoxical messages are to be found in both series.

Female characters are often devalued as sexual objects in both programmes, confirming the results of previous studies (Jacobson, 2005; Nayak & Kehily, 2008; Bindig, 2008). This devaluation and objectification becomes visible in several different ways. Women use their bodies to intimidate a man to get something done. Specific female body parts like breasts and thighs are highlighted by (subtle) screenshots, and girls appear as the real trophy that men compete for during a game. Female characters often objectify their own sexuality and see it as a prize a man can claim, or as a way to *thank* a man for his efforts. In *Gossip Girl*, female characters are even mentioned as part of a consumption culture and as *goods* that you pay for. Remarkable is the fact that in the same series, males are used and objectified by women, although in less explicit and more subtle ways.

The sexual double standard is recognised in both shows, where male teenagers who sleep around are depicted as cool and girls who do the same are portrayed as slutty (cf. Aubrey, 2004). Male sexuality is represented as insatiable; a *real* man never says no when the opportunity to have (casual) sex is offered. There are, however, a few counterexamples of men refusing such an offer and placing high value on sexual interaction.

Both the male and female teenagers in our sample have several romantic (and sexual) relationships during the seasons we researched, and having a partner is regarded as an important contribution to the development of identity. Teenagers sometimes lose themselves due to love relationships, although love is not always represented as negative. On the contrary, it is idealized by both boys and girls, and we find the same tendency when it comes to sexual behaviour. Having sex is addressed as the single greatest moment in someone's life, although it is mentioned once that it risks destroying a relationship (friendship, sexual).

Sex is often insinuated and neither the use of condoms nor sexually transmitted diseases is ever mentioned in our research sample, in keeping with the results of Aubrey (2004). The only negative consequence that is connected to sex is a possible teen pregnancy; the

emotional impact is, for the most part, non-existent in both series.

Although sex is idealized, we also found that it is often minimized. This finding is supported by the regularly recurring examples of casual, non-committed sex, where teenagers in the series do it *just* for fun. Hebdige (1979) regarded teens' sexual licence as troubling, but we think that this should be reconsidered. Twenty-first century teenagers and (casual) sex are woven together in contemporary teen fiction, and sex has become part of the 'having fun' culture among this group. However, the absence of any references to condoms in (casual) sexual relationships, as well as the lack of discussion of sexual intercourse or the emotional consequences of sex can be regarded as problematic since media shape our view of reality and offer us tools to interpret our (sexual) relationships and define our identities. We have to be careful, however, not to exaggerate the role of television, for it is not the only distributer of media, and there are other socializing influences and agents in the lives of adolescents which also have to be taken into account (Cope-Farrar & Kunkel, 2002: 75). Moreover, young viewers are not passive victims of media content and are media literate.

No overt portrayals of sexual intercourse are seen in the series; passionate kissing and embracing were the most common acts, confirming the results of Cope-Farrar and Kunkel (2002) and Jacobson (2005). In the cases in which sexual behaviour was registered in either show, female characters took decisions on the matter in what we consider to be a positive and emancipatory gender script. The 'problem' of objectification of the female body and sexuality, though, places this script in a more negative light.

Girls often engage in sexually suggestive talk and this strengthens the impression that the represented female teenagers are very sexually active. This impression of sexually active (male and female) teenagers only increases when we take all of the examples of casual, non-committed sex into account. In examples of paid for sex and threesomes, we found several illustrations of stereotypical representations of male teenage fantasies and references towards the incorporation of porn culture into the daily lives of teenagers. We can, therefore, conclude that whereas teen fiction in the nineties (Bindig, 2008) focused on the romantic and affective aspects of a relationship, *One Tree Hill* and *Gossip Girl* are built around sexual relationships between the main characters. We can even say that in the teen series we researched, sexuality is being 'casualized'.

Further work focusing on non-heterosexual relationships is necessary, as is an exploration of the differences between representations in United States and non-US teen series, possibly using methodologies such as audience reception research. Meanwhile, we plead for more diverse representations of both male and female teenagers and hope that, in time, writers and producers will present young viewers with less stereotypical images, and will incorporate positive and more realistic examples of teen life in the series that teenagers watch. Or, in the words of Douglas (1994: 294), 'Media still are our worst enemy and our best ally in our ongoing struggle for equality, respect and love.'

Endnotes

1. The cultivation hypothesis of Gerbner (1973) holds that 'television, among modern media, has acquired such a central place in daily life that it dominates our "symbolic environment", substituting its (distorted) message about reality for personal experience and other means of knowing about the world...Viewing television gradually leads to the adoption of beliefs about the nature of the social world which conform [to] the stereotyped, distorted and very selective view of reality as portrayed in a systematic way in television fiction and news' (McQuail, 2005: 497).

2. The last episode of the second season had not, however, been aired when this paper was written.

3. The Teen Choice Award is annually presented by FOX and honours the year's biggest achievements in music and television (and other disciplines), as voted on by teens aged thirteen to nineteen. In 2009, the Teen Choice Award had over 83 million votes. (http://teenchoiceawards.com/index.php and http://www.imdb.com/Sections/Awards/Teen_Choice_Awards/)

4. http://www.imdb.com/title/tt0368530/awards

5. http://www.imdb.com/title/tt0397442/awards

References

Aubrey, J.S., 'Sex and punishment: An examination of sexual consequences and the sexual double standard in teen programming', *Sex Roles*, 50:7/8 (2004), pp. 505–514.

Aubrun, A. & Grady, J., *Aliens in the Living Room: How TV Shapes Our Understanding of 'Teens'. A Report Prepared for the W.T. Grant Foundation and the Frameworks Institute*, 2000.

Bindig, L., *Dawson's Creek: A Critical Understanding*, Lanham, MD, Lexington Books, 2008.

Bordwell, D. & Thompson, K., *Film Art: An Introduction*, New York, McGraw-Hill, 1993.

Brown, J.D., Childers, K.W. & Waszak, C.S., 'Television and adolescent sexuality', *Journal of Health Care*, 11 (1990), pp. 62–70.

Brown, J.D., Steele, J.R. & Walsh-Childers, K., *Sexual Teens, Sexual Media: Investigating Media's Influence on Adolescent Sexuality*, New York, Lawrence Erlbaum Associates, 2002.

Buckingham, D., *Reading Audiences: Young People and the Media*, Manchester, Manchester University Press, 1993.

Buckingham, D., *Media Education: Literacy, Learning and Contemporary Culture*, Cambridge, Polity Press, 2003.

Buckingham, D. & Bragg, S., *Young People, Sex and the Media: Facts of Life?*, Hampshire, Palgrave Macmillan, 2004.

Cope-Farrar, K.M. & Kunkel, D., 'Sexual messages in teens' favorite prime-time television programs', in J.D. Brown, J.R. Steele & K. Walsh-Childers (eds) *Sexual Teens, Sexual Media: Investigating Media's Influence on Adolescent Sexuality*, New York, Lawrence Erlbaum Associates, 2002, pp. 59–78.

Critcher, C., 'Introduction: More questions than answers', in C. Critcher (ed.) *Critical Readings: Moral Panics and the Media*, Maidenhead, Open University Press, 2006, pp. 1–24.

Davis, G., '"Saying it out loud": Revealing television's queer teens', in G. Davis & K. Dickinson (eds) *Teen TV: Genre, Consumption & Identity*, London, British Film Institute, 2004, pp. 128–140.

Douglas, S., *Where the Girls Are*, New York, Three Rivers Press, 1994.

Eyal, K., Kunkel, D., Biely, E.N. & Finnerty, K.L., 'Sexual socialisation messages on television programs most popular among teens', *Journal of Broadcasting & Electronic Media*, June 2007, pp. 316–336.

Gerbner, G. & Gross, L., 'Living with television: The violence profile', *Journal of Communication*, 26:2 (1976), pp. 173–199.

Gunter, B., *Television and Gender Representation*, London, John Libbey & Company Ltd, 1995.

Hall, S., 'Media power and class power', in J. Curran, J. Ecclestone, G. Oakley & A. Richardson (eds), *Bending Reality: The State of the Media*, London, Pluto Press, 1986, pp. 5–14.

Hall, S., *Representation: Cultural Representations' Signifying Practices*, London, Routledge, 2003.

Hebdige, D., *Subculture: The Meaning of Style*, London, Routledge, 1979.

Heintz-Knowles, K., 'The portrayal of children on prime-time situation comedies', *Journal of Popular Culture*, 29:3 (1995), pp. 139–147.

Heintz-Knowles, K., *Images of Youth: A Content Analysis of Adolescents in Prime-Time Entertainment Programming*, Washington, D.C.: W.T. Grant Foundation and the Frameworks Institute, 2000.

Hirst, M. & Harrison, J., *Communication and New Media: From Broadcast to Narrowcast*, Oxford, University Press, 2007.

IMDb (The Internet Movie Database), Amazon.com (n.d.), 'Awards for "One Tree Hill"', http://www.imdb.com/title/tt0368530/awards. Retrieved 30 September 2008.

IMDb (The Internet Movie Database), Amazon.com (n.d.), 'Awards for "Gossip Girl"', http://www.imdb.com/title/tt0397442/awards. Retrieved 15 May 2009.

IMDb (The Internet Movie Database), Amazon.com (n.d.), 'Teen Choice Award', http://www. imdb.com/Sections/Awards/Teen_Choice_Awards/. Retrieved 16 September 2009.

Jacobson, M., *Young People and Gendered Media Messages. The International Clearinghouse on Children, Youth and Media*, Nordicum, Göteborg University, 2005.

Kaplan, E.A., 'Whose infirmary? The televisual apparatus, the female body and textual strategies in select rock videos on MTV', in S. Kemps & J. Squires (eds) *Feminisms*, Oxford, Oxford University Press, 1997, pp. 410–423.

Kellner, D., *Media Culture: Cultural Studies, Identity, and Politics between the Modern and the Post Modern*, London, Routledge, 1995.

Larsen, P., 'Mediated fiction', in K.B. Jensen (ed.) *A Handbook of Media and Communication Research: Qualitative and Quantitative Methodologies*, London, Routledge, 2002, pp. 117–137.

Lorber, J., '"Night to his day": The social construction of gender', in L. Richardson, V. Taylor & N. Whittier (eds) *Feminist Frontiers IV*, New York, McGraw Hill, 1997, pp. 33–47.

Mazzarella, S.R., 'Why is everybody always pickin' on youth? Moral panics about youth, media, and culture', in S.R. Mazzarella (ed.) *20 Questions about Youth and the Media*, New York, Peter Lang, 2007, pp. 45–60.

McQuail, D., *McQuail's Mass Communication Theory*, 5th edn, London, Sage Publications, 2005.

Mirzoeff, N. (ed.), *The Visual Culture Reader*, London, Routledge, 1998.

Morgan, M., 'What do young people learn about the world from watching television?', in S.R. Mazzarella (ed.) *20 Questions about Youth and the Media*, New York, Peter Lang, 2007, pp. 153–166.

Mulvey, L., 'Visual pleasure and narrative cinema', *Screen*, 16 (1975), 16–18.

Nayak, A. & Kehily, M.J., *Gender, Youth and Culture: Young Masculinities and Femininities*, New York, Palgrave MacMillian, 2008.

Osgerby, B., *Youth Media*, Oxon, Routledge, 2004.

Ralph, S., Brown, J.L. & Lees, T. (eds), *Youth and the Global Media*, Luton, University of Luton Press, 1999.

Signorielli, N., 'How are children and adolescents portrayed on prime-time television', in S.R. Mazzarella (ed.) *20 Questions about Youth and the Media*, New York, Peter Lang, 2007, pp. 167–178.

Silverman, L.T., Sprafkin, J.N. & Rubinstein, E.A., 'Physical contact and sexual behavior on prime-time TV', *Journal of Communication*, 29:1 (1979), pp. 33–43.

Sutton, M.J., Brown, J.D., Wilson, K.M. & Klein, J.D., 'Shaking the tree of knowledge for forbidden fruit: Where adolescents learn about sexuality and contraception', in J.D. Brown, J.R. Steele & K. Walsh-Childers (eds) *Sexual Teens, Sexual Media: Investigating Media's Influence on Adolescent Sexuality*, New York, Lawrence Erlbaum Associates, 2002, pp. 25–55.

Teen Choice '09, FOX (n.d.), Teen Choice 09!, http://teenchoiceawards.com/index.php. Retrieved 16 September 2009.

Ward, L.M., Gorvine, B. & Cytron, A., 'Would that really happen? Adolescents' perceptions of sexual relationships according to prime-time television', in J.D. Brown, J.R. Steele & K. Walsh-Childers (eds) *Sexual Teens, Sexual Media: Investigating Media's Influence on Adolescent Sexuality*, New York, Lawrence Erlbaum Associates, 2002, pp. 95–123.

Wartella. E., 'Where have we been and where are we going?', in S.R. Mazzarella (ed.) *20 Questions about Youth and the Media*, New York, Peter Lang, 2007, pp. 1–12.

Weimann, G., *Communicating Unreality: Modern Media and Reconstruction of Reality*, Thousand Oaks, CA, Sage, 2000.

West, C. & Zimmerman, D., 'Doing gender', *Gender & Society*, 1 (1987), pp. 125–151.

CHAPTER ELEVEN:
MEDIA CONSTRUCTIONS OF GENDER IN ICT WORK

Martha Blomqvist and Kristina Eriksson

The ICT sector is the icon of the knowledge economy, and researchers have long discussed whether it offers women better opportunities or produces the same old inequalities as its traditional counterpart. Those arguing the first point of view claim that the organizations in this sector are less hierarchical, women are paid comparatively well, they are offered autonomous and creative work, and the relational skills that they are assumed to have are of key interest to ICT companies. Arguments in favour of the second position, however, maintain that the sector demands total commitment to work and long working hours, expectations that are not easily combined with responsibility for a family. The ICT sector has likewise been framed and presented in quite contradictory terms by the media, ranging from euphoric and utopian visions at the one extreme, to an apocalyptic and dystopian scene at the other (Moore, Griffiths & Richardson, 2005: 4).

This paper reports on a study of how work in the ICT sector is presented in Swedish newspapers, paying particular attention to articles giving information that is allegedly based on research.[1]

Media creating social reality

The reasons for bringing newspaper articles—and their stories about—(women's) working conditions in the ICT sector to the fore are several. Most of us lack firsthand experience and knowledge of the state of the art and developments in the industry. Accordingly, our understanding of the sector depends on information from elsewhere, and television and daily newspapers are the sources that are available to most people outside the field. They form our knowledge of the relationship between gender and

technology, and give rise to our beliefs and comprehension of what it is like to be a woman working in the industry.

Newspapers and television are not, therefore, merely mediating the state of affairs in a given reality that is 'out there', but they actually 'do' a lot more; they produce a social reality such as gender relationships. Like all of us, these forms of media participate in the everyday business of doing gender. The contributions of newspaper and television journalists, however, are more widely disseminated than those of most others, and their representation of gender thus has an impact on a wider public.[2]

In order to find out what kind of information is provided about the ICT industry, this project has involved a systematic analysis of the contents of Swedish newspaper articles about the sector and women between 1994 and 2004.

Articles for analysis

The analysis is based on articles published in four Swedish national newspapers. Two of them—*Svenska Dagbladet* (SvD) and *Dagens Nyheter* (DN)—are traditional morning papers, while *Aftonbladet* (AB) is a typical tabloid and *Computer Sweden* (CS) is a newspaper which explicitly covers ICT-related stories and is published three times a week. DN is politically liberal, SvD politically conservative, AB social democratic and CS 'politically neutral'. The political backgrounds of these newspapers mainly have an imprint on the editorial page; the news desks make a point of being independent.

Three databases[3] have been used for article searches in the papers during an eleven-year period, from 1994 to June 2004. The search criteria used were 'wom* and IT' (in Swedish, 'kvinn* and IT'). The Swedish 'kvinn*' captures 'kvinna' (woman), 'kvinnor' (women) as well as 'kvinnlig' (female) and 'kvinnlighet' (femininity).

We found at least 7,000 articles in the newspapers in our sample which matched the search criteria. In many of these, the term 'IT' did not refer to information technology at all, but instead to post-*it* notes or, more often, to *it* in English song texts such as '*It*'s raining men'. These articles were excluded, as were a number of pieces mentioning 'wom*' and 'IT', but in unrelated contexts. In the remaining 1,280 articles (201 from DN, 224 from SvD, 300 from AB and 555 from CS) these terms are connected in a meaningful way and have, therefore, been subject to analysis. Figure 1 sets out the distribution of these articles in the four newspapers over the eleven-year period.

Figure 1: Articles discussing 'wom*' and 'IT' in DN, SvD, AB and CS between 1994 and 2004

The distribution of articles is similar in the four newspapers. The number of those on 'wom* and IT' increased during the second half of the 1990s, reached a peak in 2000 and then dropped to a lower level by 2004. In CS, this reduction is less spectacular than in the other publications, while in AB it is especially striking. The limited number of articles over the first few years was expected, as the concept of IT became prevalent in Sweden only in the mid-1990s, gradually replacing that of the computer (in Swedish, 'dator'). But how are we to interpret the dramatic drop in DN, SvD and AB? The answer lies with the dot.com crisis, which coincided with this period. Our data suggest that the sector's economic decline then became the focus of media attention, and did so at the expense of questions about gender relations.

A study of IT policies in the Nordic countries reveals that equal opportunity issues were customary in policy texts during the years of IT expansion, but were omitted from later policy documents (Mörtberg & Due, 2004). These researchers suggest that equal opportunity matters are emphasized only in times of prosperity (ibid.: 14). Our diagram confirms their findings; the newspapers' interest in gender relations in the ICT sector seems to be sensitive to economic fluctuations.

Article content

After deciding whether the articles were relevant to our study or not, we summarized their contents using a modified version of Kenneth Burke's 'dramatistic pentad' (Burke, 1969).

The pentad provides a method for the analysis and critique of texts, and offers a systematic way of analysing situations, statements and courses of events that are narrated in newspaper articles for example. It comprises the elements of: act, scene, agent, agency and purpose. According to Burke,

> [A]ny complete statement about motives will offer *some kind* of answers to these five questions: what was done (act), when or where was it done (scene), who did it (agent), how he did it (agency), and why (purpose). (Burke, 1962: xv)

The questions to be answered in the pentad are thus similar to those a news reporter would ask: Who? What? When? Where? Why? As we are more interested in the outcome of the act than in the speaker/writer's stated or implied goal, we made a modification by substituting the purpose aspect with an *outcome* element.

We have identified accounts of wom* and IT in the articles. In applying the pentad to these, we have read the text very closely, avoiding as much as possible the inclusion of our own ideas, conclusions and interpretations at this stage of the analysis.

The result, in the form of short statements summarizing the articles' contents, provides an overview of what is said with reference to wom* and IT. This is a shorthand account of how the newspaper articles talk about gender relations in the ICT sector.

Statements in the articles

In every article we identified one or several statements or claims, in total 3,026, and distinguished them in terms of the elements: scene, actor, act, agency and outcome. Not all of the statements comprise all of these elements. The contents of some fit well in the form of the pentad and are nicely captured in one statement. Other article texts need more than one to be reasonably summarized and make sense. Although it is important not to over-emphasize the meaning of the number of statements, they do indicate roughly which sources are given a voice on different issues and how these issues are assessed.

Who is given a voice?

Whereas many articles make use of more than one source or voice, there is generally only one behind each statement. The ICT sector came out as the basis for every third statement in all four newspapers. In this context, female managers are the most frequent sources, voicing more than 17 per cent of the statements. Female professionals and male managers appear less often, each accounting for 5 per cent of the statements. The low representation of professional women is remarkable.

The research/study category, i.e. studies, researchers, research, authors or books, is the source for 17 per cent of the statements. In SvD, research/studies are used as sources more than in the other newspapers, whereas in AB such sources appear more seldomly.

Positive and negative statements

We then categorized the statements as positive, negative or neutral/ambivalent in terms of gender relations in the ICT sector. Two researchers separately conducted these estimations, reaching agreement on more than 90 per cent of the statements. The remainder were then examined once again. Positive outcomes are either a more blanced division of women and men in IT or enhanced equal opportunities in ICT companies or in technological education and training. Negative outcomes are exclusion of women, increased or firm male domination, discrimination of women, shortcomings of women or women not being interested in computer work.

In all of the newspapers except AB, statements presenting positive outcomes are more common than negative ones. In SvD, positive outcomes predominate more than in the other publications. Comparatively, statements based on sources from the ICT sector frequently offer positive outcomes. Research/study sources, on the other hand, account for more than an average amount of statements with a negative outlook.

Studies and research

Sometimes the article contains enough information to allow us to find the study or report referred to therein, although occasionally this kind of data is lacking. The research/study sources have been categorized according to the chance of identifying them. Moreover, when it comes to the possibility of identifying sources, SvD and AB stand out. More than the other newspapers, SvD provides enough information about the research/study sources to make identification thereof possible, whereas AB seldomly includes such data.

Table 1: Statements based on research/studies classified under the major themes

Themes	DN n (%)	SvD n (%)	AB n (%)	CS n (%)
Use of computers/internet	11 (13)	11 (12)	43 (34)	74 (25)
Education	10 (11)	16 (17)	11 (9)	49 (17)
Equal opportunity	15 (17)	12 (13)	9 (7)	21 (7)
Work in the IT sector:				
Management	22 (25)	36 (39)	15 (12)	71 (24)
Salaries	5 (6)	6 (6)	12 (10)	31 (10)
Working conditions	2 (2)	6 (6)	7 (6)	20 (7)

We identified a total of 605 research-based statements: 88 in DN, 93 in SvD, 124 in AB and 300 in CS. Six major themes—use of computers or internet, education or training, equal opportunities, management, salaries and working conditions—were distinguished. Table 1 shows the number of statements classified under these themes.

In DN, statements on the themes in the table above make up 61 per cent of all research-based statements, while in SvD the figure is 73 per cent, in AB 72 per cent and 77 per cent in CS.

Whereas the management theme is the one paid most attention by DN and, even more so by SvD, information on the use of computers/internet is predominant in AB. CS gives these two themes an equal amount of attention.

The themes 'use of computers/internet' and 'education' do not refer to work in the ICT sector in any direct way,[4] while statements on equal opportunity do so only exceptionally; more often they concern the significance of ICT for equal opportunities at a societal level. However, the statements included in the management, salaries and working conditions themes generally refer to the IT sector itself.

At this point it is important to remember that there may be, and indeed probably are, more articles dealing with those themes which use research/studies as a source, but did not match our search criteria and are, therefore, not included in the analysis.

Salaries

Salaries are the concern of 54 statements, distributed throughout 37 articles. Statistics Sweden provides data on wages and salaries for different occupational categories annually, while JUSEK, a union to which many academics in the ICT sector are affiliated, and SIF (now part of a new trade union named Unionen), which is directed towards non-academic white-collar workers, also present yearly statistics for their members' occupations. These statistic-producing sources are the most common ones found in articles on salaries, indicating that quantitative information prevails.

Female computer specialists' salaries are lower than those of their male counterparts. However, when the salaries of these women are compared to those of women in other occupations which require the same standard of education, the result is very much in favour of those working in IT. This applies to situations which compare either the total amounts of money or the salaries of women as a percentage of those of men. The very same figures may therefore be used to prove opposite viewpoints, ultimately depending on the point of reference. An article in *DN* containing both types of statements can be used as an illustration. It opens with a comment about wage discrimination: 'Women get lower starting wages than men do—and the differences increase with age. New figures from SIF show that wage discrimination even occurs in a branch as young as the IT sector.'

As a final point, the salaries in the IT sector are compared with those of other professions:

> Nevertheless, it still pays for women to invest in technical training. Women technicians and engineers earn 90 per cent of men's salaries, whereas women accountants, market research analysts and staff and career professionals have to settle for 84 percent of men's wages (DN, 28 October 2002)

A comparison of women's salaries in the US IT sector with those of other fields reveals that 'women in IT earn 60 per cent more than women in other occupations' (CS, 10 November 2000).

The wider the frames of reference, the more favourable the salaries for women in IT appear to be. An article in SvD brings an international perspective to gendered wage

discrimination in Sweden (SvD, 24 January 2001). The article is based on data from an International Labour Organization publication (*ILO*).

> In the IT world, women are often given lower positions, while men get the higher and better-paid ones. According to the report, the Scandinavian countries and the US are the exceptions. Particularly in Scandinavia, where internet use is high, the gap between the sexes concerning wages and level of responsibility is almost non-existent according to the ILO.

In a global perspective, therefore, gender wage differences in the Nordic countries appear to be 'almost non-existent'.

CS is the newspaper which delivers the greatest amount of news with some kind of positive content about salaries and gender in the IT sector. In the other three publications, statements about gender discrimination predominate, thus causing a quite generalized and depressing view of the salaries paid to women in the IT industry. The overall message is that both female professionals and managers in this sector are badly paid.

Management

Research-based statements on management (see Table 1) were found in 96 articles (17 in DN, 24 in SvD, 11 in AB and 44 in CS). Information about the percentages of women working as managing directors and board members in ICT companies quoted on the exchange play a major role as a point of departure for the articles. Three studies are the main sources of these numbers. The first is a mapping study conducted by one of the newspapers, DN, in the autumn of 1999, which covered 22 ICT companies quoted on the exchange. It was followed by another mapping study, covering the same companies, conducted by the Equal Opportunities Ombudsman (JämO, 2000), as a direct response to the DN study. An official government report, Jämit, then took a closer look at the same issue and published an initial document in June 2000.

These investigations highlighted that the numbers of women who are managing directors or board members in ICT companies were disturbingly low. The fact that the figures predominantly concerned only 22 ICT firms and just a few roles within them was not always clear, and on the whole these articles give the impression that women are extremely scarce in *all* positions in the ICT sector. However, at the time when these studies reached the headlines, some 23 per cent of computing professionals in privately owned companies were women (SCB, 2009). In connection with this, Dataföreningen, an association for employees in the ICT sector, published its own report, with the explicit purpose of countering the picture of the industry as a female trap (Dataföreningen, 2000).

Unlike the data on salaries, the low numbers of women in management are generally commented on by other sources, mainly belonging to the ICT sector, and it is obvious that these prefer different explanations. One common understanding is that these low

numbers are a result of the *recruitment base*; there just aren't enough women who have the technological knowledge and education for these kinds of assignments. According to a leading article in SvD:

> We can easily establish that knowledge is not evenly distributed [between men and women]...If you think this is the case you can attend a lecture in systems science and count [them], or for that matter find out who the greatest consumers of computer games are. (SvD, 30 June 2000)

A female managing director of an IT company comments: 'Today, very few women have sufficient experience to sit on the board of a public limited company' (CS, 16 November 2001).

This recruitment-base explanation is the one favoured by male managers in the sector, and to a large extent by their female counterparts as well. However, these men also introduce *gender differences* as a justification. Women are generally assumed to be less likely than men to take risks, instead preferring security. A managing director of an IT company states: 'In reality, when we recruit new employees fewer women respond to our ads. If I were to generalise, women are less inclined to take risks.' (AB, 24 June 1999)

Power relationships as a category of explanation include male networking, the connection between masculinity and leadership, and patriarchal structures. The power relationship explanation is put forth primarily by researchers, but also by some female managers. An IT manager who is also a woman declares: 'There are only a few women IT executives for the same reason there are so few women in high-level positions everywhere. We get to a certain level, but no further.' (CS, 17 November 1999)

Charlotte Holgersson, a gender researcher, explains why she does not believe that this lack of women is a question of education and childcare.

> If you want women in leading positions, you can find them. There is no shortage of women who can run an organization. The problem is the gender order in society that defines men as the norm and women as deviating. The prevailing power structure discriminates against women, she says. (CS, 8 March 2004)

These explanatory categories are not exclusive. Nevertheless, they point in different directions when it comes to possible solutions to the problem. The 'recruitment-base' and 'gender-differentiating' approaches both draw attention away from organizational structures and the business of companies, while the power relationship argument makes them part of the problem. As a law on quotas was being discussed at the time, these arguments must also be read as contributions to that debate. While such legislation

constitutes a reasonable political response to the absence of women due to power relationships, the 'recruitment-base' and 'gender-differentiating' explanations imply that quotas are not the solution.

Only nineteen articles take a topic other than the low numbers of women in managerial positions as a starting point. Seven of these deal with salaries, while the remaining twelve point in various directions, discussing, for example, work–life balance, career opportunities and gendered aspects of management. Some of them bring to the fore research which counters the conventional understanding of gender patterns: more than 40 per cent of promoted women in Sweden state that their careers developed more rapidly than they had foreseen (CS, 14 July 1996); more men than women IT managers in the United States report a poor work–life balance (CS, 14 November 2001); and female board members in Sweden are considerably younger than male board members (CS, 21 March 2001). It is worth noting that CS is the newspaper which is keenest to report research results which challenge traditional gender patterns.

Working conditions

Data on salaries in the ICT sector are published yearly by Statistics Sweden as well as by trade unions to which IT professionals are affiliated. Facts about women and men as board members and managing directors are available from corporations' annual reports and can be easily put together for anyone who is interested. Data on other aspects of work and working conditions, such as working hours, content of work, working environment and demands, are less accessible. In order to explore these issues, studies that are designed to address them need to be conducted.

We found research-based statements on working conditions (apart from the salary and management themes) in only 27 articles (two in DN; five in SvD; seven in AB; thirteen in CS). In these pieces, negative assessments are twice as common as positive ones. AB contains more articles with negative accounts than the other newspapers.

Stress is the predominant problem featured in twelve of these articles, all of which convey negative assessments. In an SvD piece (28 May 2000), two researchers identify people who inhabit the 'new economy', stating:

> The media tell us about young men working with IT or 'e' around the clock, with unkempt hair, offices and clothes inspired by the 60s. They make more money than they can spend, though they are unlettered.

The researchers are referring to media portrayals of those populating the 'new economy'. The better part of the article deals with management thereof, with the following being stated in passing: 'The staff is worn out and will hardly fit into the sector after thirty.' Here too, the media seem to be the source; in any case, the article does not refer to any research.

As many of the statements seemed vague or confusing, and since part of the research referred to in the articles was unknown to us, we decided to take a closer look at the reports which supposedly support the statements made. In four cases we were unable to find the research alluded to because the articles provided *no information* at all about it, and we therefore did not know where to start looking. In ten cases we found the research referred to, but were able to establish that it was of *little or no relevance* in the context, either because the ICT sector had not specifically been the object of a study, or it was vaguely referring to stories told about the industry. More disturbing is that in six cases we have reason to believe that *no report* could be found, even though either the researcher or journalist gives the impression that a study had been conducted.

After ruling out the four 'impossible-to-find' studies, the ten irrelevant and the six seemingly non-existent references, only seven of the studies referred to remained. Although we have not managed to lay our hands on two of them, we have reason to believe that they exist(ed), and it would have been possible for us to find them at the time the newspaper article was published. Three of them discuss positive aspects of working conditions, while four emphasize problems. One of the reports we managed to trace deals with stress (CS, 21 March 2001):

> Three of four [people] think the branch gives opportunities to make an impact, and [in terms of] development, creative freedom and job satisfaction. But around 70 per cent reported worrying about the stress of their round-the-clock lifestyle and lack of balance between work and leisure time. As many as 65 per cent reported that work negatively affects their personal lives.

The article refers to a survey of 265 women, all members of the network World Women in Technology in the United States (Gewirtz & Lindsay, 2000). Compared to some of the statements on stress found in the articles which refer to studies of little relevance or those that we believe are non-existent, the understanding of the situation quoted above is more nuanced.

Accordingly, of the twelve references to research on stress in the IT sector, only one turned out to be reliable. There, therefore, seems to be little research evidence to support the notion that jobs in the ICT industry are particularly stressful, although almost half of the statements on working conditions suggest otherwise.

Of the remaining six research-based articles, three report on positive aspects of work satisfaction among IT professionals, the remarkably high percentage of permanent employment contracts in the sector and the development opportunities for women in the industry. Two of the negative articles deal with difficulties concerning work–life balance, while the third refers to a study reporting that nude pictures can be found in every fifth IT company.

The examination of the articles consequently leaves us with only a few reasonably reliable studies on working conditions in the sector. On the whole, the newspapers provided their readers with very little research-based data on gender and working conditions in the industry during the period studied.

Concluding discussion

This article improves our knowledge of how gender relations and working conditions in the ICT sector are covered by Swedish newspapers and, consequently, how these issues are constructed by the media. The contents of four Swedish newspapers—*Dagens Nyheter, Svenska Dagbladet, Aftonbladet* and *Computer Sweden*—between 1994 and 2004 were analysed. The analysis reveals that a rather small proportion (17 per cent) of the newspapers' statements on the sector is based on research/studies. *Svenska Dagbladet*, a conservative morning paper, is the one which used research/studies as its sources the most, whereas *Aftonbladet*, a social democratic evening tabloid, seldomly does. Among the allegedly research-based accounts or statements, we found that those referring directly to the ICT sector discussed issues of salaries, management or working conditions.

Management is by far the most common theme, and was discussed in 96 articles. Salaries, on the other hand, were the concern of 37 articles, while other aspects of working conditions were broached by only 27 pieces.

Statistical sources clearly dominate in the articles discussing management and salaries, whereas only one piece discussing working conditions refers to statistics as a source.

Statistics Sweden and the trade unions in the IT sector are the main producers of the data about salaries presented in the newspapers under study. For the most part, women's salaries are compared to those of their male counterparts in the IT sector, resulting in a general message that both female professionals and managers in the industry are poorly paid. However, when women's salaries in this sector are compared to other occupational groups, their level of pay stands out as being exceptionally high. *Computer Sweden*, a newspaper covering ICT-related issues, stands out as the publication delivering the greatest number of positive statements on salaries and gender in the IT arena.

The lack of women in managerial positions was highlighted at the turn of the century by three mapping studies. Although the numbers of women working as managing directors or board members in the ICT sector were no smaller than in many other industries, it was the state of affairs in this sector that received a lot of attention and was targeted. Numerical quantities are what most of the articles (80 per cent) on the managerial theme focus on, despite often complementing these numbers with comments that offer explanations of the situation or how to change it. In all four newspapers, the majority of the articles on management portray the lack of women as a problem; however, this tendency is less visible in *Svenska Dagbladet* than in the other publications. *Computer*

Sweden is the newspaper which is keenest to report research that opposes traditional gender patterns in management.

While secondary statistics are available for the articles dealing with salary and management issues, this is rarely the case when it comes to other aspects of working conditions, where other kinds of studies based on primary data are referred to. At first sight, when reading the articles, there seemed to be strong evidence that stress is a serious problem for employees in the IT sector. However, a closer look at the studies allegedly supporting these claims reveals that in only one of twelve articles is the research in question reliable; that is, traceable, relevant and actually in existence. Likewise, of the total of 27 articles on working conditions that claimed to be research-based, only seven turned out to be based on reliable research sources. Among the few articles dealing with working conditions, apart from salaries and management issues, negative assessments clearly dominate all four newspapers. However, *Computer Sweden* also reports a fairly high number of positive assessments.

This overview of how newspapers report the state of affairs in the ICT sector and how research/studies are used in these articles raises some important questions: why is the impact of secondary quantitative data so much stronger than other kinds of research data? Why do newspaper articles sometimes fall back on results from studies that lack reliability or cannot—for one reason or another—be found? Why are the contents of articles in *Computer Sweden* more balanced than in the other newspapers when it comes to positive and negative assessments?

Quantitative data produced by public authorities are easily accessible and obviously favoured as sources in the articles. As a result, the figures concerning women and men's salaries, as well as the absence of women in the top positions in ICT companies, are given a great deal of space at the cost of dealing with other aspects of working conditions. Numbers on salaries seem to have newsworthiness per se, whereas data on women in managerial roles are often commented on by other sources. Quantitative data is more easily utilized in articles, whereas the qualitative form is less available and requires more journalistic processing. Together, availability and time aspects make a difference to costs. Today's commercial pressures on newspapers mean that costs are part of journalists' working conditions. As Nick Davies (2008) points out, newspaper stories need to be cheap and quick to cover. Furthermore, the data need to be safe, that is, reliable to publish, which means that official sources are clearly favoured (ibid., 114; 118). The quantitative data used in articles on salaries and the numbers of women in managerial positions clearly meet these criteria.

Paradoxically, the importance of making a story reliable by using (seemingly) trustworthy sources may also partly explain why newspaper articles all too often refer to studies that either lack reliability or relevance, or whose existence is dubious. While the journalists' desire to base an article on research makes sense, some researchers' readiness to comment on the state of affairs in the ICT sector, even when lacking expertise in the

field, is more questionable. It might be a consequence of the increasing requirement for researchers to be visible and play an active role as sources of news material (Hammersley, 2006). An escalating competition for research funding and its internationalization probably adds to this development. Moreover, being the icon of the knowledge economy, the ICT sector may attract the comments of various actors and researchers, among others.

When it comes to *Computer Sweden*'s comparatively balanced reporting on the positive and negative aspects of the ICT sector, this may be partly explained by it being a trade newspaper, with an exclusive focus on the field and markedly greater numbers of articles, allowing for more variety in terms of content. Moreover, *Computer Sweden*, by way of *Computer World*, has immediate access to research news—both positive and negative—from all across the globe. This supports the newspaper's desire to cover the state of the sector more broadly. *Computer Sweden*'s inclusion of a variety of research news also seems to open up more complex and equivocal (re)presentations of gender relations, and research results confirming a traditional gender order are, therefore, less dominant in this newspaper compared to the others under study. Furthermore, in contrast to some publications, especially the tabloid press, *Computer Sweden* is less concerned with the media logic which demands sensationalist news items. Furthermore, as part of the ICT sector, it—like other actors in the industry—is inclined to make positive assessments about it. All of this taken together results in *Computer Sweden* providing more nuanced reports.

In this article we have discussed and analysed how research results are incorporated and used in journalistic work today. The journalistic practices that we have identified have implications for gender researchers that are worth considering. More theoretically informed gender research is often based on qualitative methods. Consequently, since quantitative and easily available data are preferred by the media, the impact and dissemination of qualitative research becomes circumscribed. Knowledge which contributes to a more complex understanding of gender relations in society is thus only made accessible to a limited extent outside the academic world. The ambition of gender research to contribute to the changing of structures of dominance and subordination is better served by broad communication reaching outside the research society. In order to meet this challenge, we believe that effort needs to be put into the communication and translation processes vis-à-vis the media, especially when it comes to qualitative research results. In light of the frequent use of press releases in journalism for example (Davies, 2008: 90), the way in which these are designed requires careful consideration. More thoughtful communication and translation work also meets an increasing demand on the part of both the public and research funding institutions to disseminate the findings of research nationally and internationally.

Endnotes

1. The research project *Gender Relations and Working Conditions in the ICT Sector* is financed by the Swedish Council for Working Life and Social Research.

2. Kerstin Engström (2008) looks into how different newspapers, genres and editorial sections reproduce, or contribute to change, existing gendered discourses. Unlike our study, her analysis does not focus on the ICT sector.

3. The *Presstext* database comprises all articles published in DN since 1994, the *Medie-arkivet* database comprises articles from SvD and AB, also since 1994, and the *Affärs-data* database contains all articles published in CS since 1992.

4. An analysis of the education theme is presented in Blomqvist (in print). An analysis of technology discourses in three of the newspapers—DN, SvD and AB—has been conducted by Lindsmyr (2007).

References

Aftonbladet, 'Dataslav eller IT-drottning', 24 June 1999, p. 11, http://www.mediearkivet. se. Retrieved 10 May 2005.

Blomqvist, M., 'Absent women: Research on women in IT education mediated by Swedish newspapers', in S. Booth, S. Goodman & G.E. Kirkup (eds), *Gender Issues in Learning and Working with Information Technology: Social Constructs and Cultural Contexts*, Hershey, IGI Global, in press.

Burke, K., *A Grammar of Motives*, Berkeley, CA, University of California Press, 1969 (1945).

Computer Sweden, 'Trögt för kvinnliga IT-proffs att göra karriär', 14 July 1996, http:// www.computersweden.se. Retrieved 10 May 2005.

Computer Sweden, 'Glastak hindrar IT-kvinnor i karriären', 17 November 1999, http:// www.computersweden.se. Retrieved 10 May 2005.

Computer Sweden, 'Kvinnor stressas I IT-branschen', 21 March 2001, http://www.ad.se, retrieved 6 April 2010.

Computer Sweden, 'Var fjärde IT-konsult letar efter nytt jobb', 21 March 2001, http://ww.ad.se. Retrieved 6 April 2010.

Computer Sweden, 'Därför finns så få kvinnliga IT-chefer', 14 November 2001, http://ww.ad.se. Retrieved 6 April 2010.

Computer Sweden, 'Saknas: Kvinnor i styrelsen', 8 March 2004, http://ww.ad.se. Retrieved 6 April 2010.

Computer Sweden, 'Färre IT-kvinnor i USA', 10 November 2000, http://ww.ad.se. Retrieved 6 April 2010.

Computer Sweden, 'Tre av 52 är kvinnor i IT-bolagen', 16 November 2001, http://ww.ad.se. Retrieved 6 April 2010.

Dagens Nyheter, 'Ojämlika löner i IT-branschen', 28 October 2002, Section C, p. 2, http://www.presstext.se. Retrieved 19 April 2005.

Dataföreningen, *IT-kvinnor: Den sanna bilden av kvinnorna i IT-branschen*, Stockholm, Dataföreningen, 2000.

Davies, N., *Flat Earth News*, London, Chatto & Windus, 2008.

DTI, *Women in the IT industry: How to Retain Women in the IT Industry*, 2005, http://www.dti.gov.uk/files/file9335.pdf. Retrieved 2 June 2007.

Engström, K., *Genus och genrer—Forskningsanknutna genusdiskurser i dagspress*, Umeå, Medier och kommunikation, Umeå University, 2008.

Gewirtz, M.L. & Lindsey, A., *Women in the New Economy*, GLS Consulting, Inc., 2000, http://www.glsconsulting.com/womensurvey/womensurvey1.htm. Retrieved 11 November 2008.

Hammersley, M., *Media Bias in Reporting Social Research*, Oxon, Routledge, 2006.

JämO, *Rapport från en granskning av 22 IT-företags jämställdhetsplaner*, Stockholm, JämO, 2000.

JämO, *JämO:s IT-granskning 2002—Utvärdering av 1999-2000 års granskning*, Stockholm, JämO, 2003.

Lindsmyr, E., *'Kvinnorna IT-förlorare'? En diskursanalys av mediernas konstruktioner av teknik och kön i informationssamhällets Sverige* (Master's Thesis), Centre for Gender Research, Uppsala University, 2007.

Mörtberg, C. & Due, B., 'Med IT och kön som prisma i studier av nordiska IT-policies', in C. Mörtberg & B. Due (eds) *Informationsteknologi och kön som prisma i analyser av nordiska IT-policies*, NIKK Småskrifter no. 9, Olso, NIKK, 2004, pp. 9–21.

Moore, K., Griffiths, M. & Richardson, H., *Gendered Futures? Women, the ICT Workplace and Stories of the Future*, paper presented at Gender, Work & Organization conference in Keele, June 2005.

OPK, *Listan*, 2000, www.opk.org/listan/indes.html. Retrieved 15 May 2001.

SCB (Statistics Sweden), *Employees at National Level by Occupation, Sector, Age and Sex*, Stockholm, SCB, 2009.

SOU 2000:31, *Jämställdhet och IT—En kartläggning på uppdrag av Jämit*, Jämit— Jämställdhetsrådet för transporter och IT, Stockholm, Fritzes, 2000.

SOU 2000:58, *Jämställdhet och IT—Integrations—och jämställdhetsdepartementet*, Jämit—Jämställdhetsrådet för transporter och IT, Stockholm, Fritzes, 2000.

SOU 2001:44, *Jämställdhet—transporter och IT. Slutbetänkande från Jämit*, Jämit— Jämställdhetsrådet för transporter och IT, Stockholm, Fritzes, 2001.

Svenska Dagbladet, 'Kejsare i kortbyxor', 28 May 2000, p. 40, httip://www.presstext.se. Retrieved 6 April 2010.

Svenska Dagbladet, 'Jämit vet bäst?', 30 June 2000, p. 2, http://www.presstext.se. Retrieved 6 April 2010.

Svenska Dagbladet, 'Digital klyfta vidgas', 24 January 2001, p. 36, http://www.presstext. se. Retrieved 6 April 2010.

Chapter Twelve:
Looking for Gender Equality In Journalism[1]

Sinikka Torkkola and Iiris Ruoho

In Finland, like in other Nordic countries, gender equality has been a part of official policy since the 1970s. Yet, in spite of this, labour market segregation has changed very little in recent decades (cf. MSAH, 2008). The journalistic profession has been an exception for more than twenty years because of its gender balance; in Finland there have been almost equal numbers of female and male journalists ever since the late 1980s. The amount of women in lower and mid-level managerial posts among editorial staff has also increased. Indeed, according to the membership register of the Journalists' Union in Finland, about half of editorial chiefs are women. However, this picture is not quite conclusive.[2]

There are no general Finnish statistics which specify gender differences between the different forms of media and the different managerial posts. However, it seems to be almost impossible for women to make it to the very top, to the position of editor-in-chief; female journalists do indeed encounter the glass ceiling, especially in newspapers. There are 31 daily newspapers in Finland, but only two of them have senior or executive editors-in-chief who are women. The gender balance in the profession is thus only an illusion, and is marked by both vertical and horizontal segregation (Van Zoonen, 1994: 50–51). The former refers to the fact that women are under-represented in managerial positions. This is, of course, not only a Finnish phenomenon, as female journalists all

over the world have to deal with this problem (De Bruin & Ross, 2004; Fröhlich & Lafky, 2008; Morna, 2007; Vochocová, 2008).

Horizontal segregation is evident when one considers gender balance in terms of specialization within the different journalistic activities (cf. Djerf-Pierre & Löfgren-Nilsson, 2004). According to many studies (Savolainen & Zilliacus-Tikkanen, 1992; Zilliacus-Tikkanen, 2008; Steiner, 1998; Van Zoonen, 1998; Mc Kay, 2000; Chambers, Steiner & Fleming, 2004), there are differences between women and men so far as both their experiences and editorial work are concerned. Horizontal segregation works in two ways in the field. On the one hand, career obstacles seem to diminish because *female* journalists are particularly needed today to head editorial offices for content reasons. On the other, media groups are demanding female editors-in-chief at the very least for reasons of image and competitive advantage. However, the increase in the number of women in senior positions does not necessarily lead to the dismantling of gendered journalism cultures, to use Margareta Melin's (2008) terminology. Therefore, it is both necessary and challenging to analyse the preconditions and factors under which, for example, the conceptions of journalism, leadership and cultural expectations change and begin to promote gender equality (cf. Djerf-Pierre, 2007).

Equality versus difference

Although this chapter concentrates on a comparison of the career progress of female and male editors-in-chiefs from the equality perspective, gender here is not a mere variable but a similar object of analysis and interpretation, just like other research concepts (Djerf-Pierre & Löfgren-Nilsson, 2004: 83). It is therefore possible to ask: on what basis are journalistic careers and the ideal models of leadership gendered? And, respectively, on what grounds would the increase in the numbers of women in top positions substantially change the values and ways media organizations act? In view of the female chiefs' career progression, at least three possible starting points are available to the researcher.

First, the purpose of this research is to aid in the recognition of the factors that prevent women from reaching the same positions as men. Secondly, when women's career progression is considered, we should refuse to take for granted and should also pursue an inquiry into the institutional positions in which men have traditionally done well. Thus, a critique would be targeted at the cultural practices that discriminate against women and are particularly related to leadership and journalism. Correspondingly, the issue of women's leadership would imply another kind of direction, namely a cultural change in management, ways of acting and journalism itself. However, it must be acknowledged that it is problematic to base one's thoughts on the belief that female leadership partakes of some sort of natural or essentialist characteristic.

Although the myth of female leadership described above might even, in the long run, help change the journalistic organization, it is nevertheless based on the natural and static differences between the female and male genders (Billing & Alvesson, 2000: 147–149). Therefore, an alternative third research path leads us to pose the following questions: why do we need the idea of *difference*? Should we not question all norms, ideals and practices that thrive on the idea of gender difference? In these circumstances, no cultural practice related to gender differentiation would constitute an ideal and a norm-like starting point. The aim would be to create completely new kinds of institutions and practices that are in no way founded on gendered essentialisms.

This chapter pays attention to recognizing the factors that prevent women from reaching the same positions as men. It reflects female managers' career development in media groups, as well as the overt and covert obstacles to women's professional advancement in order to consider how their careers are connected to journalism as an institution and culture.

The complexity of career

Studies on gendered journalism have thrown light on the complexity of careers (De Bruin & Ross, 2004). Inspired by social identity theory, Marjan de Bruin (2004: 2–6) highlights a difference between three categories: gender, professional and organizational identities. According to De Bruin, organizational identity exists in a collectively constructed and continuously renegotiated understanding among the members of an organization. In contrast to this, professional identity does not stem from a particular media group but from the journalistic community and its understanding of professional roles, functions and values. Gender identity is not understood as a static feminine-masculine polarity, but rather as a category including multiple identities under continuous construction and renegotiation.

Despite departing from a somewhat different starting point from De Bruin, we do not completely disagree with her. It is useful to combine the different perspectives on studying gendered career development in journalism. For example, both women's careers and leadership have been researched from a number of different perspectives (Lift & Ward, 2001; Indvik, 2004: 276), but these rarely intersect in the same empirical study. Our approach to gendered career development arises from the following three positions: the organizational, journalistic and individual. Each of these is also considered on the cultural, structural, operational or action levels (see Table 1). Here the analysis follows Julia Evetts' (2000) dimensions of explanations about women's professional careers and promotion in organizations and professions. Our multidimensional conceptualization makes it possible to recognize the ways in which media organizations, journalism and individuals act as a part of gendered social and cultural practices.

Table 1: Theoretical approaches for studying journalists' gendered careers

	Organization	Journalism	Individual
Culture	leadership	good journalism	gender expectations
Structure	occupational position	routine	social conventions
Action	ranking	specialization	Tactics

In our study, gendered careers thus consist of a complex set of *actions* such as, for example, ranking candidates in media groups, or the personal tactics and social conventions that individual journalists absorb as 'females' and 'males'. A part of these processes are the cultural ideals of good journalism and powerful leadership that are realized in the everyday lives of media organizations. These ideals are usually taken for granted and structure daily routines, conventions and traditions. Joan Acker (1998: 197) states that there is a gender substructure in the organization which operates to help reproduce gender divisions and inequalities even against the best intentions of some of the women and men working therein. These substructures are always gendered insofar as society is organized into two genders. However, according to Judith Butler (1990: 24), gender is not a noun but a doing: we do our gender in our everyday lives by using certain gestures, manners and language, all of which build us socially and culturally as women and men.

We assume that the multidimensional approach helps us, as media scholars, to highlight the social nature of individual subjectivity; that is to say, to see how society and its power relationships are overlapped in all of the gendered conventions and tactics which female or male journalists adopt when, for example, they try to specialize in certain areas, consider their personal career options and carry out their daily duties. The multidimensional approach also helps us to recognize how individual tactics are not restricted but are instead conditioned by a variety of organizational attributes, namely by the way of thinking about both ideal leadership and gender roles.

Contradictory experiences

The aim of our study is to examine and clarify the careers of female and male editors-in-chief in Finland and especially the overt and covert obstacles to the career advancement of women in media organizations and in terms of journalistic practices. The concrete research questions are: what kinds of differences are there in the careers of female and male editorial chiefs? Do the cultures and structures of media organizations and journalism explain these differences? What kinds of individual strategies and tactics do journalists themselves choose?

The data and the method

The study's data are contained in the thematic interviews of 21 female and 22 male editorial chiefs of newspapers and media companies. The interviewees were drawn from the highest management levels, and were working as senior editors-in-chief, editors-in-chief, managing editors and news editors. The interviews involved eleven daily newspapers, four television news and current affairs departments and six magazines, two of which were women's magazines and four were general interest and family publications. This report does not name the media that have participated in the research, because in a small country like Finland journalists know each other quite well and revealing the names would endanger anonymity. In addition, announcing the names of the media would be ethically questionable due to the fact that the interviewees—being only two from each media organization—do not represent the entire media company or its journalistic staff.

Among the interviewees, 22 work in newspapers, twelve in magazines and nine in television. The data does not consist of representatives of both sexes from every media form, because some of those included only have either female or male chiefs. In one case, both respondents were male because a female chief refused to be interviewed. The majority of the participants had families: 32 had a spouse and children, one was a single parent, ten were childless and, of these, eight live as part of a couple. Ten were under 40 years old, 27 ranged from 40 to 55 years of age and six were over 55. The interviewees' educational backgrounds varied, and the respondents ranged from being high school leavers to postgraduates.

The data was collected by semi-structured thematic interviews. The focus was on the interviewees' career stories. Participants were asked to talk about both their working and personal lives. Only at the end was there a general discussion on the theme of why women and men do not have equal opportunities for career advancement in journalism. The analysis undertaken included a critical close reading of the interviews and an examination of the similarities and differences between the narratives from a gender perspective (Torkkola & Ruoho, 2009).

Divided careers

A comparison between the basic facts provided by the interviewees illustrates how careers are divided between male and female journalists. There are clear differences between the careers of female and male editorial chiefs, with the latter having had a faster and more varied career development than their female colleagues. Because of the data volume, this study has no statistical significance, but it does suggest that male and female journalists have had different opportunities when it comes to progressing their careers.

The comparison of female and male careers reveals that the progression of the latter has been more rapid (Table 2). Nearly half of the male interviewees were appointed to their first chief post during the first five years of work, while only two female respondents

had been working as chiefs in the initial stages of their careers. One of them worked as an editor-in-chief at a very small local paper. Thereafter, she was employed for several years as a journalist and a press officer before her second appointment to a chief post. The other woman was first appointed as a producer of a free sheet. She then proceeded to continue her career as a sub-editor at a family magazine.

The comparison between careers indicates that male journalists are recruited from outside an organization more frequently than their female counterparts. Half of the men who had been appointed to a chief post had no previous work experience in the same media or media company that now employed them (Table 3).

Table 2: Journalistic experience before the first appointment to a chief position

Journalistic work experience in years	Female journalist	Male journalist
0–5	10	46
6–10	35	23
11–19	35	32
>20	20	0
Total	100%	100%
N	21	22

Table 3: Work experience in the same media before the first appointment to a chief position

Work experience in years	Women	Men
0	19	50
1–5	24	32
6–10	29	19
11–19	24	0
>20	5	0
Total	100%	100%
N	21	22

The journalist who is recruited to the highest position of editor-in-chief typically comes from outside the company, and this applied to ten of the 21 people interviewed herein. However, these numbers only provide a glimpse at the differences in the career development of female and male journalists. In the following sections, we will paint a more detailed picture and reveal the reasons behind these divided careers. Following our multidimensional conceptualization, we will then examine the career stories from the organizational, journalistic and individualistic perspectives.

Organizational perspective: Recruiting leaders

Through an organizational perspective, we focused on the dynamics between gender and the media organization. The media organization provides the frameworks for both journalistic practice and journalists' identities. It is not a stable structure but rather a changing process where practices connected to beliefs, values and feelings are constructed (De Bruin, 2000: 228–229). In our study, the organizational perspective indicates the mostly invisible and unconscious ways of understanding gender that shape the concrete working arrangements and recruitment processes.

In the interviews, the organizational culture and structure is revealed when the interviewees talk about the recruitment processes. Patriarchal conservatism is seen as one of the obstacles to women's career advancement. Leadership has been understood in media organizations as an attribute that naturally belongs to men. An interviewee explains how he, and not his more experienced female colleague, was recruited to the chief post.

> Interviewee: They promoted me very quickly. They hired me as a journalist, then I was a leading journalist, which is a rather strange job title, and then I became the second editor-in-chief, meaning in practice that the first editor-in-chief headed the whole association. I ran the editorial office which did have experienced journalists. They were a managing editor and a sub-editor, both women, and substantially more experienced than I was. I kind of became their superior.

> Interviewer: How did that happen?

> Interviewee: I wondered about that too. I thought that the managing editor N.N. should, without question, have been the editor-in-chief. Because she was the heart and soul of that paper. But that was a patriarchal community... (Man, 57 years, interview 17)

Networking is an elementary part of the recruitment process. It is very common for the person who is recruited to be appointed to the post without an open announcement. Moreover, when a vacancy is formally announced, networking and headhunting is a typical way of finding decent candidates. An interviewee with a successful career said that he has never sent his application anywhere because he has always been invited to his next post. The networks used in recruitment are gendered, which explains why women are not headhunted as often as men. An interviewee thinks about the importance of networks in the recruitment process. Most often headhunting is only targeted at male-dominated networks.

> If you think of something like a senior editor-in-chief in a provincial daily…in a male environment where the networks have been really male, you then have had both a push and a pull. They have looked for whom amongst us men could become a senior editor-in-chief… (Man, 42 years, interview 30)

There is a great deal of tacit knowledge in the recruitment process that directs not only the actions of the recruiters, but also those of the people being recruited. A female chief answers the question why she did not apply to the editor-in-chief's position.

> I didn't apply for it. I sensed that they were not looking for me; my type was not looked for. The senior editors-in-chief in this paper have been quite some men, sort of provincial figureheads and they've had great influence. In my mind, the senior editor-in-chief doesn't need to have such great influence. It could be a good journalist, sufficiently good to become the senior editor-in-chief. (Woman, 52 years, interview 6)

The interviewees connect leadership to masculinity in many ways. One of the oldest male respondents displays an openly chauvinistic standpoint and maintains that women do not apply for managerial positions because their interests are orientated to the home and family. In his view, there is a natural division of labour according to which 'men do the work outdoors and women indoors'. Although such blatant chauvinism does not seem to be particularly common today, it is still very familiar to the older generation of female journalists. An interviewee recounts an episode from the 1980s:

> my editor said—I had been in the political news department for a couple of years then, I was maybe 26 or 27 years old—listen N.N., you do good stories and good work but always remember that you are only a woman. (Woman, 52 years, interview 15)

Masculinity as a self-evident social norm of leadership also appears in the female interviewees' stories. To a question about the relevance of gender for managerial duties, a female respondent answers by comparing herself to men.

> Maybe in the end it is in that I have a rather good sense of humour and make jokes like any man, that in that sense I am not too sensitive. I haven't felt that I would have it more difficult because I am a woman. (Woman, 39 years, interview 22)

The women's stories about leadership are contradictory. On the one hand they deny the relevance of gender. On the other, they think that women are appointed to chief positions partly because they are naturally conceived as having the attributes that make them different leaders who are in demand in a context of changing organizations and increased competition in the media market. The same contradiction arises when the interviewees speak about journalism and journalistic cultures and practices.

The journalistic perspective: Gendered journalistic practices

Through the journalistic perspective, we focused on the gender logic that shapes the daily routines and working practices of editorial offices. Gendered attitudes to journalism arise from the dichotomy between the masculine and the feminine: while the masculine is connected to rationality, objectivity and the public sphere, the feminine, for its part, is associated with emotion, subjectivity and privacy. Opinions on gender relevance are extremely contradictory among the interviewees. Some editorial chiefs are aware of the gender logic that directs the working routines in editorial offices. The relevance of gendered practices is seen in daily editorial meetings where the topics of stories are fixed.

> The old-fashioned way was to give women the stories on handicrafts and child care and all such things, and it was thought that that was all women could do. Then came this journalism where women can do things if they really try. We did write stories for ten years from all over the place. Now gender isn't necessarily paid so much attention. Rarely do we come across an attitude of the kind—oh yeah, we have a woman here. But if you think that women and men are on a par, they are not…gender does have an effect. It's not as great an effect as people think, but it isn't a small effect either. (Woman, 52 years, interview 15)

On the contrary, some interviewees do not think that journalistic work has gender relevance, arguing instead that personal attributes and personal lives are of greater

importance to professional advancement. They maintain that whether somebody can or cannot manage in a tight spot concerns aspects other than gender. Journalists in different life situations are interested in a myriad of distinct topics. The picture, however, becomes more complicated when the interviewees think of a future situation when the majority of journalists will be female. A respondent explains why having a female majority would be problematic.

> If you nevertheless accept that there can be some differences between men and women, it can be very constructive if their thoughts meet and the symbiosis that comes from that is the thing that works for both. I think it would be a problem if we only had female political journalists. Even a couple of years ago, we actively really looked for a woman sports journalist. (Man, 45 years, interview 14)

The competition in the media market may offer better opportunities for female journalists, because there are expectations that they have the competence to do journalism that could potentially attract more female audiences. But being a female journalist does not automatically imply a different journalistic style. On the contrary, some interviewees claim that women can be more traditional 'hard news' writers than their male colleagues.

> Here is a funny thing which startled me a bit…When women become news producers, they draw, to my mind, a more male line than men [regarding the distinction between hard and soft news]. In that sense, they are somehow more traditional and I don't know why. I have talked about this to them: 'Are you sure that you allow yourself to think of all the topics from all angles? Are you really of the opinion that that it is through these topics we should always do the programmes?' (Man, 49 years, interview 20)

'Hard news' refers to the hierarchy of the journalistic genre. In traditional news, journalistic hard news is ranked at the top. A journalist who wishes to advance in his or her career in mainstream journalism has to prove his or her capability in the traditional core areas such as politics, sport or economics.[3] For female journalists this is perhaps more demanding because such topics are conventionally considered a natural part of masculine competence. Thus, female journalists have to prove their ability to go beyond the female boundaries that stop them from being taken seriously as professionals. In the current study, this phenomenon becomes most visible in the stories that focus on individual choices at work and in the home.

The individual perspective: Survival tactics

Cultural gender expectations and social conventions frame individual choices in both our personal and working lives. Within these frames, people construct survival tactics that direct their career progress. Female and male journalists meet differently gendered expectations, which are realized in hundreds of small episodes that suggest to the individual 'how to do gender' without breaking cultural norms. Women and men are in different situations because male journalists have many more role models in top positions than women. Due to the lack of female colleagues, women in the top jobs feel more isolated than men. This loneliness could be a sign of the difficulties that prevent women in middle management from seeking senior roles. An interviewee describes the situation in the following way:

> I have seen close up how demanding that job is (the senior editor-in-chief's job). My situation is that I have three under age children and there is a lot more going on in life than work so at the moment I wouldn't even want such a committed post as that of the senior editor-in-chiefs. (Woman, 40 years, interview 8)

According to traditional gender stereotypes, female journalists are expected to have good social skills and not a lot of interest in actively promoting their careers. This may be an obstacle to a career, because a woman is then not considered as a potential candidate for a job that a senior colleague could facilitate. An interviewee speaks about 'the crown prince syndrome' and asks why there are always so many opportunities for an 'angry young man' but few for an 'angry young woman'. Another participant compares gendered career expectations in this way: 'Women's ambition—well they laugh out loud at that—but not at men's ambition; it is regarded a virtue.' (Woman, 52 years, interview 15)

The 'crown prince syndrome' refers to both the masculinity of leadership and of journalism that female journalists have to adapt to before they can progress in their careers. In editorial offices, women seek acceptance by acting like one of the boys. An interviewee describes the socialization process in this way:

> They took me on in sports as one of the boys, they talked about me as a guy. They had nude pictures on the wall, and I was treated as one of the boys and for me at that point it was quite okay. I knew the guys and knew that, okay, this was their style, and I couldn't be bothered to make a fuss about it—if they liked to call me a girl and brag about their pictures, so what? Although they did this, they did it fairly and the situation was acceptable. (Woman, 41 years, interview 4)

Responsibility for the family is often seen as the reason why women do not apply for chief positions. But family responsibilities do not explain why women's careers do not progress as well as men's. Career advancement depends on the cultures and structures of the media organization and its ability to take into account different family circumstances. An interviewee from a magazine says that children have been no obstacle to her career.

> I have three children and I have really worked the whole time, really a lot. Well, I have never not applied to a job or not gone to work because I have children. But, of course, you have to think about whether you can be the senior editor-in-chief when your youngest is… (Woman, 47 years, interview 24)

According to this study there is no clear evidence that some forms of media would be more women-friendly than others. Yet it seems that in magazine journalism, women would have more opportunities to advance their careers than in the traditional news arena. In this study, there are some female interviewees who had moved from a newspaper to a magazine as a result of believing that they had no other way to progress.

The oldest interviewees had started work as journalists in the 1960s and the youngest in the 1990s. It seems that there are differences not only between the genders but also across the generations. This difference between generations is mostly visible when it comes to family issues. The oldest male journalists consider the family and children as women's business; however, men in their forties speak a lot about their family duties as well.

The career caricatures

In the interviews with editors, four different kinds of characteristics emerge which can be crystallized into four career types. These are caricatures and the careers of any single editor, managing editor or other editorial journalist cannot be explained by just one of them. Instead, single careers intersect with a number of different types. Both gender and generational differences are evident in the differences between these types. They reveal not only individual choices but also the cultural conditions and preconditions in media companies and editorial offices that create the space for individual action.

1. The young prodigy

The young prodigy is more often a man than a woman and has already been recruited into the editorial track during the first few years in the occupation. People who still lack solid journalistic experience are also recruited as young prodigies, because their 'lived' experience in society is regarded as an advantage when it comes to editorial tasks.

The generational difference is evident in the recruitment of young prodigies. It seems that despite being typically male a while ago, since the 2000s a young prodigy can also be a woman who is starting out on her career.

2. *The heroic journalist*

The heroic journalist is at the top of his or her career and he or she has a long and solid experience of journalistic tasks. He or she is not principally orientated towards management but has a personal grasp of journalism. The heroism is integrated with the institutional task of journalism. This kind of managerial post involves an active and individual participation in public debate. The heroic journalist may have been a young prodigy at the outset of his or her career who has been trusted and granted relative freedom. This caricature is typically male, but in magazines women can also become heroic journalists.

3. *The diligent professional*

The diligent professional has a long and varied experience at the top of his or her career. Often he or she has worked in the same media company for a long time. Diligent professionals are often women who have been recruited into the managerial track after a long, over ten years, journalistic experience. They do not come up against the glass ceiling, but many are placed in a glass booth. Headhunters looking for editors do not see the diligent professionals, who are seldom recruited outside their editorial offices. However, in magazines, this type does move from one publication to another.

4. *The career hopper*

Instead of progressing in the same editorial office, the career hopper has changed jobs and media companies several times. The career hopper has a varied experience in both journalism and management and the moves from one editorial office or media group to another have also advanced his or her career. This type is typically a male journalist who has been recruited into managerial tasks at the start of his career and has moved from one editorial office and media company to the next, with each hop bringing about advancement on the career ladder.

Conclusions

In this chapter we have analysed the structural, cultural and individual issues that explain the career differences of female and male journalists. The results obtained confirm those of previous research on the topic (Savolainen & Zilliacus-Tikkanen, 1992; Van Zoonen, 1994: 49–60; De Bruin, 2000; De Bruin & Ross, 2004; Chambers et al., 2004; Robinson, 2005; Fröhlich, 2007: 161–177; Melin, 2008; Fröhlich & Lafky, 2008; Zilliacus-Tikkanen, 2008). In this study we attempted to outline the complexity that is constructed when media

organizations, journalism and individuals, both men and women, meet. We compared the careers of 43 interviewed editorial journalists through three perspectives: the organizational, the journalistic and the individual. From the organizational perspective, the ideals of leadership and recruitment processes open up differing positions that require women and men to realize their careers in different ways. In the context of the Finnish debate, the lack of women at the top of organizations has been justified by their lack of willingness to seek managerial jobs. According to our research, however, this lack of willingness does not merely relate to individual choices, but to the fact that the structures and cultures of the organization construct leadership on the basis of a masculine ideal. It seems that in Finland there are increasing opportunities for female senior editors, because they are thought to improve the competitive advantage of media companies. But if women are continually offered leadership positions where they are thought to correct and complement masculine leadership, then the gendering ideal of journalistic leadership will remain as it is.

Gender-based specialization can be seen in journalistic culture and in the practical routines which offer men and women different chances of acquiring qualifications. The inequality of opportunities for gaining these qualifications and career progression is revealed in Finland by the fact that although since the 1980s there have been as many female as male journalists, women have not been recruited to senior leadership positions. On the one hand men are thought to do better in the traditional core areas of news journalism, where such male attributes as rationality and objectivity are emphasized. In the competition for the same occupational positions, female journalists have to demonstrate a particular competence, especially in the areas of journalism which have a masculine label. On the other hand, in Finland, where women are a considerable media audience, there is a demand for both female journalists and editorial chiefs. Women are believed to produce journalistic content that is thought to be feminine, and helps the media to succeed in the increasing competition for audiences.

The cultures and structures can be seen in individual action. Individual actors adapt to the status quo in one way or another. They can try to adjust to the culture of the editorial office by acting like 'one of the boys' or they can move to more woman-friendly media companies. The fact that women do not seek senior editorial posts has often been justified by their greater family responsibilities. According to this research, the situation would seem to be changing because young male journalists also emphasize combining family and work demands with gender equality. Although men's attitudes towards and actions in the family are changing, the current research suggests that these do not, however, alter gendered practices in the organization or the culture of journalism, nor do they automatically encourage men to reflect critically on masculinity as a culturally produced gendered discourse.

The three perspectives used in this research dismantle the view that the structures and cultures of journalism only offer women a narrow victim role. Individual action is not merely seen as a result of subjective positions or choices but as an interaction between

individuals, structures and cultures. Thus, the gendering of journalism is not tied to the gender division of journalists or the masculine practices of journalism, but to the whole socio-historical locus of journalism. In other words, by increasing the numbers of female editorial chiefs in media organizations, or by changing the routines of journalistic practice, it is possible to promote gender equality. However, this does not necessarily change the nature of journalism as a gendered institution.

Endnotes

1. This article is part of the project *Equality, Journalism and Career Development among Finnish Women Journalists* (2007–2009) financed by Helsingin Sanomat Foundation.

2. Although the majority of Finnish journalists are members of the Union, top editorial chiefs—the people who can alone decide on the hiring and firing of personnel or represent the employer in collective bargaining—are barred from membership. There may also be other kinds of errors in the register, due to it being based on members' own declarations (SJL, 2008; Zilliacus-Tikkanen, 2008).

3. There are different ways to define soft and hard news and there is no self-evident definition of which topics belong to soft news and which to hard news. According to Monica Djerf-Pierre and Monica Löfgren Nilsson, the different definitions derive from a different logic: those of importance and taste or pleasure. The first logic is rooted in the view that women and men have different beliefs about what the important and therefore newsworthy public issues are. Hard news includes issues related to the male-dominated spheres such as politics, the economy and business. Soft news includes issues related to such social spheres as health care and child care, traditionally understood to belong to the female-dominated sphere. The second logic springs from the view that women and men are interested in and derive pleasure from different subjects and topics. Sports, pornography, science and crime are believed to be topics for men, and personal relationships, human interest, fashion and home-making for women (Djerf-Pierre & Löfgren-Nilsson, 2004: 82–83). Furthermore, the distinction between hard and soft news could be based on the way the news is told. Hard news focuses on telling information and soft news on creating good stories (Zelicer, 2004: 132–135).

References

Acker, J., 'The future of "gender and organizations" connections and boundaries', *Gender, Work and Organization*, 5:4 (1998), pp. 195–206.

Billing Y. and Alvesson. M., 'Questioning the notion of feminine leadership: A critical perspective on the gender labelling of leadership', *Gender, Work and Organization*, 7: 3 (2000), pp. 144–157.

Bruin, M. de, 'Gender, organizational and professional identities in journalism', *Journalism*, 1:2 (2000), pp. 217–238.

Bruin, M. de, 'Organizational, professional, and gender identities—Overlapping, coinciding and contradicting realities in Caribbean media practices', in M. de Bruin & K. Ross (eds) *Gender and Newsroom Cultures: Identities at Work*, Cresskill, NJ, Hampton Press, 2004, pp. 1–16.

Bruin, M. de & Ross, K. (eds), *Gender and Newsroom Cultures: Identities at Work*, Cresskill, NJ, Hampton Press, 2004.

Bruin, M. de & Ross, K., 'Introduction: Beyond the body count', in M. de Bruin & K. Ross (eds) *Gender and Newsroom Cultures: Identities at Work*, Cresskill, NJ, Hampton Press, 2004, pp. vii–xiv.

Butler, J., *Gender Trouble: Feminism and the Subversion of Identity*, London, Routledge, 1990.

Chambers, D., Steiner, L. & Fleming, C., *Women and Journalism*, London, Routledge, 2004.

Djerf-Pierre, M., 'The gender of journalism: The structure and logic of the field in the twentieth century', *Nordicom Review*, 28: Jubilee Issue (2007), pp. 81–104.

Djerf-Pierre, M. & Löfgren-Nilsson, M., 'Gender-typing in the newsroom: The feminization of Swedish television news production 1958–2000', in M. de Bruin & K. Ross (eds) *Gender and Newsroom Cultures: Identities at Work*, Cresskill, NJ, Hampton Press, 2004), pp. 79–104.

Evetts, J., 'Analysing change in women's careers: Culture, structure, and action imensions', *Gender, Work and Organization*, 7:1 (2000), pp. 57–67.

Fröhlich, R., 'Three steps forward and two back. Women journalists in the Western world between progress, standstill, and retreat', in P. Creedon & J. Cramer (eds) *Women in Mass Communication*, 3rd edition, London, Sage, 2007, pp. 161–176.

Fröhlich, R. & Lafky, S., 'Introduction: Gender, culture and news work in the Western world', in R. Fröhlich, R. & S. Lafky (eds) *Women Journalists in the Western World: Equal Opportunities and What Surveys Tell Us*, London, Hampton Press, 2008, pp. 1–9.

Indvik, J., 'Women and leadership', in P. Northouse (ed.) *Leadership: Theory and Practice*, London, Sage, 2004, pp. 265–299.

Lift, S. & Ward. K. (2001), 'Distorted views through the glass ceiling: The construction of women´s understanding of promotion and senior management positions', *Gender, Work and Organization*, 8:1 (2001), pp. 19–36.

Mc Kay, A., 'Speaking up: Voice amplification and women's struggle for public expression', in C. Mitchell (ed.) *Women & Radio: Airing Differences*, London; Routledge, 2000, pp. 187–206.

Morna Lowe, C. (ed.), *Glass Ceiling Two: An Audit of Women and Men in South African Newsrooms*, Johannesburg, SANEF, 2007.

Melin, M., *Gendered Journalism Cultures: Strategies and Tactics in the Fields of Journalism in Britain and Sweden*, Göteborg, JMG, Department of Journalism and Mass Communication, University of Göteborg, 2008.

MSAH, *Segregation and the Gender Gap. Reports of Ministry of Social Affairs and Health*, Finland, Helsinki, Ministry of Social Affairs and Health (MSAH), 2008 English summary.

Robinson, G., *Gender, Journalism and Equity: Canadian, US and European Perspectives*, Cresskill, NJ, Hampton Press, 2005.

Savolainen, T. & Zilliacus-Tikkanen, H., *Women in Finnish Broadcasting*, Helsinki, Finnish National Commission for UNESCO, 1992.

SJL Suomen Journalistiliiton jäsenrekisteri [The register of the Finnish Union of Journalists], emailing with ombudsman Marja Palmunen 23 February 2008.

Steiner, L., 'Newsroom account of power at work', in C. Carter, G. Branston and S. Allan (eds) *News, Gender and Power*, London, Routledge, 1998, pp. 145–159.

Torkkola, S. & Ruoho, I., *Shall We Order a Female Editor-in-Chief? Female and Male Editors' Views on the Impact of Gender on Careers*, Department of Journalism

and Mass Communication Publications Series B54/2009, Tampere, University of Tampere.

Vochocová, L., 'Women in newsrooms: Idle hopes for the conquest of the masculine fortress', *Media Studies*, 3:3 (2008), pp. 231–256.

Zelicer, B., *Taking Journalism Seriously: News and the Academy*, London, Sage, 2004.

Zilliacus-Tikkanen, H., '"Women journalists and the gender gap" in Finland´s news culture', in R. Fröhlich, R. & S. Lafky (eds) *Women Journalists in the Western World: Equal Opportunities and What Surveys Tell Us*, London, Hampton Press, 2008, pp. 139–155.

Van Zoonen, L., *Feminist Media Studies*, London, Sage, 1994.

Van Zoonen, L., 'One of the girls? The changing gender of journalism', in C. Carter, G. Branston & S. Allan (eds) *News, Gender and Power*, London, Routledge, 1998, pp. 33–46.

Claudia Alvares, Sofie van Bauwel and Tonny Krijnen

The relationship between gender and media has received scholarly attention from the 1970s onwards. The emergence of feminist media studies and the link to emancipatory and women's movements (Krolokke & Sorensen, 2005) has constructed a specific relationship between academia and gender issues. Feminist or wider research on gender and the media is intertwined with societal and political realms. Notions of diversity and equality are at the core of these two worlds and function as a bridge between them, contributing to the establishment of a relationship of co-existence which is, nevertheless, not always the essence of scholarly work on gender and communication. As Byerly and Ross (2006: 3) argue, this particular inclusivity is reflected by 'the women-and-media relationship [which] begins to reveal the process of struggle that women have engaged in for use of media to gain a public voice, presence, and influence'. This perspective, which has roots outside academia and stresses the inequality of the gendered power struggle, lies at the core of such research.

Although until the 1990s feminist research was primarily focused on 'women', contemporary preoccupations are now increasingly centred on 'gender', in particular on the latter's intersections with a host of societal and political issues which contribute to the production and reproduction of gendered discourses in daily life. Moreover, the field can, and in our opinion should, open itself up to inquiries into gender from a posttructural perspective, influenced by 'queer' theory, where the emphasis is placed on the construction of masculinity and femininity. As Gauntlett (2002: 9) has pointed out, 'the ideas of "masculinity" and "femininity" have been pulled through the social changes of the past decades in quite different ways'. Such constructs are in flux and hybrid, resulting not only in new articulations but also in revisions and entry into hegemonic spaces. Notions of gender are now applied in research on the levels of production, text

and audiences, and are using paradigmatic perspectives ranging from political economy to deconstructive explorations of poststructuralism. Contemporary transformations in society and politics illustrate the workings of a gendered machinery where notions of femininity and masculinity are altered. Such transformations are particularly visible in communication and media institutions, which provide a crucial research space for 'doing' and 'undoing' gender.

In the introduction, Liesbet Van Zoonen describes the contents and approach of *Gendered Transformations* as the re-establishment of a research agenda on gender and media as 'normal science'—a *forward to the past*. Consisting of a selection of articles originally presented at the 2008 ECREA conference in Barcelona, this anthology is intentionally eclectic in scope, encompassing a wide range of topics which reflect the entwining of media and gender in the context of discussions on identity politics, definitions of public/private spheres, visual culture, cyber culture and access to media professions. It aims to bring together scholars who, despite coming from a variety of disciplinary backgrounds, share a common research focus. *Gendered Transformations* provides an overview of cutting-edge perspectives on the intersections between gender and media, while simultaneously exploring the wider implications and interdisciplinary nature of this academic field.

By drawing attention to a plurality of intertwining approaches to this theme, the book situates itself 'between camps' (Gilroy, 2000), exploring perspectives that range from the essentialist—which presuppose a pervasive commonality inherent in women—to the anti-essentialist—which problematize and aim to deconstruct the commonality of a sexualized essence (see Benhabib, 1992). The discourse of sex thus opens itself up to a discourse on gender, the constitution of which is performatively enacted in daily life, namely in communication and the media. On the one hand, the essentialist discourse of sex is a valuable political asset in that it permits one to fight back against 'sexism' (Spivak, quoted in Harasym, 1990: 12). On the other, by seeking recourse in transformative projects that rely on the concrete classification—and representation—of a cohesive identity, the anti-essentialist discourse on gender is no less valuable in that it fragments the subject so as to open the latter up to the non-identical, namely conflictual intersections such as class, ethnicity and race. Both essentialist and anti-essentialist perspectives ultimately—and perhaps paradoxically—point to a political dimension: if essentialist approaches may be strategically helpful in drawing attention to the historically rooted dimensions of sexual discrimination in the materiality of bodies, anti-essentialist approaches pave the way for a postmodern politics that seeks to remain open to the 'permanently contingent' (Butler, 1995: 41), thereby preserving the plurality and diversity distinctive of gender expressions.

The link between gender and media translates, in this anthology, into the dimensions of representational politics, embodied performativity and social constructions of reality. The first section, titled 'Gendered Politics', discusses the representation of women in the public sphere, exploring the extent to which the latter is permeable to issues allegedly

pertaining to the private realm. The focus on the political representation of women is clearly essentialist in that it presupposes that women as a collective identity—strategic or otherwise—have a set of legal rights to recognition in the public sphere. The level of autonomy and equality—liberal democratic values so highly prized in Western society— enjoyed by women in any society can be gauged, according to this perspective, by the extent to which they are effectively recognized in the public sphere. Karen Ross, for instance, argues for a cultural and political change in the way women are represented by news discourse, pointing to the fact that the current increase in the number of female journalists does not necessarily mean that women are depicted more fairly in the news. Claudia Alvares, in turn, analyses the link between academic feminist discourse and the journalistic representation of 'feminine issues' in two Portuguese 'quality' newspapers, querying the degree to which the general public interest is effectively regarded as overlapping with private matters. Women's entrance into the realm of politics, one of the remaining 'bastions' of male hegemony, is explored by Marlène Coulomb-Gully in terms of identity construction, reactions to the latter, and contextual specificities. Margreth Luenenborg, Jutta Roeser, Tanja Maier and Kathrin Mueller also focus on the increasing visibility of female politicians, examining the changes both in the media representation of such women as well as in the way they are perceived by media consumers.

The second section, titled 'Embodied Performativities', is concerned with the gendered body that is produced and enacted in a variety of media texts. The opposition of complementary terms—masculine and feminine—occurs within a grid of institutionalized heterosexuality and heteronormativity that limits the gendered possibilities within a rigidified binary system of gendered polarities. By drawing attention to the fact that a solid definition of gendered identity can only be defined oppositionally against the characteristics one lacks, a non-essentialist focus on gender attempts to deconstruct the rigid dichotomy between male and female, drawing attention to the fluidity of these categories. Frederik Dhaenens, Daniel Biltereyst and Sofie Van Bauwel argue for the integration of queer theory into historical film research into gay and lesbian representations, focusing on the challenge presented to the Motion Picture Production Code by three popular films of the late 1950s and early 1960s which engaged with the themes of homosexuality and queer identity. Begonya Enguix-Grau examines film approaches to intersexuality, claiming that these are rare precisely because intersexuality evades the mappings of our representational frameworks, which are usually based on the existence of two sexes and a gender dichotomy. The normalization of the male/female dichotomy, respectively connoting oppressive/ submissive modes of conduct, in the infrastructure of popular virtual world platforms is explored by Delia Dumitrica and Georgia Gaden, a process that risks conditioning consumers' 'options and choices' as well as their perception of gender. Olena Goroshko and Olena Zhigalina also concentrate on the virtual world, focusing on the fluidity and instability of gender as a category that is almost rendered invisible in the construction of an online political identity in the blogosphere.

The third section, 'Gendered Socializations', offers insight into the dynamics involved in shaping gendered ideologies in daily life, namely the manner through which stereotypes connoted with sex-based essentialisms are reproduced and reinforced by the media. Topics of concern are the media professional in context, as well as the gendered discourses visible in media content that mould socially conditioned views of the world. Tonny Krijnen focuses on the gendered manifestations of emotion and morality in reality TV, inquiring into the degree to which the stereotypical views according to which emotions are inherently feminine and morality intrinsically masculine intertwine in such shows. The role played by the media as an instrument of socialization is analysed by Elke Van Damme, who concentrates on how the discourses of popular series are used by teenagers to define their own gendered identities, especially in the articulation of sexuality. Martha Blomqvist and Kristina Eriksson explore the construction of gender in the ICT sector by Swedish newspapers, drawing attention to the fact that the media's strategy of making women more absent than they in fact are only serves to perpetuate the status quo in gender relations. Examining the gendered inequalities in the Finnish media sector, Sinikka Torkkola and Iiris Ruoho claim that this industry is torn between the acceptance of journalistic practice as being gender neutral on the one hand, and the concrete creation of gendered divisions of labour that ensue from genre stereotypes on the other.

The sections 'Gendered Politics', 'Embodied Performativities' and 'Gendered Socializations' each address specific concerns relating to the intertwining of gender and media. However, the neutral and transparent status that the media claim is an accurate presenter of a 'true picture of reality' (Van Zoonen, 2007: 152) provides a common link between those three sections: representational politics seeks to challenge inequalities in the way women are represented in the public sphere; the focus on the enactment of the gendered body through media texts aims to open up the heterosexual binary matrix to other possibilities; and the exploration of sex-based essentialisms that are visible in the media emphasizes the extent to which ideologies condition our daily life. Accordingly, we can affirm that at the heart of this book lies a concern with the media as agents of both public knowledge, contributing to citizen-formation, as well as of entertainment, namely industrialized popular culture (Corner, 1991: 268; Livingstone & Lunt, 1994: 179). The links between public knowledge and entertainment, that is, between cognitive and emotional domains, is visible in the manner through which the media are regarded as aiding the promotion of normative social consensus and, ultimately, in the construction of hegemonic morality.

However, this is not to deny the capacity of audiences to autonomously interpret media messages according to a variety of socio-cultural contexts in which they are received. What is in fact sustained is that the poststructuralist emphasis on gender as an ambiguous and unstable category may not necessarily imply a rejection of politics, but rather a redefinition of the terms in which the latter have traditionally operated (Van Zoonen, 2007: 154). As such, a new, more democratic political potential ensues from the

emphasis on the polysemic nature of media texts, as well as on the promotion of audiences' interpretative abilities. The struggle for women's rights and equal representation by the media and within the media industry can thus be complemented by a further political dimension that is linked to that of audience research.

The essays collated in *Gendered Transformations* provide a valuable contribution to the area, due precisely to the interdisciplinary scope of the volume, coupled with its objective of deconstructing existing theories and methodologies, pointing out, in the process, novel ways of combining the latter. In effect, this anthology opens up the field of gender by analysing traditional perspectives thereon in light of recent advances in the field of media theory and methodology. The title, *Gendered Transformations*, points to the alterations that such new and fruitful combinations of theories and methodologies may lead to, transcending the restrictive compartmentalizations of pre-established disciplinary discourse. We hope that the critical reflection presented here on the intersections of gender and media may indicate novel ways of deconstructing traditional views of areas that are irreducible to disciplinary camps due to their permanent engagement with the field of possible experience in 'actuality'. In our view, the deconstruction of delimited 'camps' can deliver new insights into the reason why gender continues to be a topic that is well positioned on the research priority list, particularly due to its multiple imbrications with media analyses.

References

Benhabib, S., *Situating the Self: Gender, Community and Postmodernism in Contemporary Ethics*, London, Routledge, 1992.

Byerly, C.M. & Ross, K., *Women and Media: A Critical Introduction*, London, Blackwell, 2006.

Butler, J., 'Contingent foundations: Feminism and the question of "postmodernism"', In L. Nicholson (ed.) *Feminist Contentions: A Philosophical Exchange*, London, Routledge, 1995, pp. 35–57.

Corner, J., 'Meaning, genre and context: The problematics of "Public Knowledge" in the new audience studies', in J. Curran & M. Gurevitch (eds) *Mass Media and Society*, London, Edward Arnold, 1991, pp. 267–306.

Gauntlett, D., *Media, Gender and Identity. An Introduction*, London, Routledge, 2002.

Gilroy, P., *Between Camps: Nations, Cultures and the Allure of Race*, London, Penguin Press, 2000.

Harasym, S., 'Criticism, feminism and the institution', in G.Ch. Spivak (ed.) *The Postcolonial Critic: Interviews, Strategies, Dialogues*, London, Routledge, 1990, pp. 1–16.

Krolokke, C. & Sorensen, A., *Gender Communication Theories and Analyses: From Silence to Performance*, London, Sage, 2005.

Livingstone, S. & Lunt, P., 'Studio discussions, social spaces and postmodernity', in *Talk on Television: Audience Participation and Public Debate*, London, Routledge, 1994, pp. 162–180.

Van Zoonen, L., 'Conclusion', in *Feminist Media Studies*, London, Sage, 2007, pp. 148–155.

The Editors

Claudia Alvares (claudia.alvares@ulusofona.pt) is associate professor in culture and communication at Lusofona University, Lisbon, Portugal, where she directs the centre in applied communication, culture and information technologies (CICANT) as well as a masters programme in journalism, politics and contemporary history. She obtained a PhD from Goldsmith's College, University of London, in June 2001, under the British Council Chevening Scholarship and the Portuguese Government/European Union Praxis XXI Joint Scholarship. Chair of the ECREA gender and communication section, Alvares is principal investigator of four research projects, funded by the European Union, focusing on the relationship between gender and media. She is, moreover, one of the partners of the UNESCO chair on gender equality and women's empowerment that has recently been established at the University of Cyprus.

Among her main publications are *Humanism after Colonialism* (2006), *Representing Culture: Essays on Identity, Visuality and Technology* (2008) and *Perspectivas Interdisciplinares da Comunicação* (2008). Alvares is currently working on a book resulting from one of her European Union-funded research projects.

Tonny Krijnen (krijnen@fhk.eur.nl) is assistant professor in media and communication at the Erasmus University of Rotterdam, the Netherlands and a member of the Erasmus Research centre for media, communication and culture and the centre for popular culture. Her research interests include popular culture, in specific television, and its relation to morality and emotions with its audiences; gendered dimension of these relationships, and the production of moral-emotional content of popular television. She has published on the moral content of television, moral citizenship and its gendered dimensions, and notions of morality in media studies. She is also the vice-chair of the gender and communication section of ECREA.

Sofie Van Bauwel (Sofie.van Bauwel@UGent.be) is a professor in film, television, and cultural studies at the department of communication studies, Ghent University, Belgium and a member of CIMS—centre for cinema and media studies. She researches popular culture, film and television, and gender. She has published on gender bending in visual culture, gender representations in the media and feminist media theory. She is also the vice-chair of the gender and communication section of ECREA.

The Authors

Daniel Biltereyst (Daniel.Biltereyst@UGent.be) is a professor in film, television, and cultural studies at the department of communication studies, Ghent University, Belgium, where he leads CIMS—centre for cinema and media studies. His research and publications are on film and screen culture as sites of controversy and censorship, situated within public spheres.

Martha Blomqvist (Martha.Blomqvist@gender.uu.se) is associate professor in sociology and senior lecturer at the centre for gender research, Uppsala University. Her main research interest is gender in working life. The last decades her research has centred on gender and organization, exploring changes in the gender division and gender relations as a consequence of organizational change. She is the series editor of *Crossroads of Knowledge*, an interdisciplinary research publication. A current interactions research project aims at studying and initiating change in gendered and gendering processes within a technological research centre in Sweden.

Marlène Coulomb-Gully (marlene.coulomb@univ-tlse2.fr) is former student of the 'Ecole Normale Supérieure' and 'Agrégée de Lettres'. She is also gratuated in sociology and doctor in information and communication (PhD). She teaches as professor at the University of Toulouse 2—Mirail (France). Her main research fields are: political communication, media (especially TV), elections, gender and politics.
She is the author of *Radioscopie d'une campagne* (1994) ; *Les informations télévisées* (1995); *La démocratie mise en scènes* (2001). She is the editor of numerous journal issues; the most recent being 'Le 8 mars à la Une: Femmes et médias, une comparaison internationale', *Sciences de la société,* 70 (2007) and 'Présidentielle 2007: Scènes de genre', *Mots-Les langages du politique,* 90 (2009).

Frederik Dhaenens (Frederik.Dhaenens@UGent.be) is a PhD student and a member of CIMS—centre for cinema and media studies and of television studies at the department of communication studies, Ghent University, Belgium. His research focuses on queer theory, queer representation and screen culture.

Delia Dumitrica (dddumitr@ucalgary.ca) is a doctoral student in communications at the University of Calgary, working on nationalism and the internet. Her doctoral research looks at the role of discourse in shaping our understanding and use of new media. Previously published research discussed nationalism in the media, and the role of new media in identity constructions.

Begonya Enguix Grau (benguix@uoc.edu) PhD in social and cultural anthropology, is a lecturer at the Arts and Humanities department, Universitat Oberta de Catalunya, Barcelona, Spain. She also holds a university diploma in advertising. Her publications include, among others, the book *Poder y deseo: La homosexualidad masculina en Valencia* (1996) and later articles: 'Gendered sites: Géneros en Internet' (2008), Espacios y disidencias. El orgullo LGTB' (2009 'Bodies in action: Performing gender and identity in online settings' (2009), 'Fronteras, cuerpos e identidades gays' (2009), 'Identities, Sexualities and Commemorations: Pride Parades, Public Space and Sexual Dissidence (2009)' and 'Bodies in action: Performing identity in datig sites' (2010). She belongs to the International Communication Association and to the European Association of Social Anthropologists and is a member of the research group on anthropology of the body (Catalan Institute of Anthropology) and of the quality research group on social anthropology (Universitat Rovira i Virgili, Tarragona, Spain). Her current research is focused on bodies, genders, sexualities and identities, and their intersections with urban and media anthropology.

Kristina Eriksson (kristina.eriksson@gender.uu.se) PhD in sociology, has been working as a researcher, in various research projects concerning gender issues, at the centre for gender research at Uppsala University, Sweden, for the past six years. Her main field of research is gender relations in professional and organizational contexts as well as the (re)production of gender and gender (in)equality in the everyday lives of married and cohabiting couples. She is currently involved in the interaction research project *Change and Gender in Focus* (funded by Vinnova). This research project aims at studying and initiating change in gendered and gendering processes within and together with a technological research centre in the middle of Sweden.

Georgia Gaden (georgiagaden@gmail.com) is a PhD candidate at the University of Calgary. Her doctoral research is concerned with exploring values of quality and success among bloggers and how these values might pervade and regulate the day-to-day lived experiences of these bloggers as well as the texts they produce. Her research interests extend beyond blogging specifically to the internet and popular culture more generally. She is a feminist and a new mum, both of which bring her great joy.

Olena Goroshko (olena_goroshko@yahoo.com) is professor of linguistics and sociology of communication and head of the cross-cultural communication and modern languages department at the National Technical University 'Kharkiv Polytechnic Institute', Ukraine. She is also affiliated with the International Sociological Association, (Russian) Communication Association among them.

Goroshko's professional interests cover psycho-sociolinguistics, gender and internet studies, CMC forensics and elearning. Olena was a visiting fellow in the Oxford internet institute, University of Oxford (2004). She is the author of many articles and four books on socio-, psycho- and computer-mediated communication. Goroshko's works have appeared in *The Handbook of Research on Virtual Workplaces and the New Nature of Business Practices* (2008), *Russian Cyberspace Journal* (2009), *Yezyk@multimedia* (2005), *Linguistica Computizionale* (2003), *Gendered Transformations in New Media* and the *Wiener Slawistischer Almanach* (1999; 2010), among others. She participated in a number of projects in gender equity and empowerment in education. Currently she is involved into the UNESCO project *UNESCO Chair on Gender Equality and Women's Empowerment* and *Global Report on the Status of Women in the News Media* sponsored by International Women's Media Foundation.

Margreth Lünenborg (margreth.luenenborg@fu-berlin.de) PhD, 1963, professor for journalism studies at the institute of media and communications, FU Berlin, since 2009. Before 2009 she was professor for media and communications at the University of Siegen, as well as different teaching and research activities at various universities in Berlin, Vienna, Salzburg and Leipzig. Until starting out a scientific career, she worked in journalism and political communications. Her main research interests include: journalism studies—also internationally comparative, gender and communications, media and cultural studies, media and migration. Her publications include, among others: *Politik auf dem Boulevard? Die Neuordnung der Geschlechter in der Politik der Mediengesellschaft* (2009); *Gender and Ethnicity in the German Mass Media—Current Research on the Representation of Female Immigrants*, in: Kumarini Silva, Kaitlynn Mendes (HG.): *Commentary and Criticism*, Feminist Media Studies, 9:2 (*with Annika Bach*); and 'Journalismus als kultureller Prozess. Zur Bedeutung von Journalismus in der Mediengesellschaft' (2005, Wiesbaden: Verlag für Sozialwissenschaften).

Tanja Maier (tanja.maier@Fu-berlin.de) PhD, postdoctoral research fellow on the joint project *Women at the Top Represented by the Media* at the Free University Berlin. Between 2006 and 2008 she was research associate at the University of Goettingen, as well as conducting different teaching activities at various universities in Oldenburg, Klagenfurt and Siegen. Her main research interests include culture and media theories (TV, print, film), cultural gender studies, discourse analysis, popularization of knowledge. Her publications include, among others: *Gender und Fernsehen. Perspektiven einer kritischen Medienwissenschaft* (2007).

Jutta Roeser (roeser@uni.leuphana.de) is professor of communication science at the Leuphana University of Luenenburg and director of the institute for communications and media culture. The main focus of her work is in the field of audience studies, in cultural media studies and gender studies. Her current research projects are on *The Domestication of the Internet in Germany 1997-2007* and *Women at the Top Represented by the Media* (with Margreth Luenenborg, Tanja Maier & Kathrin. F. Mueller). She worked together with the German association of female journalists on the GMMP research 2005 and carried out a more detailed analysis of the press (*Praesenz von Frauen in den Nachrichten*, 2006). Her books include *MedienAlltag: Domestizierungsprozesse alter und neuer Medien* (2007); *Kommunikationswissenschaft and Gender Studies* (2001), with Elisabeth Klaus and Ulla Wishermann; and *Fernsehgewalt im gesellschaftlichen Kontext* (2000).

Karen Ross (Karen.Ross@liverpool.ac.uk) is professor of media and public communication at the University of Liverpool, United Kingdom. She teaches political communication and gender and media. She has written extensively on the relationship between women, politics and media and has also written more broadly on aspects of media culture such as media and the public, media and identity politics and audience studies. She has written or edited fifteen books and numerous journal articles, chapters and conference papers. She is the foundational editor of the latest ICA/Wiley-Blackwell journal, *Communication, Culture and Critique* which launched in March 2008.

Her most recent books include: *Gendered Media: Women, Men and Identity Politics* (2009); *The Media and the Public: 'Them' and 'Us' in Media Discourse* (with Stephen Coleman, in press); *Popular Communication: Essays on Publics, Practices and Processes* (edited, with Stuart Price, 2008); *Rethinking Media Education: Critical Pedagogy and Identity Politics* (edited, with Anita Nowak and Sue Abel, 2007); *Women and Media: A Critical Introduction* (with Carolyn Byerly, 2006); *Gender and Newsroom Practice* (edited, with Marjan de Bruin, 2004).

Iiris Ruoho (iiris.ruoho@uta.fi) DSocSc, is the adjunct professor in the department of journalism and mass communication at the University of Tampere, Finland. She acts as the supervisor in the project *Equality, Journalism and Career Development among Finnish Women Journalists* and the project *Women's Magazines as a Public Forum*. Ruoho specializes in feminist media studies, including journalism research. She wrote her doctoral dissertation *Utility Drama* (2001) on a Finnish television serial drama. Ruoho has been a visiting researcher at the University of Texas and the University of Oregon. She is the chair of the multidisciplinary University Network for Communication Sciences and the vice head of the department of Journalism and Mass Communication at the University of Tampere.

Sinikka Torkkola (sinikka.torkkola@uta.fi) PhD, is a senior researcher in the department of journalism and mass communication at the University of Tampere, Finland. In 2008-2009 she worked as a researcher in the project *Equality, Journalism and Career Development among Finnish Women Journalists*. Torkkola specializes in health communication and health journalism. In her dissertation (2008), '*Sick Story. A research on the theory of health journalism and the newspaper hospital.*', she examines the theory of health journalism and the construction of the hospital and patienthood in the newspaper. Sinikka Torkkola is a member of the board in the European Communication Research and Education Association (ECREA). She is also the Vice Chair of the ECREA's Women's Network.

Elke Van Damme (eevdamme.vandamme@ugent.be) is a researcher from the Research Foundation-Flanders (FWO) (2008–2012) and a member of the centre for cinema and media studies in the department of communication studies at Ghent University, Belgium. She studies the representations of teenagers in contemporary Flemish media, with a specific emphasis on gender, sexuality and identity; as well as the possible interpretations and meanings the viewing youngsters may give to these images.

Olena Zhigalina (zhigalina@mail.ru) is a senior lecturer of cross-cultural communication and modern languages department at National Technical University 'Kharkiv Polytechnic Institute', Ukraine. Her professional interests lie in the sphere of internet linguistics, corporate communication and elearning. Olena Zhigalina is working on her PhD thesis, the subject of which is the lingual design of English-speaking corporate blogs. Olena is the author of several articles on the language of the internet and distance education. She is also a co-author of four distance courses on business English and English for computer science students, which are currently used in students' education in the cross-cultural communication and modern languages department at the National Technical University 'Kharkiv Polytechnic Institute'.

Liesbet van Zoonen (e.a.van-zoonen@lboro.ac.uk) joined the department of Social Sciences at Loughborough University on January 1, 2009 as professor of Media and Communication. Liesbet is also a professor in media and popular culture at Erasmus University Rotterdam (Netherlands) for one day a week. For more than 20 years she worked at the University of Amsterdam, most recently as head of the Department of Communication. She also held various positions at other universities in the world, most notably as professor II at Oslo University, and as visiting professor at the University of the West Indies (Jamaica) and the Hochschüle für Film und Fernsehen (Germany).
Currently her research is moving in the direction of media and religion, in particular with respect to the question how popular culture is both an arena for, and a means in social conflict about religion. She received a grant from the AHRC in the Religion and Youth

program for research about the anti-Islam film Fitna and the video respons on YouTube. This topic is embedded in her wider interest in the many and diverse articulations of media and citizenship, in particular the increasing connections between political communication and popular culture. Her exposition of these connections in her latest book *Entertaining the citizen: when politics and popular culture converge* (Rowman and Littlefield, 2005) received positive reviews in leading international academic journals, and is considered an important innovation in political research. She is furthermore internationally known for her work on gender and media (*Feminist Media Studies*, Sage, 1994), which has been translated into Chinese, French, Portuguese, Serbian and Italian.